The Fundamentals of
WATERCOLOUR
— PAINTING —

A Complete Course in Techniques, Subjects and Styles

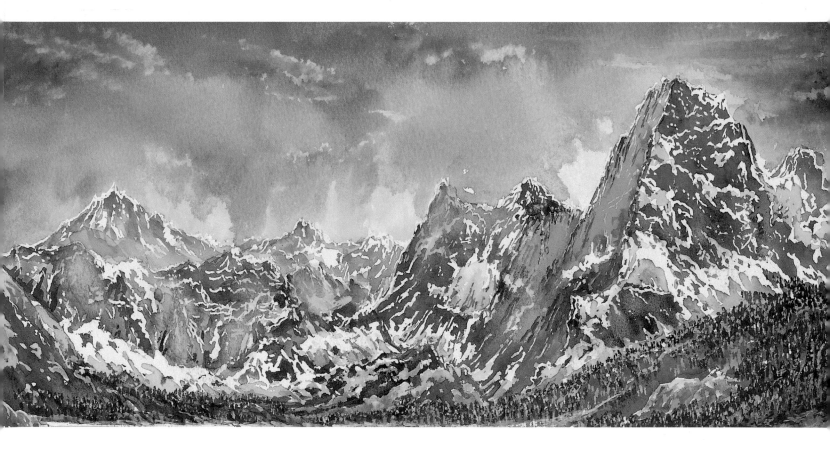

Keith Fenwick

ARCTURUS

To Dorothy, my wife, for her support, advice and typing of the text, and to all my students over the years whose needs have helped me to determine the content of this book.

ARCTURUS

This edition published in 2013 by Arcturus Publishing Limited
26/27 Bickels Yard, 151–153 Bermondsey Street,
London SE1 3HA

ISBN: 978-1-78212-233-3
AD003562EN

Printed in Singapore

CONTENTS

INTRODUCTION

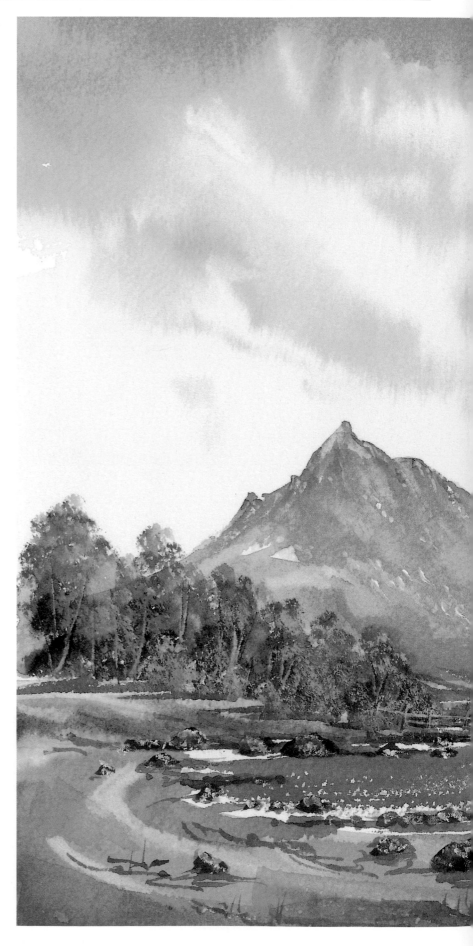

Watercolour painting opens up a new world for the artist. It is an exciting medium, since the unexpected can happen when colours blend together to create wonderful effects. It is also famed for its luminosity, with the white of the paper showing through translucent washes. As well as traditional watercolours, acrylic paints can also be applied with watercolour techniques to give a similar effect, and you will find many examples of their use in this book.

Many people think they can't paint. Well, I say they can. I don't believe painting is a gift. Anyone can be taught to paint. However, whatever we hope to achieve in life, we have to work at it. The same goes for painting. Even if you never reach masterclass level, painting will change your life – ask any artist. Yes, you will make mistakes; we all do. The secret is to understand what has gone wrong and to learn from your mistakes.

My aim in this book is to save you 20 years of learning by telling you about the techniques, tips and useful practices I have developed over decades. I shall show you how to paint a wide range of outdoor scenes, including mountains, lakes, trees, water, buildings, bridges and walls. In addition I shall be demonstrating how to bring atmosphere and mood to your paintings.

It is not my intention to impose a specific style of painting on you. With practice you will develop your own, and this will become your handwriting in paint, easily recognizable by others as your personal signature.

Learning to paint in watercolours is fun, and it's easier than you think. I welcome this opportunity to show you how it's done. Happy painting!

Keith H Fenwick

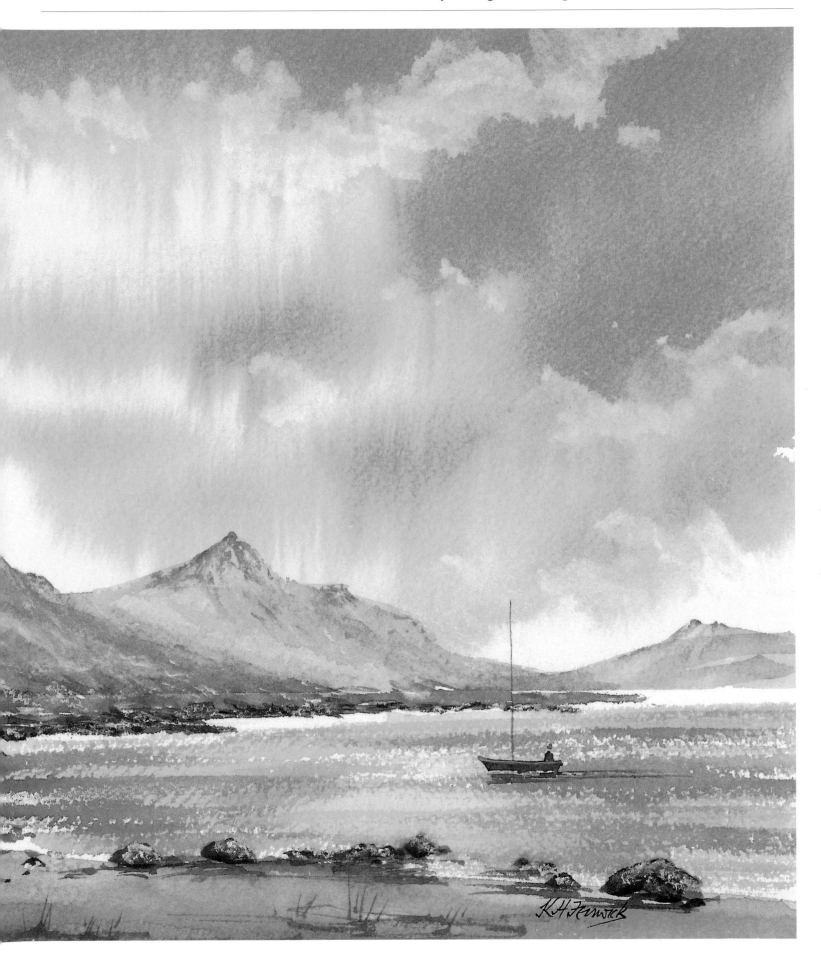

Introduction

A visit to an art store can be a confusing experience as so much is on offer. My preference is to use good-quality materials, and I advise you to do the same. Buying the best you can afford will work out cheaper in the long run and save you a great deal of frustration.

Paints

Most professional artists prefer tube colours because they are moist and more convenient for mixing large washes of colour. Pans of paint become very hard if left unused and release less colour.

The choice of colours is personal to the artist, but you won't go far wrong if you begin with my basic range. This comprises:

Skies
Alizarin Crimson
Cerulean Blue
Cobalt Blue
French Ultramarine
Indanthrene Blue
Payne's Grey
Winsor Red

Earth
Burnt Sienna
Burnt Umber
Cadmium Yellow Pale
Gold Ochre
Permanent Sap Green
Raw Sienna
Winsor Yellow

Rocks
Alizarin Crimson
Burnt Sienna
Burnt Umber
Payne's Grey
Raw Sienna

Trees
Alizarin Crimson
Burnt Sienna
Cadmium Yellow Pale
Cerulean Blue
French Ultramarine
Payne's Grey
Permanent Sap Green
Raw Sienna

Water
Alizarin Crimson
Burnt Umber
Cerulean Blue
French Ultramarine
Payne's Grey

Light
Cadmium Yellow Pale
Gold Ochre
Raw Sienna
White of the paper
Winsor Yellow

Atmosphere & mood
Alizarin Crimson
Burnt Umber
Cerulean Blue
French Ultramarine
Payne's Grey
Raw Sienna

Shadows
Alizarin Crimson
Burnt Umber
French Ultramarine
Raw Sienna

Brickwork
Burnt Sienna
Cobalt Blue
Raw Sienna
Vermilion

Stonework
Alizarin Crimson
Burnt Sienna
Cobalt Blue
Raw Sienna

Special applications
Gold Ochre
Purple Madder
Winsor Red
Winsor Yellow

Palette

All artists have their own way of painting. I prefer to use a large open palette. I simply draw my colours into the centre of the palette and mix them to my requirements. For large washes I premix colours in saucers. The palette includes a lid which provides more than ample space for mixing colours.

Brushes

For painting skies and other large areas, I use a 1cm/½in hake brush and for control a size 14 round. For buildings and angular elements, such as mountains and rocks, I use a 2in/¾in flat. For fine detail, such as tree structures, I use a size 3 rigger (originally developed for painting ships' rigging, hence the name), and for detailed work a size 6 round.

Papers

Good-quality papers come in different sizes, textures and weights. They can be purchased as sheets or in gummed pads, spiral-bound pads or blocks (glued all around except for an area where the sheets can be separated).

I prefer to purchase my paper in sheet form, size 76 × 55cm/30 × 22in, and cut it to the size I need. The paintings in this book were made on 425gsm/200lb or 640gsm/300lb Rough watercolour paper.

A choice of surfaces and weights is available. For example:

HP (Hot pressed) has a smooth surface, used for calligraphy and pen and wash.

NOT (Cold pressed) has a slight texture (called 'the tooth') and is used for traditional watercolour paintings.

Rough paper has a more pronounced texture which is wonderful for large washes, tree foliage, sparkle on water, dry brush techniques, and so on. I always use a Rough paper.

The weights most suitable for water-colour painting are as follows:

190gsm/90lb paper is thin and light; unless wetted and stretched, it cockles very easily when washes are applied.

300gsm/140lb paper does not need stretching unless very heavy washes are applied.

425gsm/200lb and 300lb/640gsm papers are very sturdy and stand up to heavy washes.

Other items

The following items make up my painting kit:

Tissues: For creating skies, applying textures and cleaning palettes.

Mediums: Art Masking Fluid, Permanent Masking Medium, Granulation Medium and Lifting Preparation are all selectively used in my paintings.

Masking tape: To control the flow of paint, mask areas in the painting and fasten paper to a drawing board. I prefer 2cm/¾in width as it is easier to remove.

Cocktail sticks: For applying masking when fine lines are required.

Greaseproof paper: For applying masking.

Atomizer bottle: For spraying paper with clean water or paint.

Painting board: Your board should be 5cm/2in larger all round than the size of your watercolour painting. Always secure your paper at each corner and each side (eight places) to prevent it cockling when you are painting.

Eraser: A putty eraser is ideal for removing masking.

Sponge: Natural sponges are useful for removing colour and creating tree foliage, texture on rocks and so on.

Water-soluble crayons: For drawing outlines, correcting mistakes and adding highlights.

Palette knife: For moving paint around on the paper.

Saucers: For mixing large washes and pouring paint.

Hairdryer: For drying paint between stages.

Easel and stool: I occasionally use a lightweight easel and a stool on location.

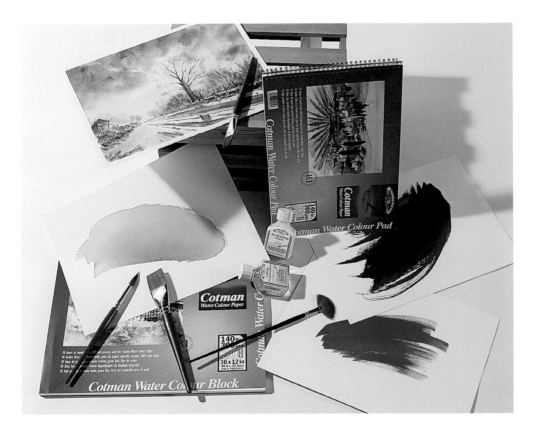

Skies are exciting to paint and they take so little time – less than three minutes. They establish the atmosphere and mood of the painting and, as they can represent up to two-thirds of a painting, it's important to paint them well.

As the weather changes, the sky influences the colours in the landscape. A pale blue sky drenched in sunshine makes the landscape sparkle. When the blue changes to grey, indicating an approaching storm, the landscape colours become dull and moody. A full-blown storm creates a sense of fear and awe.

Sometimes there will be no clouds in the sky on the day you have chosen to work outdoors. It's not unusual for me to create an interesting sky to complement my landscape. If nature's perfect, copy it; if it's not, use artistic licence to improve it. Be creative, use your imagination.

Often I will paint the landscape and then paint in the sky to fit it. Acrylic paints are particularly useful in this instance, because if the sky colour runs over my underpainting the colour can't be lifted – a big advantage.

In this part of the book my aim is to show you how to paint a wide variety of interesting skies. Skies aren't difficult to paint, but they must be painted quickly. No two artists are ever going to be able to paint identical skies because of the speed at which they have to be painted to avoid hard edges forming – but that's what is so exciting about watercolour painting.

I hope the examples in this book will inspire you. Constant practice will boost your confidence until the painting of skies becomes second nature.

You will call on a range of colours to paint skies. Here are the ones I find most useful:

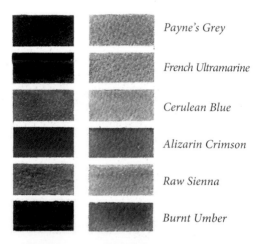

Payne's Grey

French Ultramarine

Cerulean Blue

Alizarin Crimson

Raw Sienna

Burnt Umber

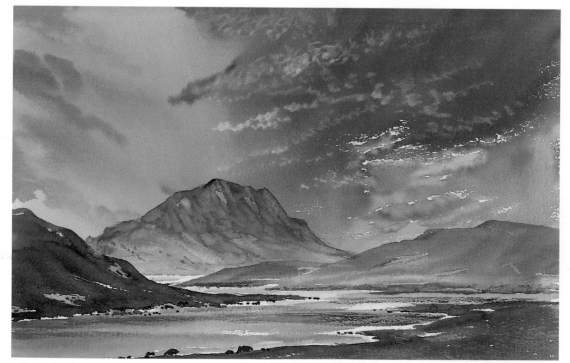

In this sketch I used a very simple technique, creating the cirrus sky by removing paint with an absorbent tissue.

Which cloud?

To identify clouds, think descriptively. You might explain the four basic cloud types in these terms:

CIRRUS: *hair-like or feathery*
CUMULUS: *balls of cotton wool*
NIMBUS: *dark rain-bearing clouds*
STRATUS: *clouds in layers*

The golden rule when painting skies is: a simple foreground necessitates an atmospheric sky, a detailed foreground demands a simple sky.

9

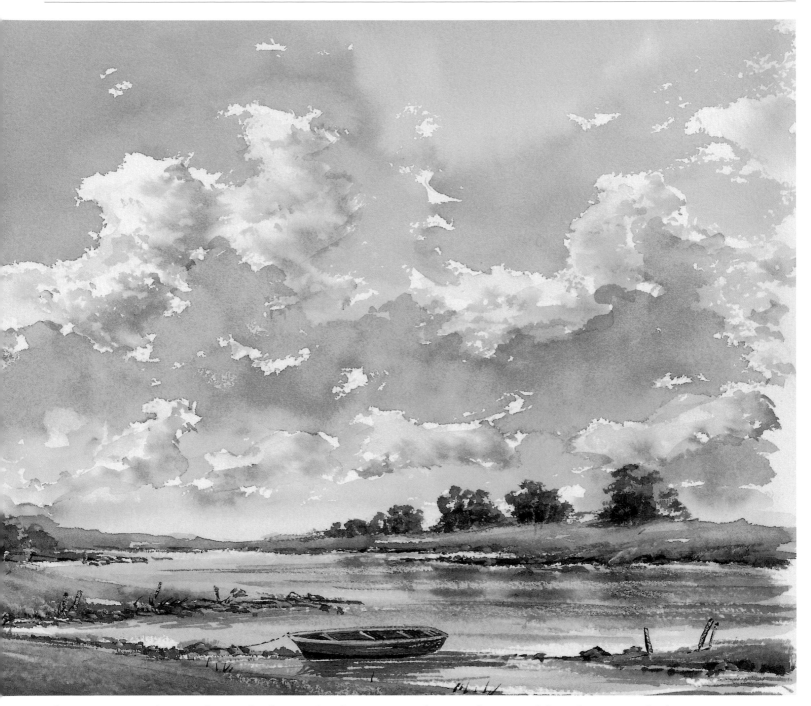

This painting provides a good example of a cumulus sky; see page 15 for an explanation of the techniques involved.

TYPES OF CLOUD

More important than being able to identify clouds is to be able to represent them realistically. Observation is important if you are going to make them look real. Let's look at a few of the basic types in more detail:

Cirrus clouds appear as wispy streaks high up in the sky.

Cumulus clouds are soft and fluffy, like balls of cotton wool floating in the sky. The effect of perspective makes them appear smaller at the bottom, which is further away. Cumulus clouds display shadows and on a sunny day their tops sparkle with a soft yellow. Their base is usually quite flat.

Nimbus clouds tell us that a storm is imminent. Dark and rain-bearing, they can fill us with a sense of awe or foreboding.

Stratus clouds, as the name suggests, form in almost horizontal layers across the sky.

The sky can represent up to two-thirds of your painting, creating the atmosphere and mood of the landscape. It goes without saying, then, that the ability to paint an interesting sky is important. However, it's neither possible nor necessary to represent the sky exactly – you can't be expected to compete with nature. As artists, our challenge is to paint a believable representation.

Timing is paramount when painting skies. Hard edges occur when wet paint is applied over an underpainting that is more than one-third dry. Each successive layer of paint should be stiffer (less wet) than the underpainting. Practise until you've managed to paint a sky in under three minutes without hard edges forming.

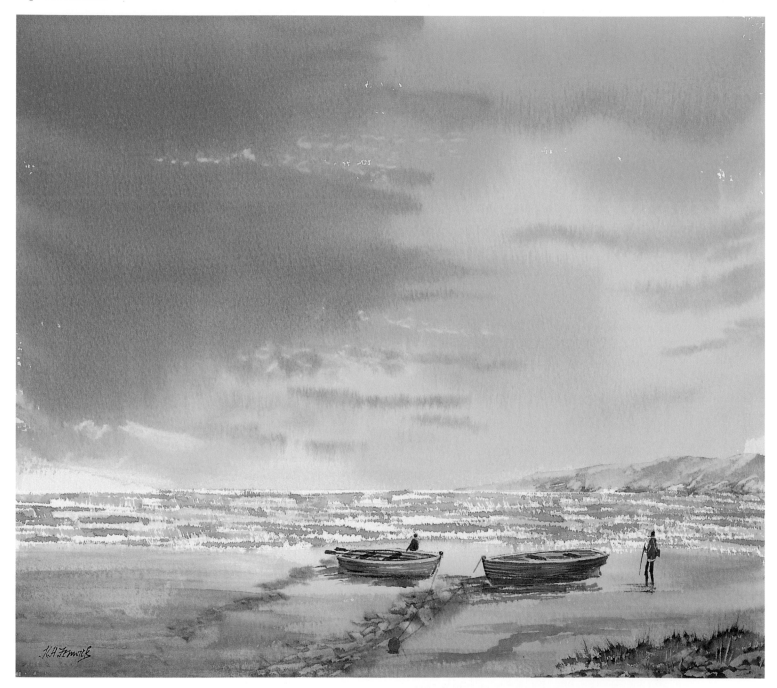

This soft sky was painted by initially applying a Raw Sienna wash. The clouds were painted with broad strokes of my 4cm/1½in hake brush loaded with a Payne's Grey/Cerulean Blue mix. I used a tissue to create a few wispy white clouds.

Painting clouds

When you're putting in clouds, it's a good idea to leave about 50 per cent of your underpainting uncovered.

Avoiding hard edges

The reason for the formation of hard edges is that wet paint has been applied over an underpainting that is more than one-third dry. A simple experiment will show you what an unpleasant effect this creates.

Try it for yourself. Paint in any dark colour, let it partially dry, drop a splash of water in the middle and watch the hard edges form.

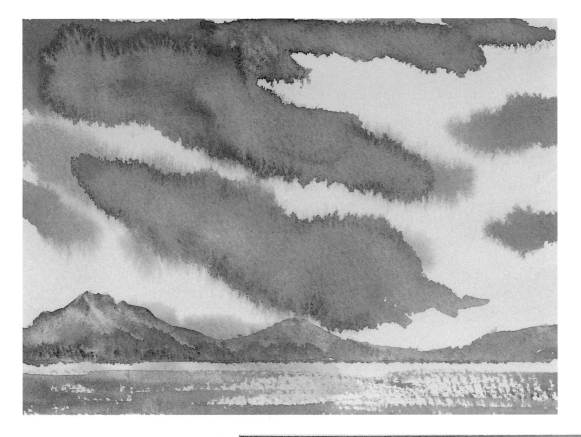

The picture shown left is typical of that produced by beginners to watercolour painting who haven't yet mastered the timing. Two things have happened here. Wet paint has been applied over an underpainting that was about half dry, creating the unwanted feather-like hard edges, and the cloud edges haven't softened and been able to blend into the drier underpainting. The result is a muddy-looking, unattractive sky. Compare this with the effect achieved in the painting below.

Here the cloud formations were painted when the shine had gone off the underpainting, resulting in a soft, fresh-looking, wet-into-wet sky. To achieve this effect, your sky must be painted in under three minutes.

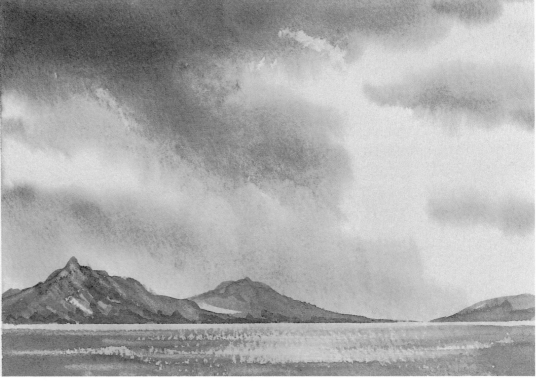

Each type of sky provides us with an interesting upper section to our painting and creates the atmosphere and mood. These in turn determine the colours and tones we use to paint them.

The colours and mixes shown here are those I most commonly use when painting skies. There may be occasions when I require a particular depth of colour or subtle tone, and in these circumstances I may select additional colours.

Indanthrene Blue mixed with Payne's Grey, for example, produces a deep rich blue. Purple Madder is useful when painting evening skies. I find Raw Sienna invaluable as an initial wash over the paper. It adds warmth to the sky, but apply it as a very pale wash. There is a vast range of colours available, so why not try a variety of them.

BRUSHWORK

Use a light touch with a large brush, and the minimum number of brush strokes. If you brush over the underpainting more than is necessary, your sky will look muddy.

A 4cm/1½in hake brush is ideal for painting skies. Familiarize yourself with it by using it to try the skies on the facing page. Apply bold, sweeping strokes with your arm rather than using a wrist action.

To achieve the correct balance of colour you will need to experiment with mixing colours. The mixes shown right are just some of the variations possible using the colours shown below left.

The colours shown below right are mixes useful for clouds and varying strengths of Raw Sienna for underpainting.

	Strong colour	Water added
Payne's Grey		
French Ultramarine		
Cerulean Blue		
Alizarin Crimson		
Raw Sienna		
Burnt Umber		

Top row: Payne's Grey and Cerulean Blue – cloud colours
Second row: Payne's Grey and Cerulean Blue – more cloud colours
Third row: Payne's Grey and Alizarin Crimson – cloud colour variations
Fourth row: Raw Sienna – varying strengths for the underpainting

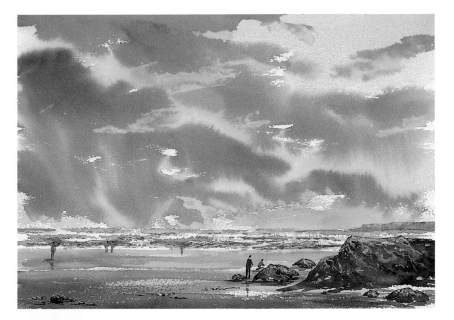

I used a 4cm/1½in hake brush to paint this atmospheric sky, applying a weak Raw Sienna wash to the whole of the sky area and quickly washing in some Cerulean Blue at the top right and a weak Alizarin Crimson in selected areas. When the shine had gone from the paper surface (less than one-third dry), I painted in the dark clouds using strong mixes of Payne's Grey/Alizarin Crimson.

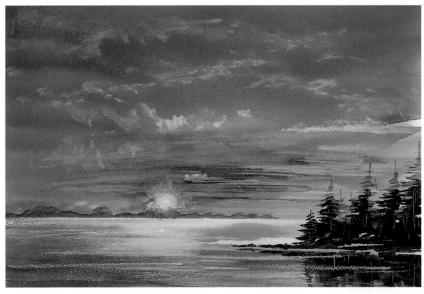

For this evening sky, I initially painted Raw Sienna above the horizon line and added some Alizarin Crimson, then immediately painted the blue sky by brushing in a strong wash of a Payne's Grey/French Ultramarine mix, allowing the paint to run down and blend with the Raw Sienna/Alizarin Crimson washes. A soft tissue was used to remove paint to create the white feathery clouds. The setting sun was painted with a little Cadmium Yellow Pale.

You'll enjoy painting this sunset using the 4cm/1½in hake brush. Initially I applied a Raw Sienna wash to the whole of the sky area and painted in some Cerulean Blue at the top right. The dark clouds were painted using a Payne's Grey/Alizarin Crimson mix, leaving about half of the underpainting showing through.

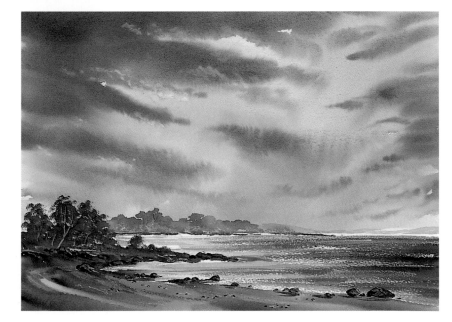

Once you have mastered the brush strokes and timing, you will really enjoy painting skies.

All skies are painted wet-into-wet. This means that you paint wet paint into a wet underpainting. We have already seen how tricky this can be, so always apply the basic principles discussed previously to avoid hard edges. The hake brush is traditionally used for painting skies. I prefer one that has soft hair (goat hair) and is 4cm/1½ in wide. The secret when painting skies is to wet your paper initially with clean water or a weak dilution of Raw Sienna. You can apply your wash quickly with sweeping strokes, using arm rather than wrist movements.

Once I see the shine going off the paper I paint in my cloud structures, using a light touch of the hake. Don't brush over the paint too many times. The fewer brush strokes you use, the fresher your sky will look.

Your board should be angled at approximately 15 degrees, just sufficient to allow the paint to run slowly down the paper. Timing comes with experience, so you will need to practise painting lots of skies – after all, they only take three minutes.

The right look

Don't forget, when using watercolours – if it looks right when it's wet, it's wrong! As the paint dries you can lose up to 30 per cent of tonal value, so you must paint with darker tones to allow for this.

I observe this kind of sky most evenings when I look out of my window. I painted a Cadmium Yellow Pale wash, adding Raw Sienna and Alizarin Crimson to produce a variegated underpainting.

The clouds were painted using various strengths of Payne's Grey/Alizarin Crimson mixes. I wanted some of the cloud edges to be soft and the larger clouds at the top to have harder edges. Timing was important here.

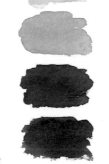

Cadmium Yellow Pale
Raw Sienna
Alizarin Crimson
Payne's Grey

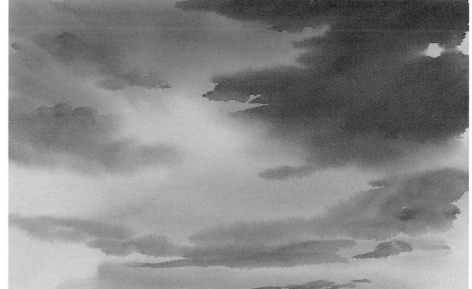

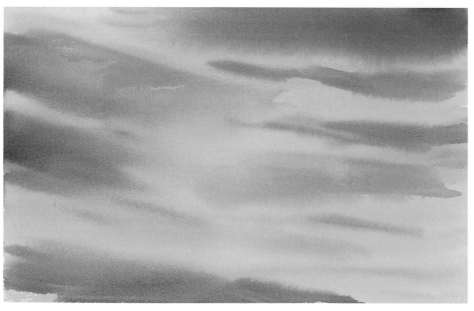

Raw Sienna
Payne's Grey
Cerulean Blue

This cirrus-type sky was painted in less than two minutes by applying a very pale Raw Sienna wash to cover the whole of the sky area.

Using broad sweeps of the hake, I painted in the darker Cerulean Blue/ Payne's Grey clouds. This type of sky is very easy to paint in less than two minutes.

I could not resist painting this lovely early morning sky. Initially I painted the usual Raw Sienna wash, then added some Alizarin Crimson as I worked downwards. When the painting was approximately one-third dry, I used a strong Payne's Grey/Alizarin Crimson mix for the cloud formations. Lifting off paint a tissue, I created a few soft white clouds.

Raw Sienna
Payne's Grey
Alizarin Crimson

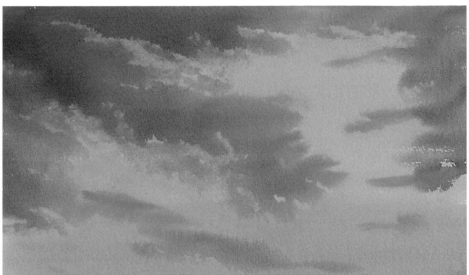

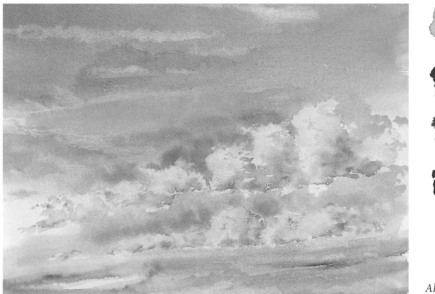

Cumulus clouds are like balls of cotton wool floating in the sky. The easiest way to represent them is initially to paint your underpainting using Ultramarine Blue/Payne's Grey mixes, adding darker tones here and there for variation. Then, while the wash is still wet, blot out the cloud shapes using absorbent tissues.

Wet a few of the white clouds at a time with clean water and drop in deeper values of sky colours plus Alizarin Crimson to represent shadows. If it's a sunny day, add a little Raw Sienna to the tops of the clouds to create sparkle.

Raw Sienna
French Ultramarine
Payne's Grey
Alizarin Crimson

This soft evening sky was created by initially painting a Cadmium Yellow Pale wash and adding patches of Cerulean Blue, Raw Sienna and Alizarin Crimson. The clouds were painted with a mixture of Alizarin Crimson and Payne's Grey. The soft edges to the clouds were achieved by painting them when the underpainting was quite wet. It's a matter of timing. Subtlety is what is required here, so don't use garish colours.

Cadmium Yellow Pale
Raw Sienna
Alizarin Crimson
Payne's Grey
Cerulean Blue

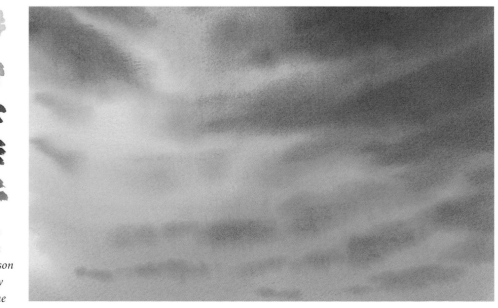

This is a fine example of an atmospheric sky. Various techniques were used to create the effect of an approaching storm. The clouds have cast shadows over the land and it's time to seek shelter. There are no bright blues in this sky. The clouds were painted with mixes of Payne's Grey/Cerulean Blue, with a little Alizarin Crimson added to achieve variation, over a wet pale Raw Sienna underpainting. I used a 4cm/1½ in hake brush and a minimum of strokes, lightly dancing it across the surface of the 300gsm/140 lb paper.

The whole sky was painted wet-into-wet in less than three minutes. It's important that the clouds are painted in while the painting is no more than one-third dry, to avoid the occurrence of hard edges (see page 11).

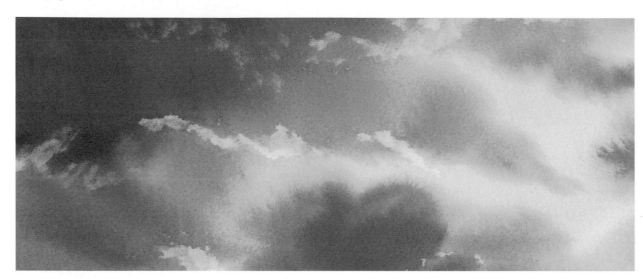

Cloud formation

The cloud formation which is probably the most important part of this painting represents the approaching storm and has therefore been painted in a slightly darker tonal value. The clouds were painted using circular motions with the corner of the hake brush.

The Raw Sienna underpainting was no more than one-third dry when I painted in the clouds, allowing the cloud edges to soften and creating a natural effect. You'll notice that I've separated the cloud formations by leaving a small light area. A simple touch like this can achieve a pleasing effect.

Using counterchange

The clouds have not been painted right up to the farmhouse, ensuring counterchange (light against dark, dark against light) between the building and the sky area. This is important, as it makes the buildings and trees behind them stand out against the sky. Note the inclusion of a few sheep and the smoke from the chimney, adding life to the finished painting. The sky shadows have been washed across the foreground.

Creating light areas

To create light areas and realistic cloud formations, an absorbent tissue was used to remove colour with a gentle dabbing action, turning the tissue to absorb colour and reveal the white of the paper. This technique must be used while the sky area is still wet. It's a simple technique, and one I often use to create interesting cloud structures.

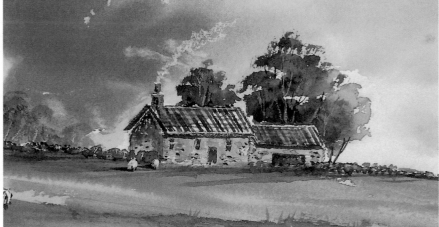

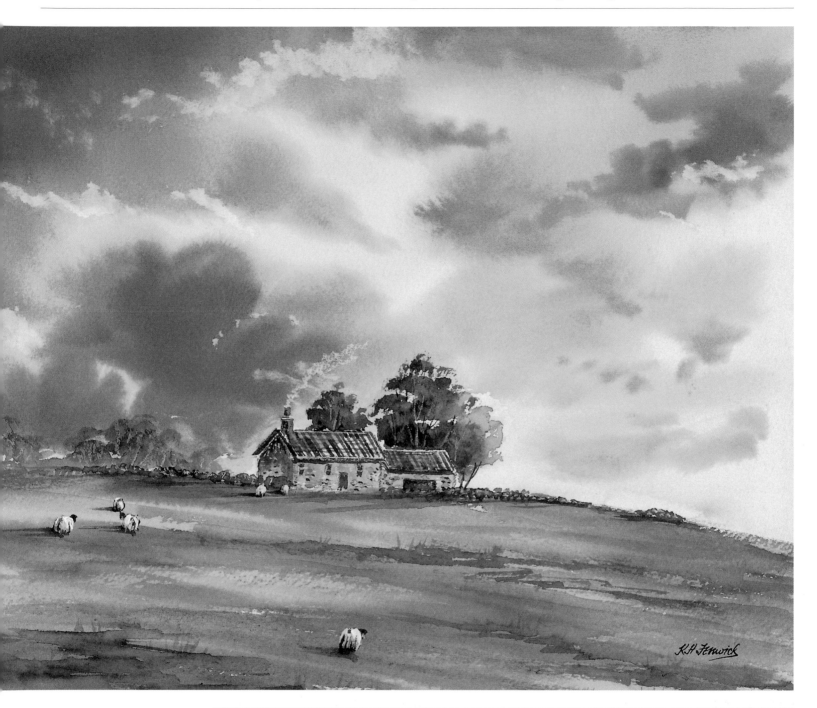

Adding interest

The addition of a small splash of another colour can provide a more pleasing sky structure.

You'll notice that I have added a touch of Alizarin Crimson here, to give the picture warmth and variation.

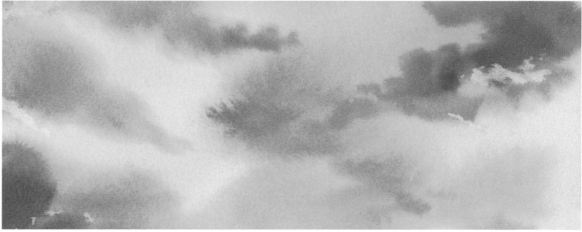

Evening Splendour is an ideal painting for the less experienced painter to attempt. It also provides me with the opportunity to introduce you to the concept of glazing. A glaze is produced by mixing a little paint with a lot of water to make a pale-coloured wash. Glazes can be applied using traditional watercolours, but acrylic colours have the advantage of allowing several subtle glazes to be applied without the risk of the underpainting lifting.

1. The sky and bushes

I positioned masking tape unevenly across the painting to represent the horizon. The sky was painted using a 4cm/1 ½ in hake brush loaded with a weak Raw Sienna wash, followed by Payne's Grey/Alizarin Crimson mixes for the clouds. Tissues were used to create the cloud shapes.

The bushes were painted using the cloud colours. When these were dry, I applied a little white acrylic to add snow to the foliage, which I stippled with a round-ended hog-hair brush. When I painted the fence I made sure that the distance between the posts was twice the height of the fence.

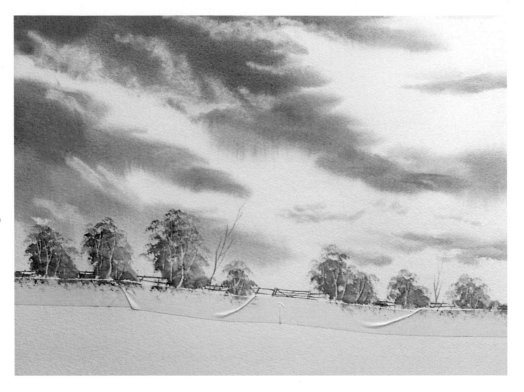

2. The foreground

The masking tape was slowly removed and the foreground painted by using a stippling action with the hake brush, lightly dancing across the paper to shape the track and represent stubble in the snow. Light sweeps of the hake were applied in the foreground to provide a dry brush effect.

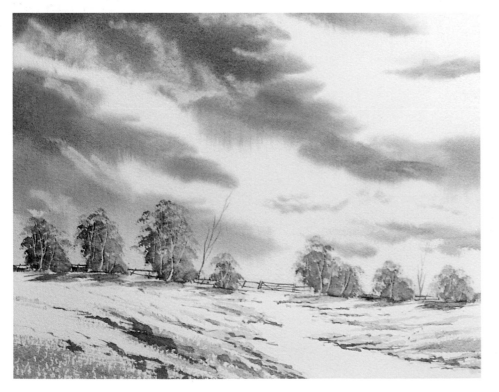

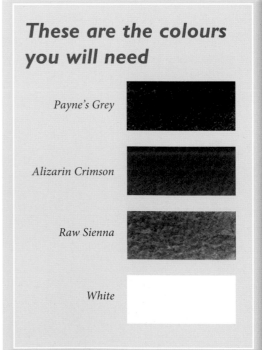

These are the colours you will need

Payne's Grey

Alizarin Crimson

Raw Sienna

White

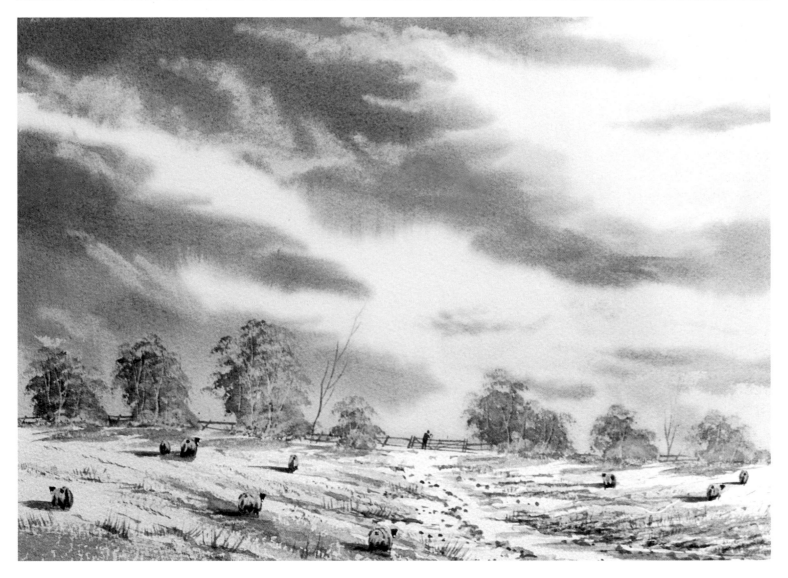

3. Applying the glaze and adding details

I love snow scenes, which don't have to look cold. I added some warmth to this painting by applying a Raw Sienna glaze over the whole of the sky and adding a little Alizarin Crimson nearer the horizon.

The glaze was mixed in a ceramic saucer and applied with a 4cm/1½in hake brush, working from top to bottom.

I transferred some of the sky glaze to selected areas in the snow to achieve a balance of colour in the painting. When the paint was dry, I felt the addition of a few sheep and a shepherd leaning over the gate would enhance the scene. Detail was added to the track using a rigger brush.

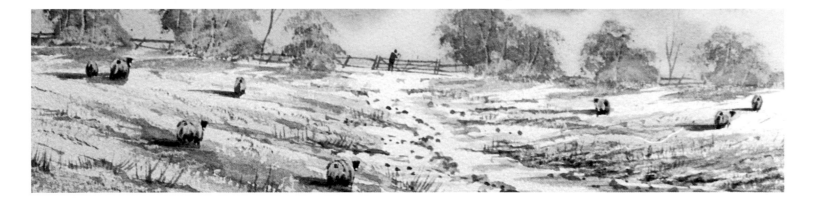

Here I want to introduce you to some speciality mediums that I find exciting to use. Do try them where appropriate. You will find them a useful addition to your range of materials.

GRANULATION medium was introduced to provide a granular appearance to colours that normally give a smooth wash. For maximum effect, if you dilute your colour with medium alone you can achieve a variety of results. I find this medium useful for painting skies or where a light texture effect is required.

PERMANENT MASKING medium is a non-removable transparent liquid mask which can be applied directly to your paper, or mixed with colour and applied to achieve a one-stop mask. It also washes out of brushes very easily by simply rinsing in water; traditional art masking fluid, by contrast, can be difficult to remove from brushes.

Unlike traditional art masking fluid, which has to be applied, dried, painted over, removed and then your element painted in colour, with permanent masking you paint your element in colour, and once it is dry you can overpaint it, the masking repelling the wash.

I have used permanent masking to create texture on rocks,

In the painting on the right I've used the granulation medium for the sky and permanent masking medium for the tree foliage. For the foliage, I applied the masking with crumpled tissue and overpainted to create the texture.

foregrounds, foliage and so on. Experimenting with this medium has shown me that it works best with light washes. When these are dry, thicker paint can then be applied over the masking to add details.

TEXTURE medium produces a textured finish for watercolours. It can be applied directly to the paper and when dry overpainted or mixed with watercolour and then applied.

LIFTING medium enables the removal of paint at a later stage. Some colours are staining colours and difficult to remove. By applying the lifting medium first, the colour can be easily removed.

BLENDING medium slows drying, providing the extra time that is sometimes needed in hotter climates. For maximum blending time, dilute your colour with medium alone. Diluting with water too will provide a variety of drying times.

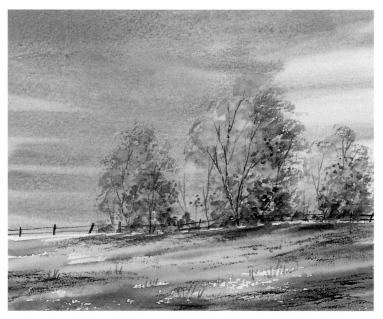

In this simple 'doodle' I experimented with a range of mediums.

In the painting on the left I used lifting medium for the sun and overpainted with a Cadmium Yellow wash. When it was dry, I teased the colour away from the centre by gently rubbing with a small bristle brush and dabbing with a tissue.

To paint the sky, I applied a Cadmium Yellow wash and added some Raw Sienna and Alizarin Crimson as I progressed down to the horizon. The sky colours were transferred into the water. When they were dry, I added the darker clouds using a mix of Payne's Grey/Alizarin Crimson/Burnt Umber.

Although there is a lot of colour in this sky, it still looks subtle and warm. Don't make your sunsets too bright as they will be overpowering.

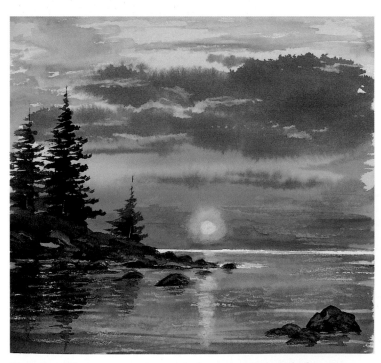

Evening Glow *represents a typical evening sky, with the sun going down across the lake.*

The sky here was painted by spattering permanent masking, allowing it to dry, then overpainting the sky with blue mixed with granulation medium. The result was the effect of falling snow. Lifting medium was initially painted over the areas filled with fir trees.

I used white paint mixed with texture medium to add the snow to the trees and when this was dry I washed away some colour between the trees. Having previously applied the lifting medium, I was able to lighten these areas. The rocks were formed by using a palette knife.

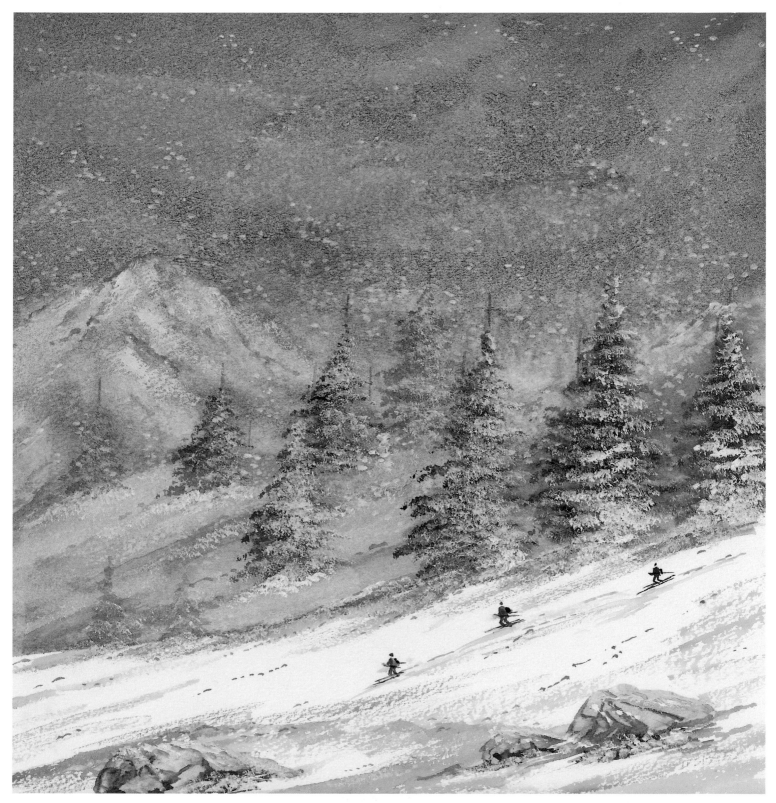

Ski Patrol *was an experimental painting I completed to test the appropriate use of the speciality mediums.*

My aim here is to introduce you to further techniques to enable you to create interesting skies. As the sky can cover two-thirds of your painting, it's important that you practise these techniques to achieve a realistic impression. Glazes can be applied to selected areas in a painting or to the painting as a whole to harmonize the colours, as each colour in the painting will be tinted by the same glaze.

Applying a glaze

A glaze is a small amount of colour mixed with lots of water. For this scene I applied a warm Raw Sienna wash and added a touch of Alizarin Crimson to selected areas.

Medium tones of Payne's Grey/ Alizarin Crimson/Burnt Umber were used to paint the clouds. I used a tissue to create structure in the clouds. When the paint was dry, I mixed a Raw Sienna glaze and, using the hake brush, washed over the whole of the sky area to give it added warmth and glow.

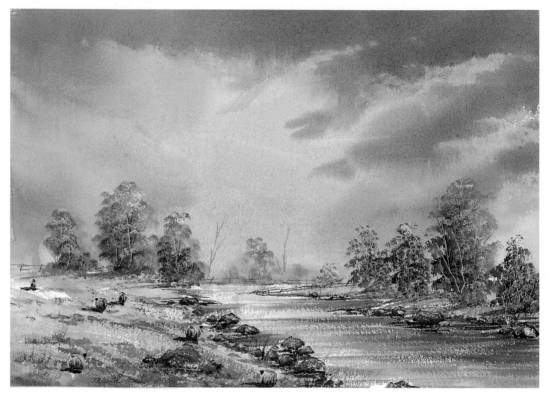

The glow in the sky was what inspired me to paint **First Snow** *with acrylic colours. The beauty of acrylics is that if you become bored with a painting, you can apply glazes to change it.*

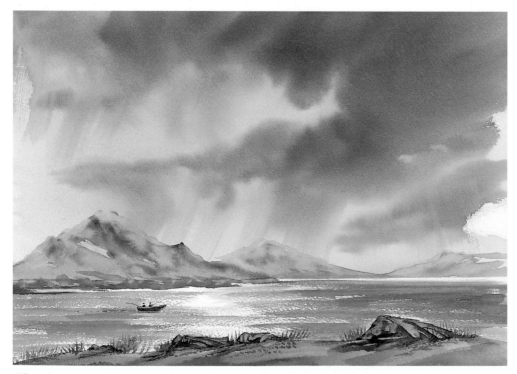

Rain clouds

Here I applied an initial wet wash of very pale Raw Sienna and quickly painted the dark nimbus clouds with a Payne's Grey/Cerulean Blue mix.

I tilted my watercolour pad until it was almost vertical, allowing the paint to run to represent the shafts of rain. When the paint had run sufficiently, I laid the pad flat and used a tissue to soften the tops of the mountains.

There's not much colour in this study, **Rain Clouds.** *I painted it as I saw it.*

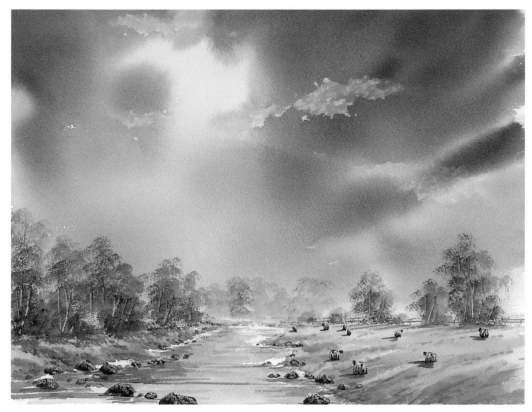

Tilting the board

Interesting skies can be painted by applying a wet wash – here Raw Sienna – and while this is still wet, adding stiffer colours; in this example these were Payne's Grey/Cerulean Blue on the right and Payne's Grey/ Alizarin Crimson on the left.

I lifted the board and tilted it in different directions to allow the paint to blend. It takes experience and control to ensure the Raw Sienna is not completely covered; tilt to the left and, of course, both colours will run to the left, tilt to the right and both will run to the right. When I was happy with the result I laid the board flat again, blotted the sky area with a tissue to add a few white clouds and then allowed the sky to dry naturally.

Evening Light *You will enjoy this technique, which I use to produce large, fresh skies. You must apply strong colours for your overpainting as they will weaken significantly when the paint runs and dries.*

Brushwork

In this study I painted a weak Raw Sienna wash and, using the hake, brushed in various mixes of Payne's Grey/Cerulean Blue with Alizarin Crimson added to provide variation.

The brush strokes were the important factor in giving the sky the necessary atmosphere. I stroked, dabbed and turned the brush to achieve the desired effect. An absorbent tissue was used to remove paint to represent the patches of white cloud.

The shafts of light were created by applying pressure with a wedge-shaped tissue from the mountain tops upwards.

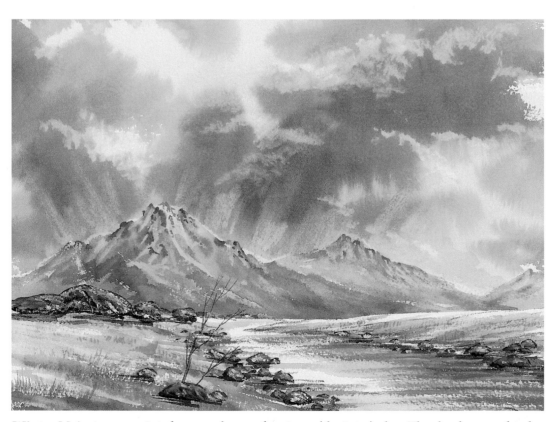

Winter Majesty *was painted very early on a freezing cold winter's day. The clouds seemed to be moving in several directions, with shafts of light dancing over the mountain tops.*

Mountain scenery has always held a great fascination for me. I can't resist painting snow-capped peaks rising to the sky, and even large hills have me reaching for my sketchbook. This sort of scenery doesn't have to be outside your window for you to paint it: you can do it from a picture you see in a book or magazine, or on television.

Time taken studying the structure of the mountain you are to paint will be well spent. Identify the main features such as distinctive gullies, fissures, promontories and peaks. You will find a small pair of binoculars invaluable for picking them out. Whatever the characteristics of the mountain you are painting, always simplify its structure. It's not realistic to paint every snow-capped ledge or promontory.

Don't forget that you're not trying to reproduce a photograph. Discard any detail that won't significantly contribute to the success of your painting. Concentrate on capturing its profile, its principal structural features, the variations in colour and tone,

the lights and darks. All these considerations will help you in your aim to create a believable representation.

Mountains are exciting and challenging to paint. Practise the techniques shown in the following pages and you will soon be able to paint realistic mountains.

You will call on a range of colours to paint mountains. Here are the ones I find most useful:

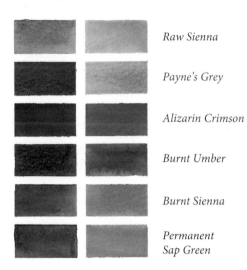

Raw Sienna

Payne's Grey

Alizarin Crimson

Burnt Umber

Burnt Sienna

Permanent
Sap Green

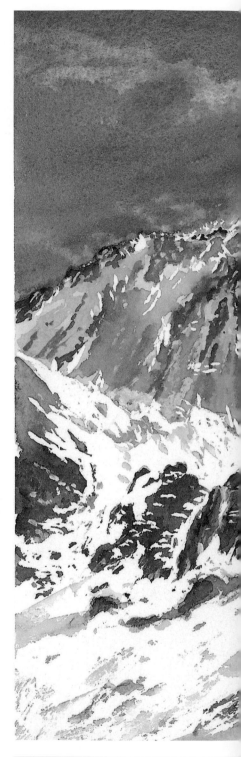

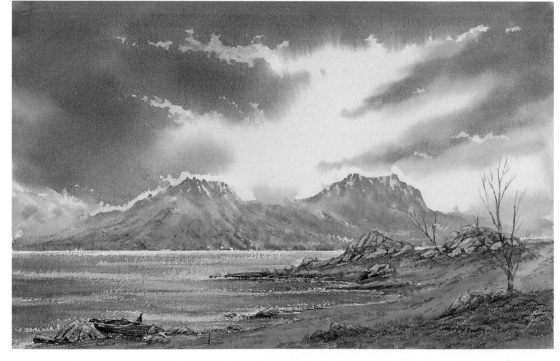

Going Fishing *is my vision of a Scottish loch. I used tissues to create the cloud formations and the distant mountain peaks, a palette knife for shaping the rocks, light strokes with the side of a round brush to paint the sparkle on the water, and stippling techniques for the heather and textures in the foreground.*

Mountain painting checklist

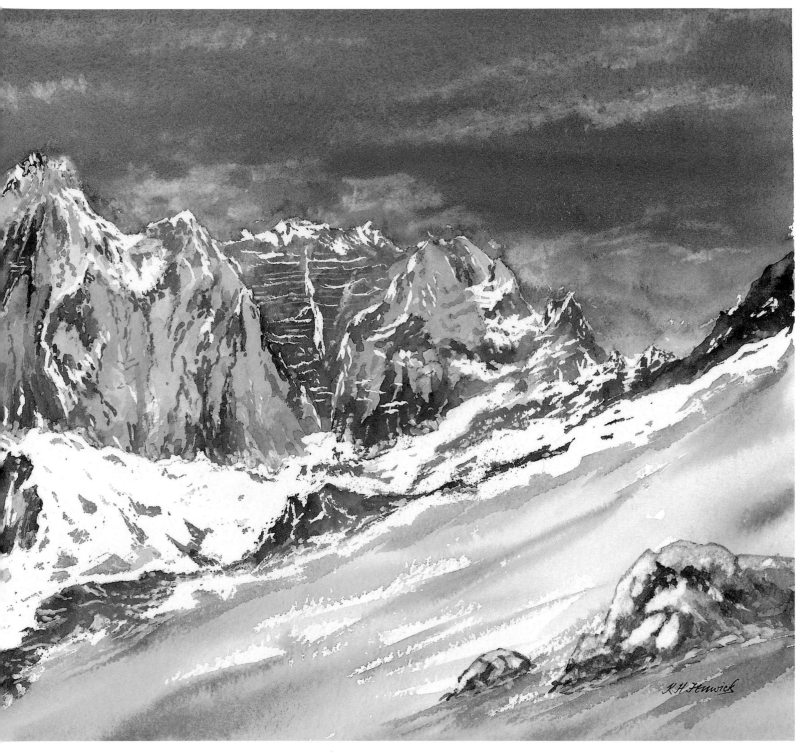

- Don't be too ambitious initially; choose a mountain that you feel lies within your compass of expertise.
- Study your subject closely, then simplify its structure, excluding unnecessary details.
- Observe the main colours and tones.
- Shape your mountain carefully to make it look real.
- Don't add details that aren't characteristic of the region you are painting.

Majestic Peaks *represents the landscape in all its glory and also conveys a sense of awe. I have used many techniques here – tissues for the sky, masking in the mountains, the use of a palette knife to create structure and subtle touches of colour to enhance the landscape.*

Numerous techniques can be used to create mountain structures and features effectively. I find that the structure of the mountain will determine the techniques I use to paint it. In the next few pages I'll show you a variety of techniques that I use.

Brushwork

In **Peace and Tranquillity**, *the soft, realistic effect is achieved by initially painting a Raw Sienna wash and brushing in darker tones of various colours. Your brush strokes must follow the structure of the mountain. While the paint was still wet I used a damp size 6 brush to create structure.*

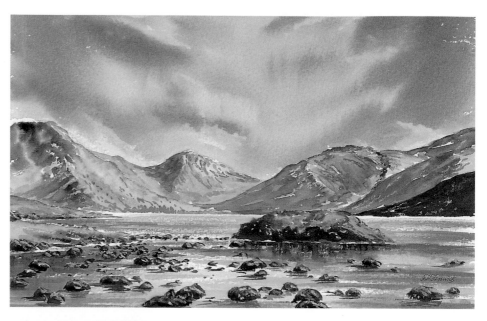

Traditional masking fluid

For **Room at the Top**, *traditional masking fluid has been applied using a piece of greaseproof paper (cling film or tissue are also worth trying). The greaseproof paper can be pressed to a rough shape for the larger areas or to a point for detail. I often use a cocktail stick dipped in masking fluid to give thin lines.*

Once the masking is dry, washes can be applied. I find gentle rubbing with a putty eraser the easiest way to remove the masking.

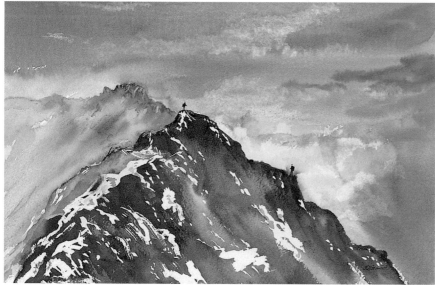

Using a paper wedge

In **Pastures New**, *I have painted the mountains using various colours and tones and created structure by removing some of the paint while it was still wet. This is done by making a tight wedge of tissue and wiping downwards from the top of the mountain. You'll need to continually form new wedges to ensure the paper does not become stained as the removed paint builds up on the tissue.*

If you use this method, ensure that you follow the shape of the promontories of the mountain, otherwise your painting will not look realistic.

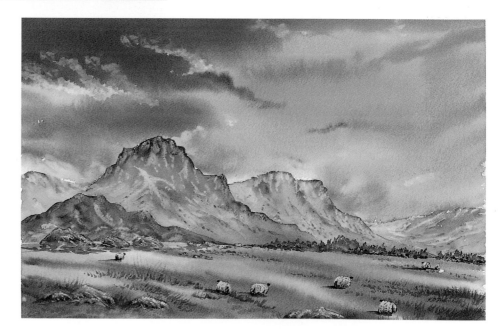

Palette knife

Where Eagles Fly is a good example of how a palette knife can be used effectively to create texture, especially in the case of rock, earth and other rugged surfaces. I applied a wash of Raw Sienna and brushed in Burnt Sienna and Payne's Grey/ Alizarin Crimson mixes. When the paint was no more than one-third dry, the texture was created by moving paint around with the palette knife.

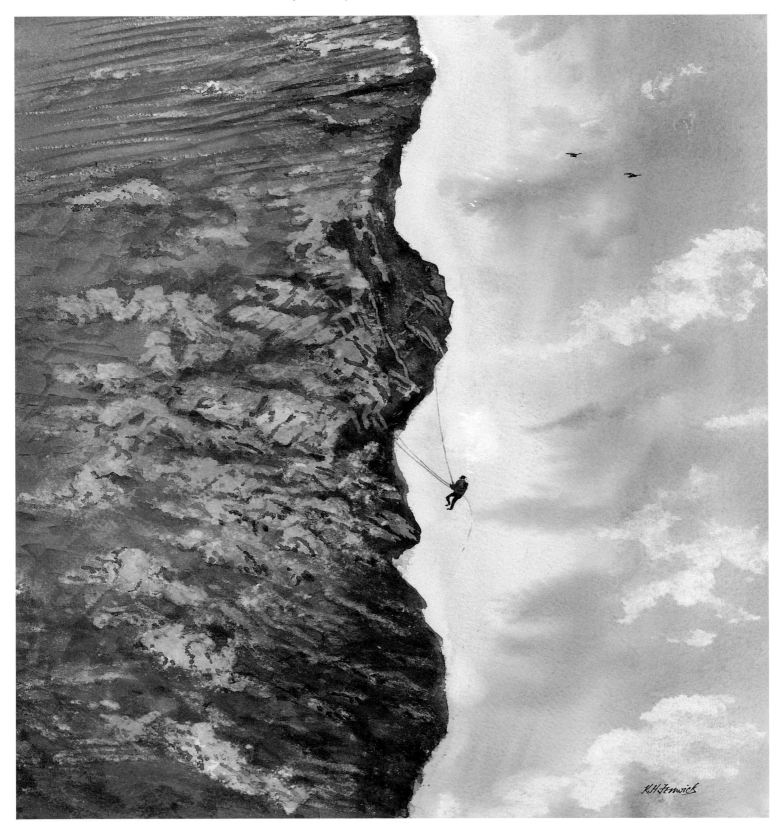

To establish the best vantage point for your composition, complete a quick tonal sketch using a dark brown water-soluble crayon, then compare it with the shape, structure and tonal variations of the scene in front of you.

You can continue modifying the sketch until you're happy that you've achieved an acceptable representation. You'll find this exercise very helpful when you come to apply paint to paper. The beauty of the crayon is that any marks wash out as the painting progresses.

The most time-consuming part of this painting was drawing the outline with the dark brown water-soluble crayon and applying the masking fluid. The drawing and masking were done prior to the sky being painted.

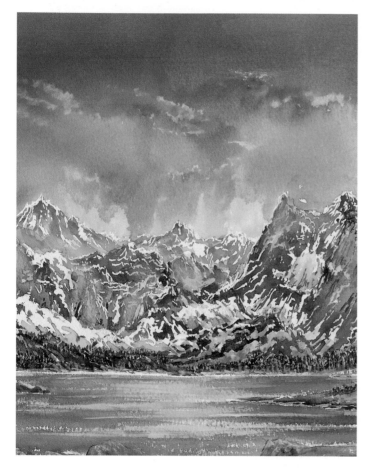

Sky and water

I felt I needed an atmospheric but not too overpowering sky for this painting, because there was lots of detail in the structure of the mountain range. I applied a very weak Raw Sienna wash to wet the paper and brushed in mixes of Payne's Grey/Cerulean Blue/Indanthrene Blue with the 4cm/1½in hake brush. Patches of white cloud were created by using an absorbent tissue to remove the paint.

The colours for the sky were also echoed in the water of the lake. For this, I used the side of a size 14 round brush, taking care to ensure the brush strokes were perfectly level. A light touch of the brush left some of the white paper showing through, representing sparkle on the water. Think of the texture of your paper as representing mountains and valleys. If you move your brush quickly and lightly across the paper you will deposit paint on the peaks of the paper only, leaving the valleys (the white of the paper) uncovered.

Trees

The fir trees were painted using a technique I developed many years ago. I position a piece of 2cm/¾in masking tape on the paper to represent the base of the trees, then I take a size 6 rigger brush loaded with paint (in this case Permanent Sap Green), hold it out in front of me, with my hand almost flat to the paper, and dab away at the paper. The shape of the brush ensures that distant trees look realistic. The rock was included to help balance the painting.

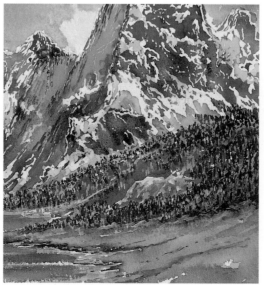

Think simple

I produced this painting, **Wilderness,** from my imagination after reading a series of books by a wonderful American author, David Thompson. It might look complex, but it's really quite simple. Think of it as a jigsaw with each part of the painting representing a piece of the jigsaw. For example, the mountain range can be broken down into several pieces, each one painted separately.

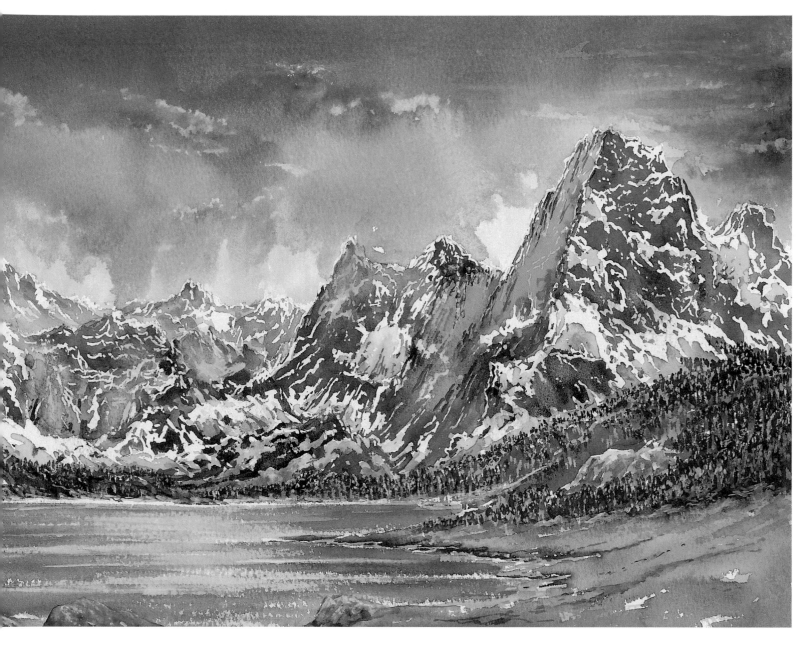

Mountains

Once the sky was painted, Raw Sienna and Raw Sienna/ Burnt Sienna washes were applied to create light and dark areas in the mountains. A Payne's Grey/Alizarin Crimson mix was added to paint the shadows in the mountains. Never use black for shadows; it kills a painting.

Once dry, I removed the masking using a putty eraser and added a Cerulean Blue wash to selected areas of the snow to represent cloud shadows.

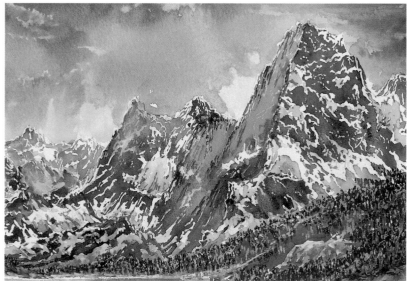

My students enjoy painting **Walk on the Beach**, a coastal scene at evening. The techniques used to paint the cliffs and the rocks on the beach are exactly the same ones I would use for painting mountains.

No initial drawing was done for this project. Instead I positioned a piece of 2cm/¾in masking tape horizontally, approximately one third up the painting. The top of the masking tape represents the horizon or water line.

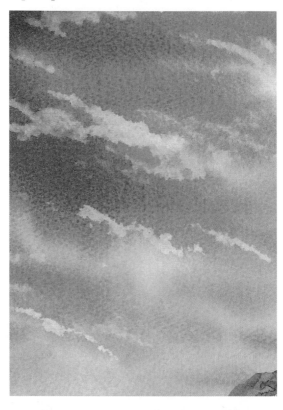

The sky

I began with the sky, applying a Raw Sienna wash and, while this was still wet, brushing in Cerulean Blue and splashes of Alizarin Crimson. When the shine had gone off the surface and the wash was approximately one-third dry, the clouds were painted with a Payne's Grey/Alizarin Crimson mix.

Finally, I removed paint with an absorbent tissue to represent cloud structures. The sky was allowed to dry completely.

2 Cliffs and rocks

The next stage was to paint the distant cliffs in a light tone to achieve recession, darker tones being added as the cliffs become closer. For these, I used a Raw Sienna underpainting with splashes of Burnt Sienna and a Payne's Grey/Alizarin Crimson mix.

When the paint was one-third dry I used a palette knife to move the paint to create the rocky appearance. The paint was dried using a hairdryer and then the masking tape slowly removed.

The same process was used to complete the cliffs on the right of the painting, adding darker tones to the nearest rock grouping.

A smaller, darker group of rocks was added on the left to balance the painting. It always amazes me how realistic-looking rocks can be created: simply by brushing on three colours and moving them around with a palette knife.

The sea was painted using a 4cm/1½in hake brush loaded with a soft blue mix. To create the effect of distant waves, I moved the brush in horizontal lines, depositing paint every 4cm/1½in (the width of the brush).

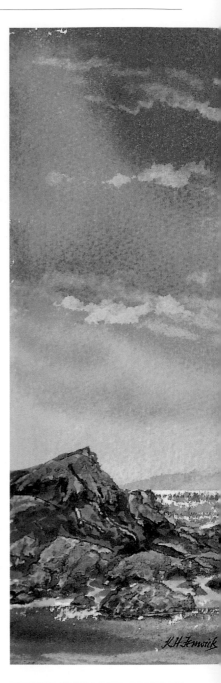

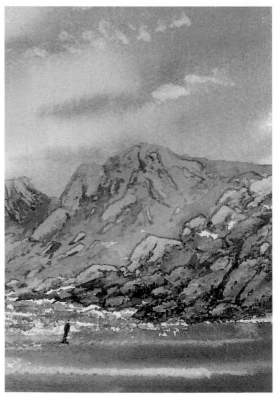

The colours you will need

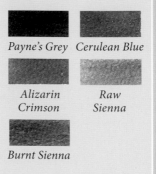

Payne's Grey	Cerulean Blue
Alizarin Crimson	Raw Sienna
Burnt Sienna	

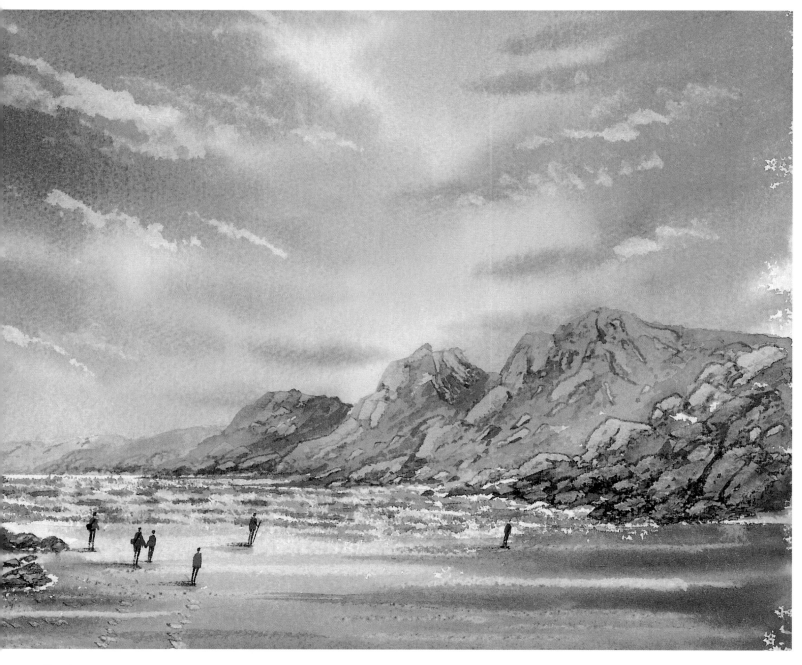

3 The beach and adding the figures

The beach was painted using horizontal strokes with a 4cm/1½in hake brush. The same colours as for the sky were applied – lighter colours in the distance, darker ones in the foreground. Once dry, the figures were added. Don't forget to add shadows under the figures. I even scratched in a few footprints with the palette knife for realism.

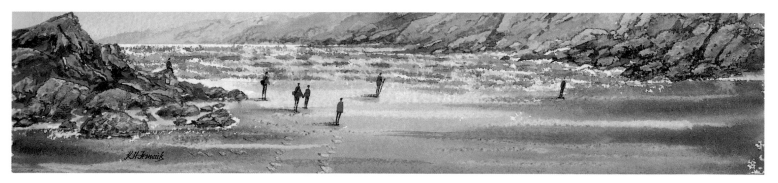

Water lends itself ideally to watercolour techniques. Generally speaking, water comes in three types: motionless, as in a puddle in a country lane, a still pond or a calm lake; moving water, as in a slow-moving river, a wind-blown lake or a harbour; and turbulent, such as a waterfall, stormy seascape or fast-flowing river.

In this section we will be concentrating on painting lake scenes. Water itself has no colour; it reflects elements around it such as a mountain range, a building or tree, but in the main it is the colours of the sky – blue, grey, or brown clouds, for example –that gives the water its colour. A sunset reflected in water is a beautiful sight.

When you observe a still lake, the rocks, trees, banks and other surrounding objects reflect as a mirror image. However, it takes only a slight breeze to ruffle the water and then the colours of the reflections change significantly. The colours I find most useful for lakes are shown below right.

When you are painting lakes, always bear in mind the following points:

■ *Water and reflections are continually shifting, depending on the weather. Don't try to change your painting as the conditions change. Form an initial impression in your mind and paint from that.*

■ *Water has no colour; its surface reflects sky and objects around it.*

■ *Use the largest brushes possible and apply horizontal brush strokes – water doesn't flow uphill.*

■ *Reflections are best painted wet-into-wet, so paint your water in last, once the reflecting objects have been painted.*

■ *Light objects usually reflect darker, dark objects lighter.*

■ *To achieve recession in a painting, paint the water lighter in tone near the horizon and darker as it approaches the foreground.*

■ *Don't confuse reflections with shadows. Reflections will always be a near-vertical mirror image of the reflecting object. The direction of the shadows will depend on the source of light.*

■ *The angle of a reflected object will be opposite to that of the object itself. A tree trunk at an angle is a good example. The reflection will be vertically below the tree but reflected in the water at the opposite angle.*

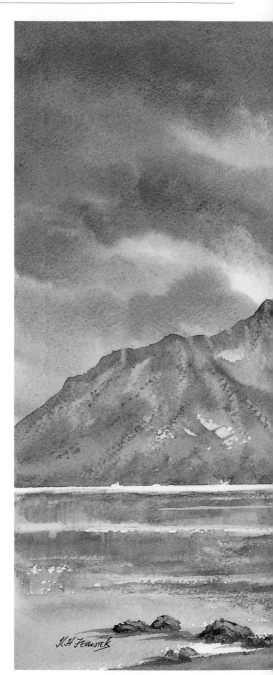

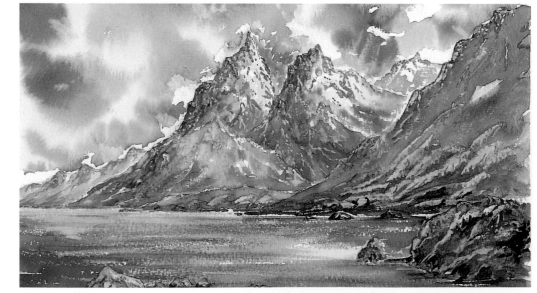

In **Snow Capped** *the sky colours were reflected in the water. Sparkle on the water was achieved by moving the brush lightly and quickly across the paper. The atmospheric sky is a feature in this sketch. The foreground rocks were created with a palette knife.*

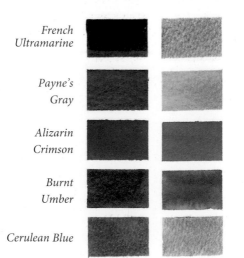

French Ultramarine

Payne's Gray

Alizarin Crimson

Burnt Umber

Cerulean Blue

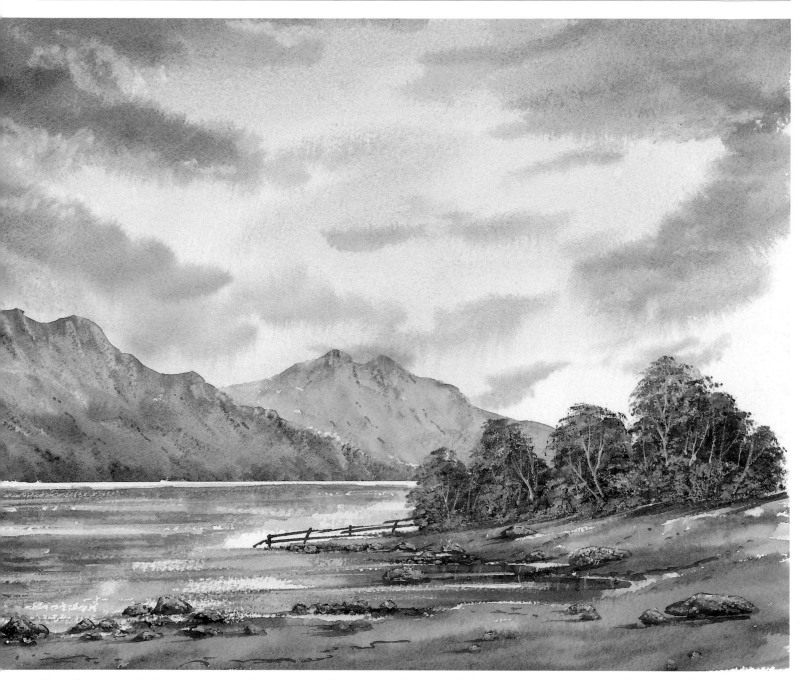

*The reflections in **Autumn on the Loch** were painted as a mirror image of the mountains, using downward strokes with a loaded 2cm/³⁄₄in flat brush. A white water-soluble crayon softened in water was used to indicate wind lines across the loch.*

Basic considerations when painting a lake scene

In the distance you will see a white or pale-coloured line where the light shimmers across the water as it meets the land. Of course the water in a lake is always level, so it's vital that your brush strokes follow this. I have seen many amateur paintings where the brush strokes haven't been horizontal, giving the impression of the water running downhill.

Recession: This is accomplished by painting distant objects in pale tones and foreground objects in darker tones.

Reflections: For best results use downward strokes with a flat brush, following a mirror image of the reflecting object. Note that the mirror image must be measured from the base of the reflecting object, which may not come down to the water's edge.

Grand Teton National Park in Wyoming offers a breathtaking range of jagged peaks which appear to rise out of Jackson Lake to heights above 4000m/13,000ft. The area is noted for its intense blue skies and these contrast sharply with the snow-capped peaks. The reflection of the mountains in the clear water of Jackson Lake is the subject of this stage-by-stage project, which I've called **Evening in the Tetons**.

1 The outline drawing and the sky

I positioned 2cm/¾in masking tape across the paper approximately one-third of the way up the painting to represent the water line. The profile of the mountains was drawn using a dark brown water-soluble crayon.

I used a mixture of French Ultramarine/Payne's Grey, applied with a 4cm/1½in hake brush, to paint the sky. Subtle touches of Alizarin Crimson were added to selected areas. Dabbing the paper with a soft absorbent tissue folded to a wedge shape, I removed colour to create the white clouds.

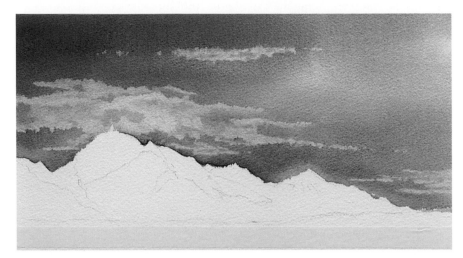

2 The mountains

The basic structure of the mountain was painted with a pale wash of Payne's Grey with darker tones applied to the peaks and selected areas. The white of the paper was left uncovered to represent the snow. While the paint was still wet, I used a tissue shaped to a wedge to soften the edges. A size 6 round brush was used to add detail.

Various mixtures of Payne's Grey/Burnt Umber/Permanent Sap Green and Payne's Grey/Alizarin Crimson were used to apply directional strokes with the side of a size 14 round brush upwards from the tape.

I finished by adding a few fir trees at the water's edge, using the size 6 brush loaded with Permanent Sap Green. The masking tape was carefully removed.

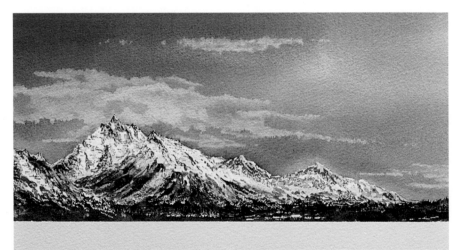

3 The water

We now come to the painting of the water. Initially I used a 4cm/1½in hake brush loaded with the sky colours. I kept my brush strokes precisely horizontal to ensure that the water looked level.

When the paint was one-third dry I painted the reflections, using downward strokes with a 2.5cm/1in flat brush. I used the colours of the sky to paint the mountains, ensuring that the reflections were a mirror image of the mountain range. I used a tissue to remove paint to indicate reflections from the snow.

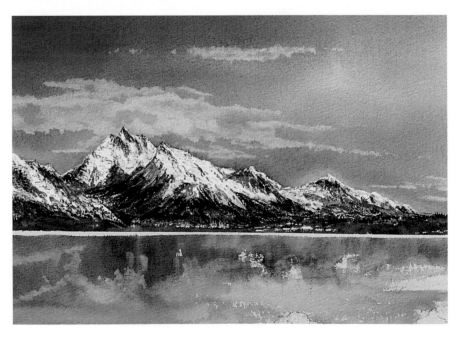

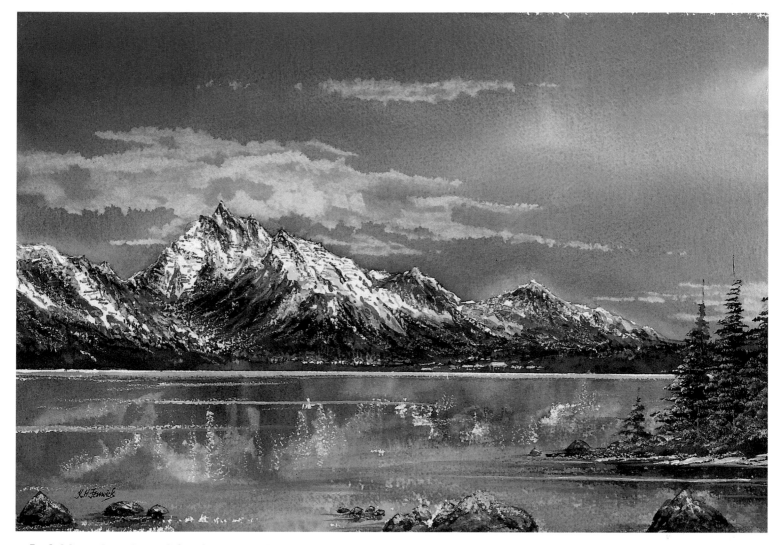

4 Adding details and finishing touches

Using a 2cm/¾in flat brush, I balanced the painting by adding the land area and fir trees (Permanent Sap Green/ Payne's Grey mix) and positioning a few rocks.

To finish the painting, I dipped a white water-soluble crayon in water and allowed it to soften before applying it to the fir trees and to the tops of the rocks in the foreground, to represent snow. I applied a few upward strokes of the softened crayon to the surface of the lake, too, to add sparkle to the reflections. Horizontal strokes with the crayon represented wind lines on the surface of the water.

To complete the water, I painted the right-hand side with a little weak Alizarin Crimson to represent reflections from the sky.

These are the colours you will need

Payne's Grey

Alizarin Crimson

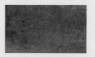

Permanent Sap Green

French Ultramarine

Burnt Umber

Here I want you to practise the three principal elements that are the subjects of this section in one watercolour painting: skies, mountains and lakes. The scene I have chosen for this exercise is typical of the Scottish Highlands, with a tranquil loch overlooked by a traditional croft, a majestic mountain in the background and a spread of sparkling water. The principal design considerations in this painting are the need for recession and the importance of balance between the elements.

As always, build up your painting. Begin by preparing an outline drawing, then position a piece of masking tape across the paper to represent the horizon or water level. Now, follow my instructions to complete the painting.

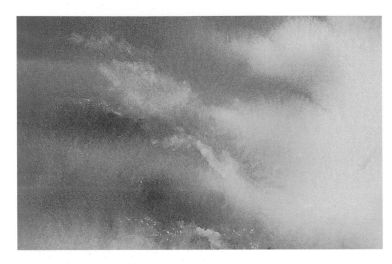

The mountains

For the sake of realism it is important that your brush strokes follow the structure of the mountain. After initially applying a Raw Sienna wash, I used a Payne's Grey/Cerulean Blue mix for the peaks of the mountains in the foreground. Then I used a tissue pressed to a wedge to remove paint and create the features of the mountains.

A Permanent Sap Green/Payne's Grey mixture applied with a dabbing action was used for the impression of trees at the foot of the mountains.

To achieve recession, the distant mountain was painted in light tones of a mixture of Payne's Grey/Alizarin Crimson. Then I used a tissue to soften the structure, enhancing the illusion of recession.

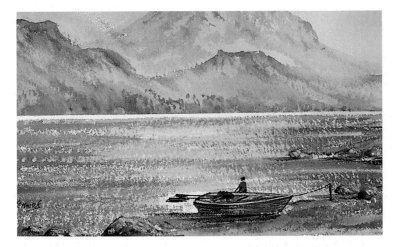

The sky

As we have seen, the sky establishes atmosphere and mood, and takes up almost two-thirds of a painting. A fresh wet-into-wet sky is required here, with cool darker clouds painted in on the left to balance the warm colours of the croft. The mixture for the cloud structures was produced with Payne's Grey and the addition of a little Cerulean Blue and Alizarin Crimson over a Raw Sienna underpainting. A soft absorbent tissue was used to remove some of the colour to shape the cloud formations and soften their edges.

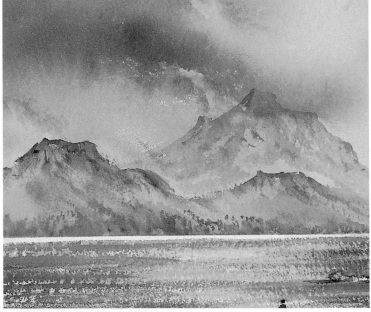

The lake

In order to create sparkle on the water, move your loaded brush quickly and lightly across the surface of the paper. This will leave some of the white of the paper uncovered to represent light on the water. The boat is important compositionally and was added to balance the building diagonally.

The colours used were a mixture of Payne's Grey/Cerulean Blue/Alizarin Crimson. When these were dry, I applied a pale wash of Raw Sienna to selected areas.

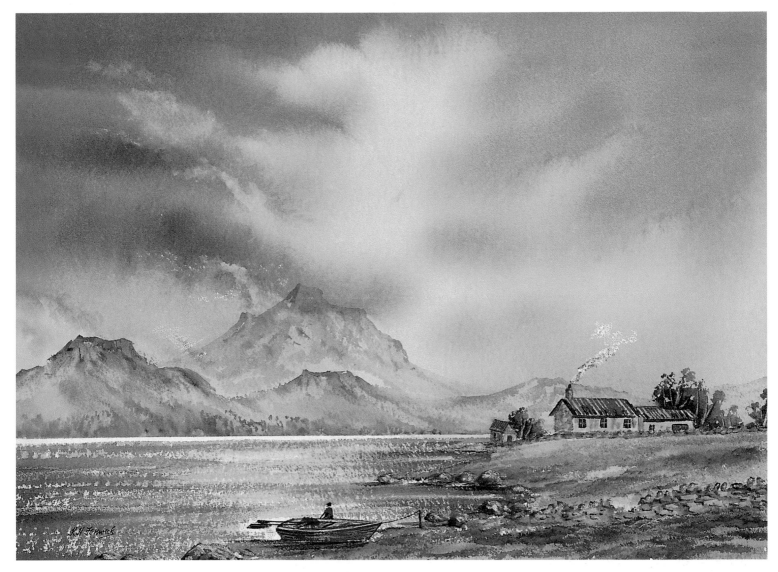

Buildings and foreground

The roof of the croft adds warmth to the painting. It was painted with a mixture of 20 per cent Alizarin Crimson and 80 per cent Burnt Sienna. The smoke was achieved by painting a little white over a Payne's Grey underpainting.

The foreground was painted by applying several washes of green made from mixes of Permanent Sap Green and Raw Sienna. Payne's Grey was added to the mixture to darken the green in the near foreground.

The rocks and stone wall were added using mixes of Raw Sienna and Burnt Umber. While the paint was still wet, a tissue was used to remove paint from the tops of the rocks to represent light reflecting off them.

Levelling the water line

When painting mountains that fall down to the water's edge, I position a piece of masking tape across the paper representing the water line and paint my mountains down to the tape. If the paint goes over the tape slightly, it doesn't matter. When the paint is dry, I carefully remove the tape. The water line will appear perfectly level – a useful technique.

A tree is a living organism that reflects the warmth of spring by growing fresh shoots and leaves. In the autumn it slows down its growth and in many species assumes marvellous autumn tints before shedding its leaves. The evergreens, of course, retain their foliage, providing contrast with their bare deciduous cousins. Each tree displays its own character through its shape.

I spent my childhood playing in acres of mixed woodland. I imagine that's why I love trees and enjoy painting them. You don't have to know the name of a tree in order to paint it successfully, but being able to paint trees that look like trees requires an understanding of basic shape and structure. We'll be looking at these in more detail later.

I get a great deal of enjoyment just from looking at trees. Certainly, careful observation will help you to get your painting of them right.

When I'm painting trees I take the following points into consideration:

- *Does the structure of the tree look sufficiently sturdy to support its foliage?*
- *Does the base of the trunk look as if it is capable of supporting the boughs, which support the branches, which support the twigs, each becoming thinner as they reach out from the trunk?*
- *What is the arrangement of the branches on the boughs? In nature branches rarely grow opposite each other on a bough. Make sure you reflect this in your painting.*

The way the brush is used and the fluidity of the paint is most important. In the following pages I aim to show you a wide range of techniques for painting trees and bushes.

The colours I find most useful are shown below.

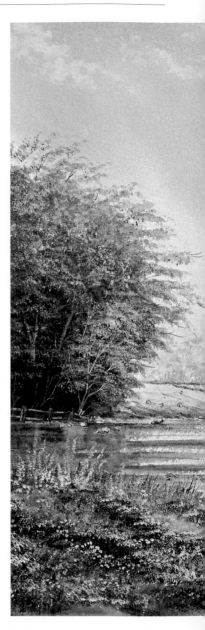

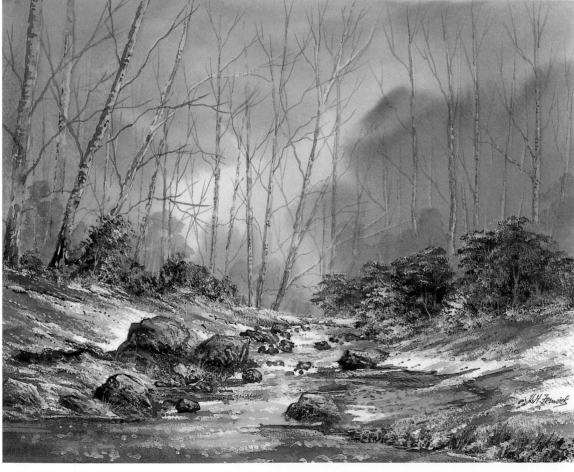

Winter's Flow *shows the importance of a soft atmospheric background to the bare tree structures, which were scratched out with a palette knife. Darker tones were painted on the trunks of the trees to represent texture.*

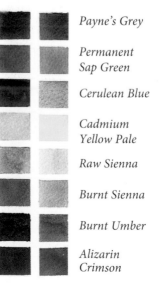

Payne's Grey

Permanent Sap Green

Cerulean Blue

Cadmium Yellow Pale

Raw Sienna

Burnt Sienna

Burnt Umber

Alizarin Crimson

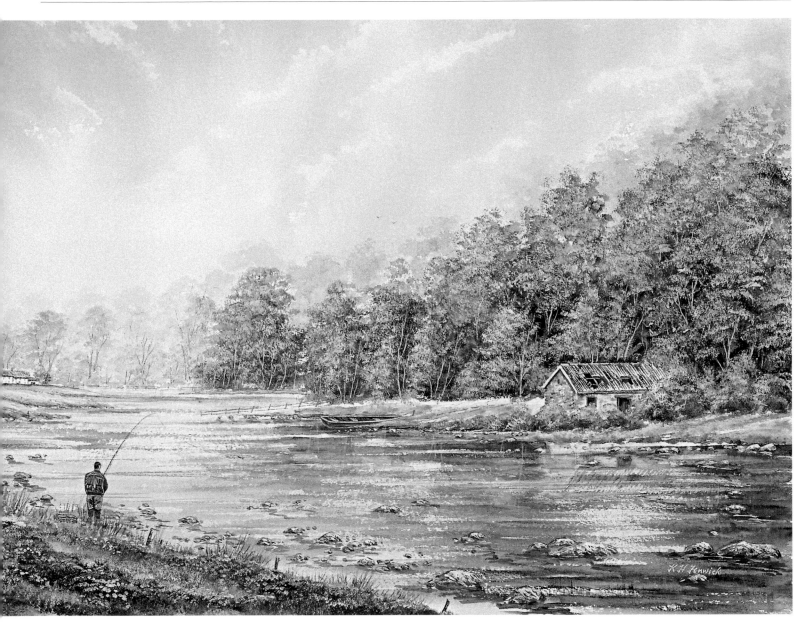

First Catch *was painted in acrylic colours. Pale tones were used to represent the distant trees and a variety of tonal values and colours went into painting the groups of trees. It was important to give a rough texture to the bank in the foreground. The reddish roof of the old building contrasts nicely with the green of the trees.*

Points to remember

- If your tree is going to look as though it's growing, it's important to show a diminishing thickness from trunk to bough, and from bough to branch and twig.
- Always leave some gaps in the foliage so that you can paint a few branches showing through. This gives a sense of structure.
- Trees display a variety of tonal values in their foliage.
- Trunks vary in colour between the seasons, from a pale grey to a rich red brown, depending on the particular variety of tree.

- Coniferous trees look the same in summer and autumn – they don't shed their leaves. Deciduous trees shed their leaves and look entirely different when unfrocked.
- Shadows give depth to foliage. Trees look dark on the inside and light on the outside.
- Mature trees weren't planted yesterday, so show some vegetation growing around their base.
- Recession is achieved by painting distant trees with pale cool colours and foreground trees with warm rich colours.

Of all the elements in a composition, it's the painting of trees that my students find most difficult. While they need to be represented convincingly, you don't have to paint them as botanical specimens but as impressions. Structure, tone and colours are what you're going to have to master.

For painting purposes, trees can be simplified into three basic shapes: the pyramid, the upturned bucket and the upturned teacup. We'll look at each of these in turn.

Pale washes initially establish the shape of the tree. Darker tonal mixes are added to paint the detail and add depth to the foliage.

PYRAMID
Examples include conifer, spruce, Lombardy poplar, fir and pine.

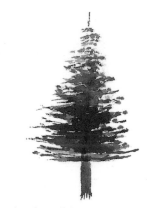

To paint this Norwegian spruce I used a 2cm/¾ in one-stroke brush with an initial pale tone of a Permanent Sap Green/Payne's Grey mix followed by darker tones of the same mix to create depth.

UPTURNED BUCKET
Examples include beech, oak, elm, chestnut, poplar and ash.

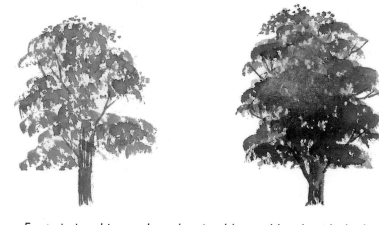

For painting this tree I used a size 14 round brush with the brush held as flat to the paper as possible and the handle virtually horizontal. Short downward strokes, lightly touching the paper, are required.

UPTURNED TEACUP
Examples include weeping willow and bushes in hedgerows.

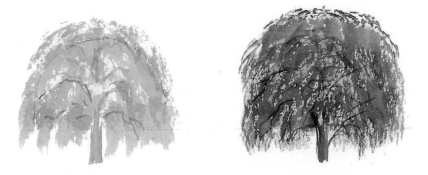

This weeping willow has been painted using identical downward strokes as described above. The shape is very similar but more of a semi-circle.

Design considerations – exercises

- Build your understanding of structure by sketching trees when the leaves have fallen.
- Choose different types of deciduous tree and paint the same tree in each of the seasons. You will be amazed at the changes you observe.

- Practise painting the same tree at different times of the day: early morning, midday and evening. You'll notice significant variations as the light changes. Paint the shadows the tree casts, too.

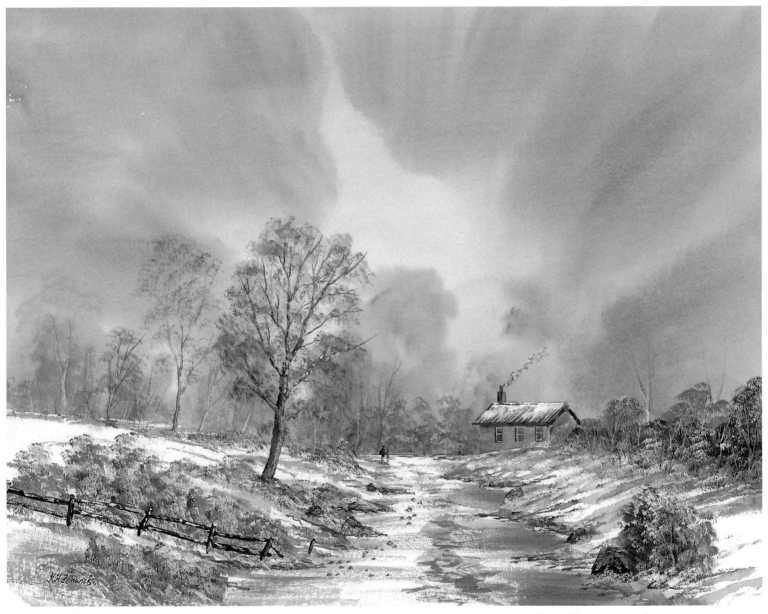

Winter Light, *an acrylic watercolour demonstration to an art society, shows how recession is achieved by painting distant trees wet-into-wet with minimal detail and describing trees and bushes in the foreground in greater detail.*

Aerial perspective

Trees in the distance should be painted in lighter tones with cooler colours and less detail. Use increasingly warm and rich colours for trees in the middle distance and the foreground. Also add some detailed structure to your foreground trees. This approach helps the viewer look into the painting.

The inexperienced landscape painter finds great difficulty in representing the foliage on trees and bushes realistically. Here are five simple techniques for you to practise.

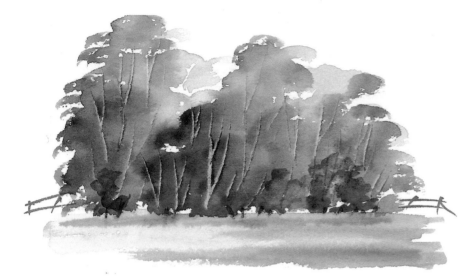

To create this loosely painted group of bushes, I initially loaded a size 14 round brush with pale Raw Sienna and holding it close to the paper, with the brush almost horizontal, I applied a series of quick downward strokes following the shape of the bushes, lightly depositing paint on the paper – see demonstration opposite.

While the paint was still wet I repeated the process, this time with stiffer mixes of mid to dark green colours to give variation and depth to the bushes. I used my thumb-nail to scratch in some structure.

This group of trees and bushes in a hedgerow was painted using an oil painter's round hog-hair brush – see demonstration opposite. Several colours and tones were painted using a stippling action to create a more detailed representation. I used my thumbnail to scratch in some structure; a cocktail stick or corner of a palette knife could be used instead.

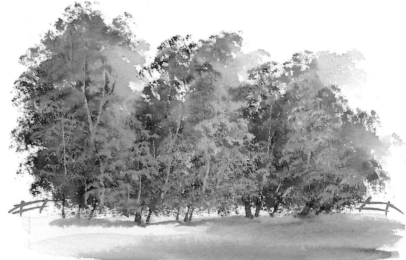

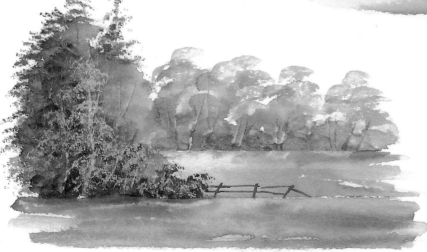

This 'doodle' illustrates the effect of recession. To achieve recession, I painted the distant trees in cool colours, using the quick downward strokes described in the first example. The grouping in the foreground was then painted. To add the necessary detail to this grouping, I used a stippling action. You could try using a piece of crumpled tissue or greaseproof paper dipped in paint or a natural sponge to achieve this – see demonstration opposite. Test the effect on scrap paper first.

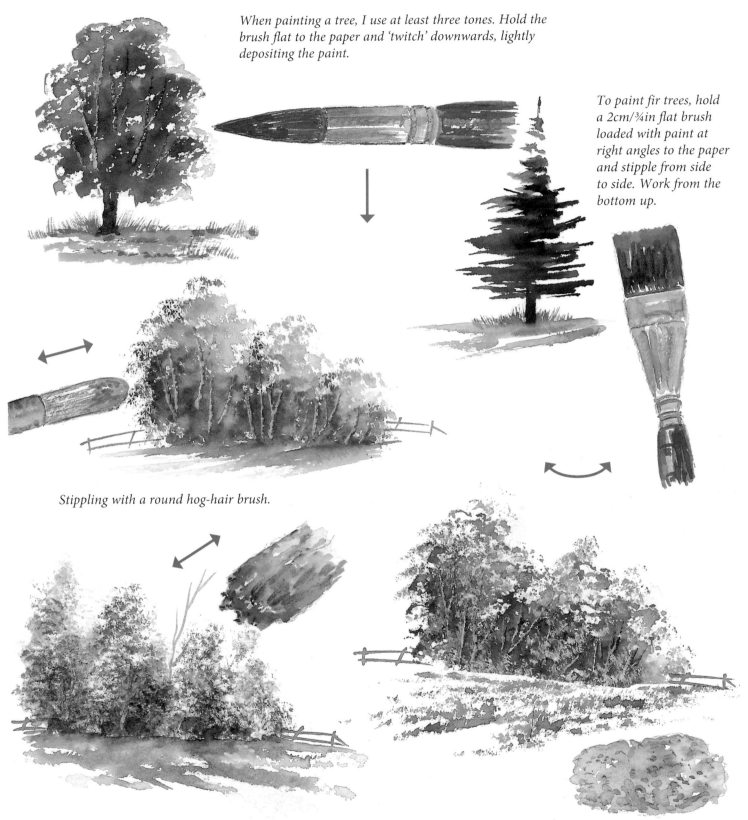

When painting a tree, I use at least three tones. Hold the brush flat to the paper and 'twitch' downwards, lightly depositing the paint.

To paint fir trees, hold a 2cm/¾in flat brush loaded with paint at right angles to the paper and stipple from side to side. Work from the bottom up.

Stippling with a round hog-hair brush.

Stippling with a crumpled piece of greaseproof paper.

A sponge can be used to create texture. Don't squeeze the sponge as you stipple.

I never complete a painting in one sitting. I prefer to look at it over a two-week period so I can make any changes I feel are necessary.

These changes may involve removing paint, or adding highlights or more detail. In **Autumn Gold**, I added depth to the foliage of the trees in the right foreground, in order to help balance the painting.

Before I began this painting, I positioned a piece of 2cm/¾ in wide masking tape a third of the way up the paper, the top of the tape representing the distant water line.

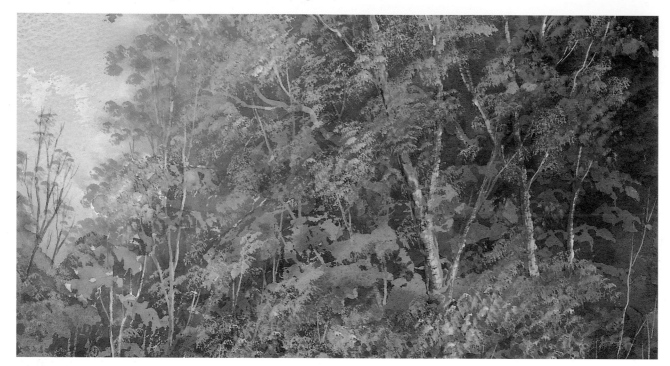

The trees

First, I used a sliver of mounting card dipped in masking fluid to draw in the main shapes. For the fine lines, I used a cocktail stick dipped in the masking fluid. The next stage was to mask the tree foliage. The technique I used was to crumple a piece of greaseproof paper, dip it in the masking fluid and stipple in the shapes of the foliage. Crumpled tissue or cling film can also be used. Which you choose will depend on the size of the deposits you wish to make.

Once the masking fluid was dry, I brushed in washes of pale green, Raw Sienna and Payne's Grey/ Alizarin Crimson, tilting my board to allow the colours to blend.

I removed the masking fluid when the washes had dried. I brushed pale washes of the colours into the white areas to make the foliage of the trees look realistic. Some detail was painted into the tree structures using a rigger brush. When this had been done, I carefully removed the masking tape.

The rocks

The rocks are an important feature in this painting. I drew them with a paint brush dipped in Raw Sienna in order to establish the shapes. When the paint was one-third dry I took a size 6 brush and added Burnt Sienna and Alizarin Crimson mixed with Payne's Grey. I moved the paint around to create structure. When I needed to remove surplus colour, I used a tissue shaped to a point.

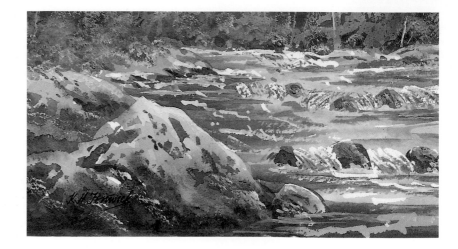

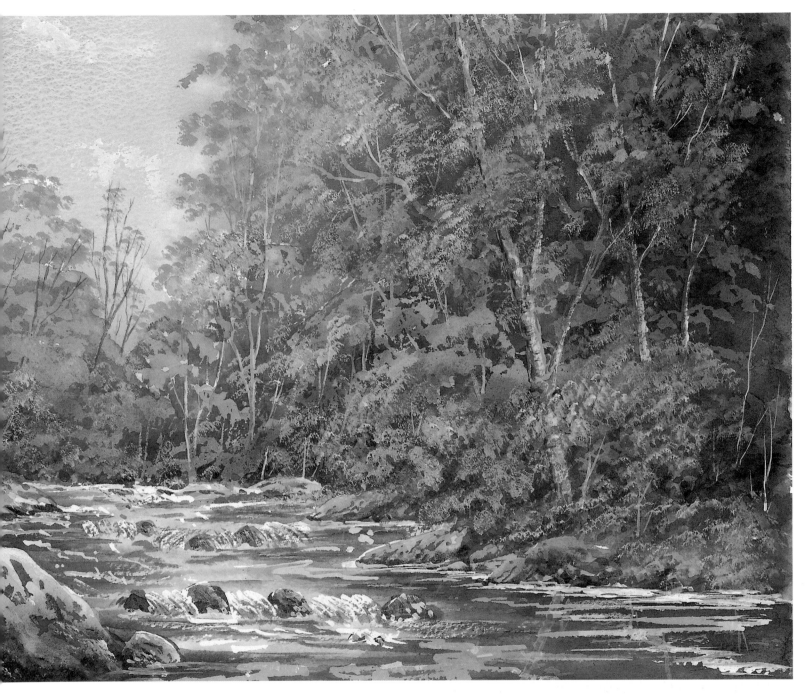

The water

Masking fluid was applied to the areas between the rocks, where the fast-flowing water was to be painted, and to other areas of white water. When the masking fluid was dry, I used a hake brush to paint the whole of the river area, washing over the masking fluid. When this was dry, the masking fluid was removed.

To create fine lines, I loaded a size 14 round brush with Payne's Grey and spread the hairs between thumb and forefinger, fanning them out. Then I painted the fast-flowing water between the rocks, using quick, light directional strokes of the brush.

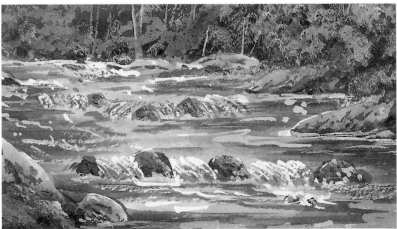

I was asked to make the painting **Constable Country** for a TV programme. The challenge was to represent the great variety of trees, bushes and vegetation effectively, given the size of the painting (55 × 38cm/22 × 15in). I chose to stipple with a sponge, which enabled me to build up the detail and make a pleasing final picture. If I had chosen unwisely, and opted instead to use a brush, I would have had to apply a great number of brush strokes and the painting could have ended up looking lacklustre as a consequence.

1 *Drawing and preparation*

I used a water-soluble crayon for the initial drawing. A pale blue wash was applied to paint the sky and when this was dry I painted a rough representation of trees by stippling with a sponge dipped in various tones of green. Washes were applied to the river bank, made by mixing Raw Sienna, Cerulean Blue and Permanent Sap Green. When using the sponge, don't squeeze it or you will create surplus water, resulting in blobs of paint rather than an open effect to represent the foliage effectively.

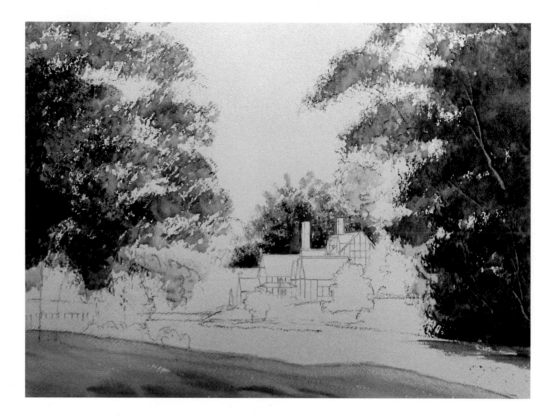

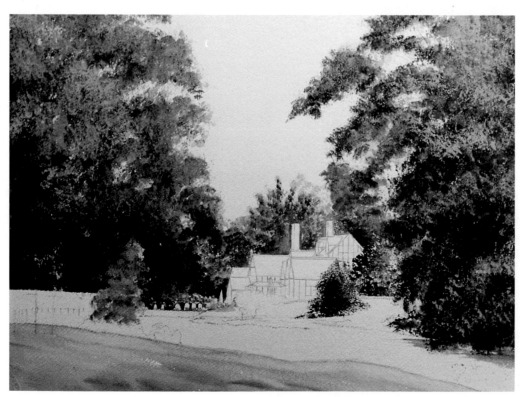

2 *The foliage*

More detail was added to the trees, using a stippling action with the sponge, and the initial shape of the bushes was defined. I used a blue-green for the tree on the left, and added more yellow to produce a softer green for the tree on the right. The colour mixes used for the foliage were made from Cerulean Blue, Cadmium Yellow Pale, Raw Sienna and Payne's Grey, darkening them to add depth to the foliage. A touch of Alizarin Crimson/Burnt Sienna was used to paint the flowers in the distance. To describe the chairs on the patio I used a technique called negative painting, where you paint the spaces around an object rather than the object itself.

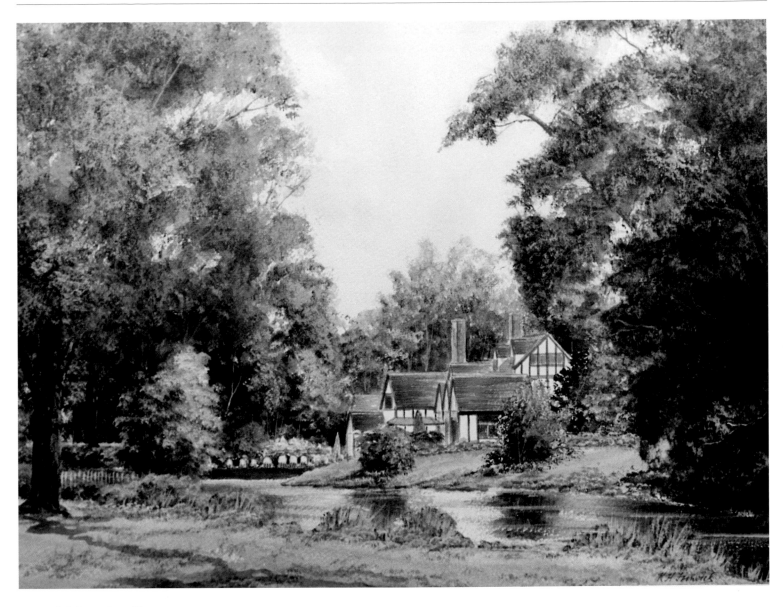

3 Adding detail

The roofs of the buildings were painted using a mix of approximately 20 per cent Burnt Sienna/80 per cent Alizarin Crimson. The tree structures were painted with Raw Sienna/Burnt Umber mixes. For the trunk, I applied a Raw Sienna wash and while this was still wet I added darker tones of Burnt Umber.

To shape the distant trees and the middle-distance bushes, I stippled with a hog-hair brush loaded with mixes of soft green and yellow green. I painted the reeds on the river bank and added detail and shadows. Finally, I painted the water and reflections wet-into-wet and put in the white fence on the left side with a dry white water-soluble crayon.

These are the colours you will need

| Payne's Grey | Cerulean Blue | Alizarin Crimson | Raw Sienna | Burnt Umber | Cadmium Yellow Pale | Permanent Sap Green | Burnt Sienna |

Several techniques can be used to paint tree structures. Some of the most interesting involve the use of a palette knife. In addition to this technique, you will also find advice here on how to use permanent masking medium to create structures and how to add interest to an underlying structure.

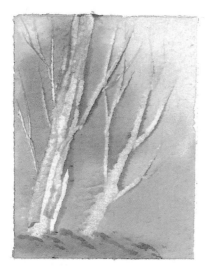

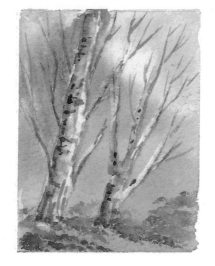

Using a palette knife

After painting the background, I left the paint until it was approximately one-third dry and then, using a palette knife, moved the paint about to create the tree structures.

You will need to purchase a knife and practise with it before you try this technique in a real painting. The width of the structure of your tree will depend on how you use the knife: press down hard with the whole edge of the knife and you will get a trunk that is the width of your knife; press lightly and you will produce narrower widths; use the corner or edge of the knife and you'll produce thin lines.

Using permanent masking medium

The tree structure here was painted using permanent masking medium. With traditional masking fluid several stages would be involved, whereas permanent masking medium is mixed with colour, used to paint the subject and then left on the paper. When dry it will repel light washes.

First, the masking medium was applied to create the tree structure (right). Next, detail was added to the trunk with the masking medium, and when this was dry a background wash was applied (far right).

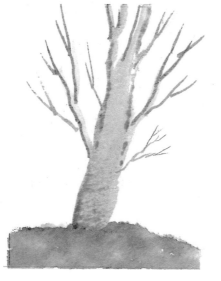

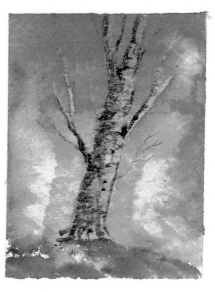

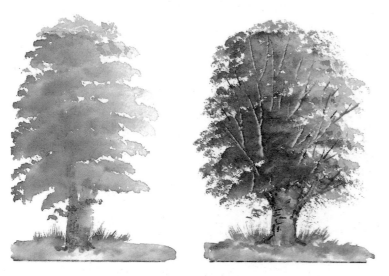

Creating realism

In the first stage of this painting I used Raw Sienna for the underpainting to determine the shape, and while this was still wet I overpainted with a deeper green. To add depth to the tree some Payne's Grey was overpainted when the first stage was approximately one-third dry.

Finally the trunk was painted and some branches were scratched in using a palette knife. Realism and depth have been achieved by ensuring that the tree is darker on the inside.

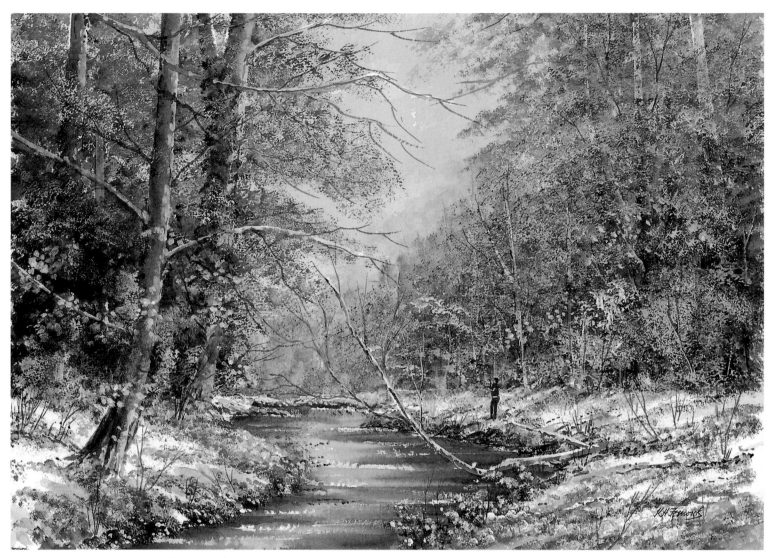

In this painting I used permanent masking medium to paint in the tree structures, the palette knife to scratch out branches and texture medium to make the paint thicker and thus give the foliage texture. Note how I have achieved a feeling of recession by painting the distant trees in lighter tones.

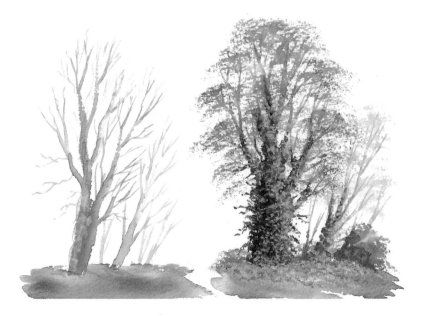

Foliage as structure

In this example the trunks have been overpainted to represent ivy. This is simply executed by adding a dark underpainting and when this is dry, taking a hog-hair brush, dipping it in a soft green mixed with a little white gouache or acrylic paint and stippling in impressions of leaves.

Adding tonal value

To ensure your trees look realistic and have depth, it is important to overpaint with darker toned glazes.

The painting of rocks has always been a difficult subject for the beginner to master. In a river, they may look rounded or long and flat, as they have been shaped over the years by fast-flowing water. In a mountainous region they may appear pointed or roughly structured where they have been broken off larger deposits and have rolled down to find their own place in the landscape.

Their composition will have contributed to their structure and shape, depending on whether they are of a soft material or a hard brittle volcanic rock. Fortunately, as artists, we only have to paint them to look natural in their environment. The careful positioning of rocks in a painting can significantly improve the composition or balance. Their positioning may be determined by choosing the best vantage point from which to view the scene, or using artistic licence.

Like all subjects there are different ways to paint rocks. I always try to use the most appropriate technique, and this may depend on my mood at the time, or the size, shape or position of the rocks in the landscape.

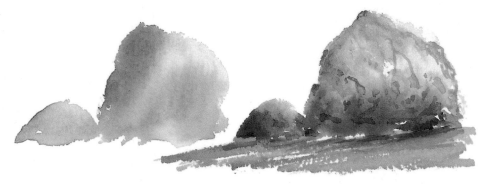

In this technique, I washed in some Raw Sienna and Burnt Sienna and while this was still wet added darker, stiffer tones of a Payne's Grey/Alizarin Crimson mix to create structure and depth. The paint was allowed to blend into the underpainting.

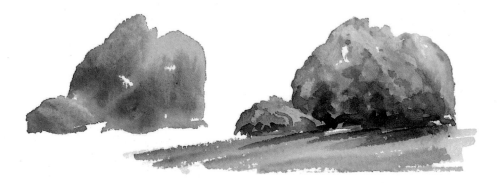

Here, I've painted an initial Raw Sienna wash and added some Burnt Sienna and darker tones of Payne's Grey/Alizarin Crimson. I used a crumpled piece of absorbent tissue to remove the paint, creating a textured appearance.

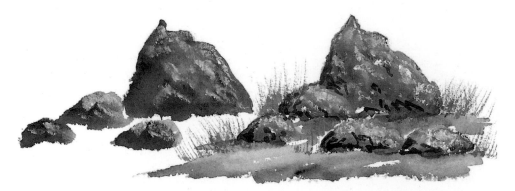

These rocks were created by initially painting their structure using a variety of dark tones and, when these were dry, adding highlights with a softened white water-soluble crayon. You can blend the white in using a damp brush, or colour the rock further by adding Burnt or Raw Sienna to the white.

This waterfall is typical of many to be found in the English Lake District in the autumn when the water levels are high. The water is tumbling down from the mountains, washing its way through a rocky landscape.

The rocks were painted with a flat brush, using several tones and colours; I used Raw Sienna, Alizarin Crimson and Payne's Grey, and when they were dry I added highlights with a softened white water-soluble crayon.

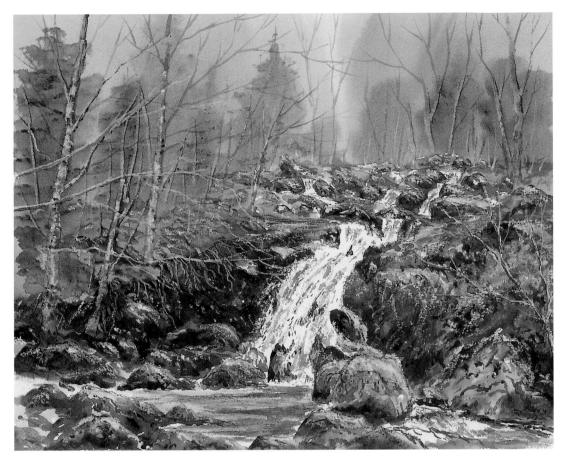

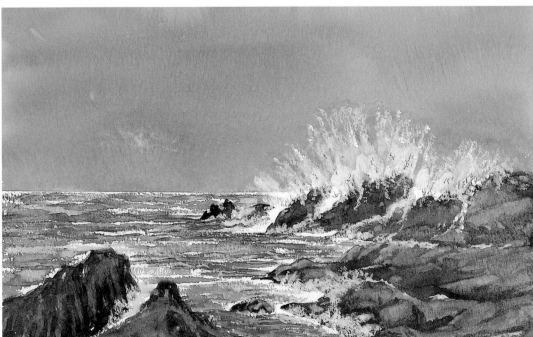

I was fascinated by the sea pounding the rocks in this sketch, completed on a painting tour of South Africa. To create the effect of the spray, I used a combination of the white of the paper and directional strokes with the side of a softened white water-soluble crayon.

Creating variation

Practise painting a group of rocks, creating variation in your grouping; make the first rock rounded, the second larger and angular, and then place an even larger and pointed rock behind the two.

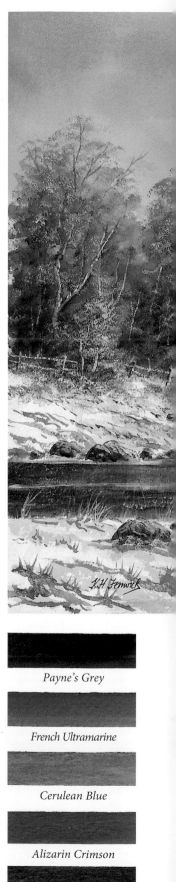

Water is a constant source of inspiration for the landscape painter, offering a choice of river scenes, waterfalls, lakes, ponds, seascapes and even puddles in a country lane. As artists we are faced with three types of water:

- Motionless – a calm lake, a local pond, a puddle on a woodland path or even a rain-drenched street scene.
- Moving – a river, a mountain beck, a wind-blown lake.
- Turbulent – a fast-flowing waterfall, a mountain beck or a stormy seascape.

In this section we shall concern ourselves with the last two types.

Moving water

In a fast-flowing river or mountain beck, the whiteness of the water provides an indication of the speed of flow, particularly when the flow is restricted by rocks.

Water is best painted using the minimum number of brush strokes and a light touch of the brush. As a general rule, the faster the flow the lighter and quicker your brush strokes should be.

I sit by the water and observe the flow patterns, colours, tones, shadows and reflections. Squinting one's eyes to observe the flow helps to establish the main characteristics. I like to produce a quick tonal study with a dark brown water-soluble crayon. When it is finished I hold it in front of me and compare it with the actual scene. If I feel changes are necessary, I will sketch them in prior to painting the scene. Too much

detail makes water look fussy and unnatural. The key word is 'simplify'.

Turbulent water

There is no more beautiful sight than a tumbling mountain beck or waterfall. The speed of flow and the depth of water will determine whether the water appears light or dark in tone where the water flows over a shelf or rock. When the flow is interrupted by rocks the effect will be of white water.

When turbulent water has completed its fall or been restricted by rocks, some spray may occur. The water will be darker in tone as it flows away from the base of the fall or a rocky outcrop.

I find a camera useful to capture the flow pattern, which sometimes the eye and brain have difficulty in determining.

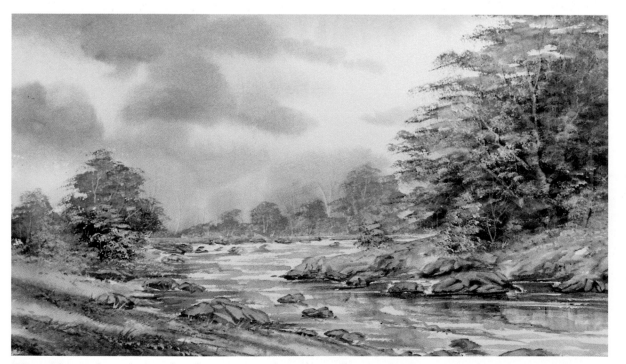

River Rhapsody *represents fast-flowing water through a rocky river bank.*

Payne's Grey

French Ultramarine

Cerulean Blue

Alizarin Crimson

Burnt Umber

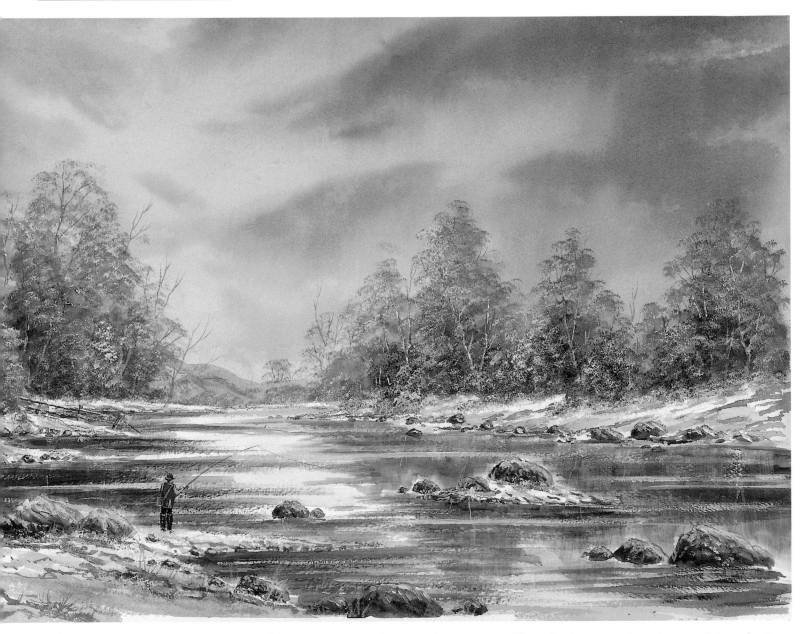

Reflections *was a painting commissioned by an international construction company. The reflections are mirror images of the reflecting objects and the sky colours repeat on the surface of the water.*

Reflections

Reflections will appear blurred in moving water, and as a mirror image in still water. Where there are reflecting objects, I paint the water last. A wet wash is painted followed by vertical strokes for the reflections.

It's important to understand that reflections reflect from the base of the reflecting object. For example, a large tree or building a field away may only reflect its top in the water, not its whole.

General guide to painting water

- Brush strokes should follow the flow.

- Shadows should be painted horizontal.

- Reflections should be painted vertical.

- To achieve freshness, apply quick brush strokes using a light touch of the brush.

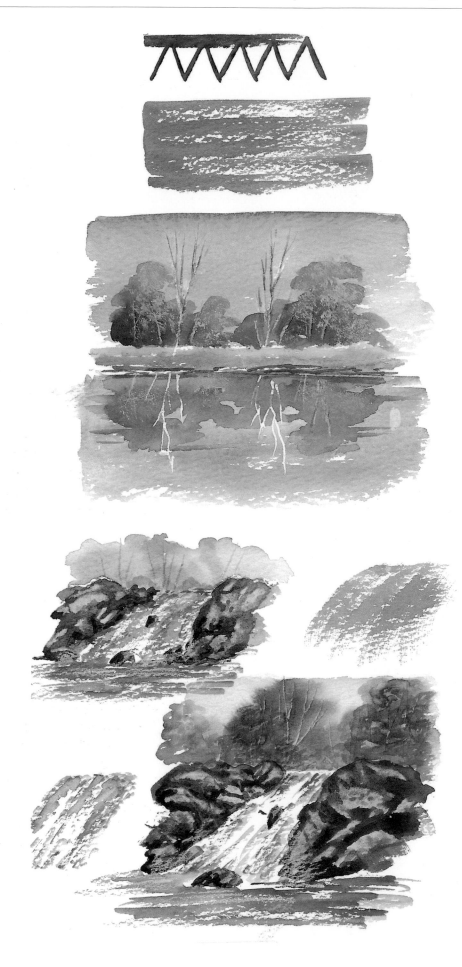

Using texture

Think of the texture of your paper as being like mountains and valleys. If you move your brush quickly and lightly across the mountain tops, the paint will be deposited on the peaks of the paper, and not be allowed time to run down into the valleys. The result is broken colour. You can use this technique to create sparkle on water – see painting on opposite page.

Using permanent masking medium

Here I have used permanent masking medium to paint the reflections representing the tree structures. I used a cocktail stick dipped in the medium to draw the fine lines; this saves cleaning a brush. When the masking was dry the water and reflections of the trees and bushes were painted over it. The masking repelled the liquid washes. As the name suggests, permanent masking is not removed, unlike masking fluid.

Using a hake brush

This water was painted using a hake brush. It's a good idea to practise first on a piece of paper similar to the paper you are using for your painting. Remember, fast strokes with a light touch are required for painting water. When you have managed to deposit the paint in this manner on your test paper, paint in the water on your landscape.

Using a rigger brush

I've used downward strokes with the side of a size 6 rigger (a size 6 round will suffice instead) to paint the water. Take care, it's so easy to apply too many coats. The aim is to leave lots of white paper showing through. Just a twitch of the brush is required to achieve the light, quick strokes you need to paint water.

Creating sparkle

Here I've demonstrated the technique discussed opposite to create sparkle on the water. The size 14 round brush or the hake should be held as flat to the paper as possible to achieve the desired effect.

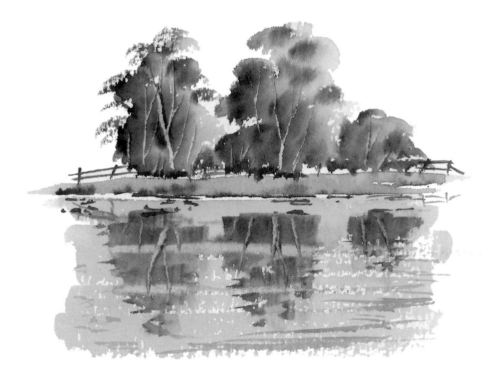

Creating reflections

I scratched out the background tree structures and their reflections in the water using my thumbnail when the paint was approximately one-third dry. If this technique is used when the paint is very wet, a dark line will result as the scratched-out areas fill in with wet paint. Timing is important.

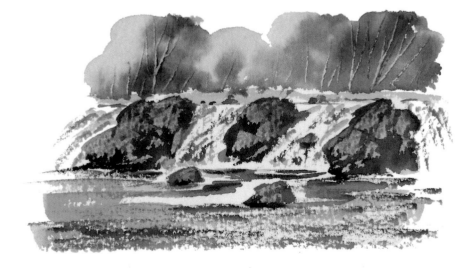

Creating falling water

In this simple exercise, the falling water was painted using the side of a rigger brush, with the brush strokes following the angle of flow.

I painted the background trees in cool colours, wet-into-wet, to achieve recession and scratched out the tree structures. The texture on the rocks was created using a palette knife.

Problems in colour mixing usually result from using a palette that isn't large enough for the purpose. You will need a large mixing area that allows you to display the colours with adequate spaces between them. I find it essential to lay out my colours in a logical sequence – sky colours, earth colours and mixers.

I prefer tube colour to the small hard pans of colour because I like to begin each painting with soft fresh colour.

I often add a little Alizarin Crimson to brighten the mix or a little Burnt Umber to darken it. For shadows, if you add 20 per cent of any colour on your palette to 80 per cent Payne's Grey you will be able to produce a wide range of interesting greys. Don't use black for shadows – it deadens a painting.

To achieve the correct balance of colour you will need to experiment with mixing colours. The mixes shown here are just some of the variations possible using the colours shown below.

The colours shown opposite are mixes for water.

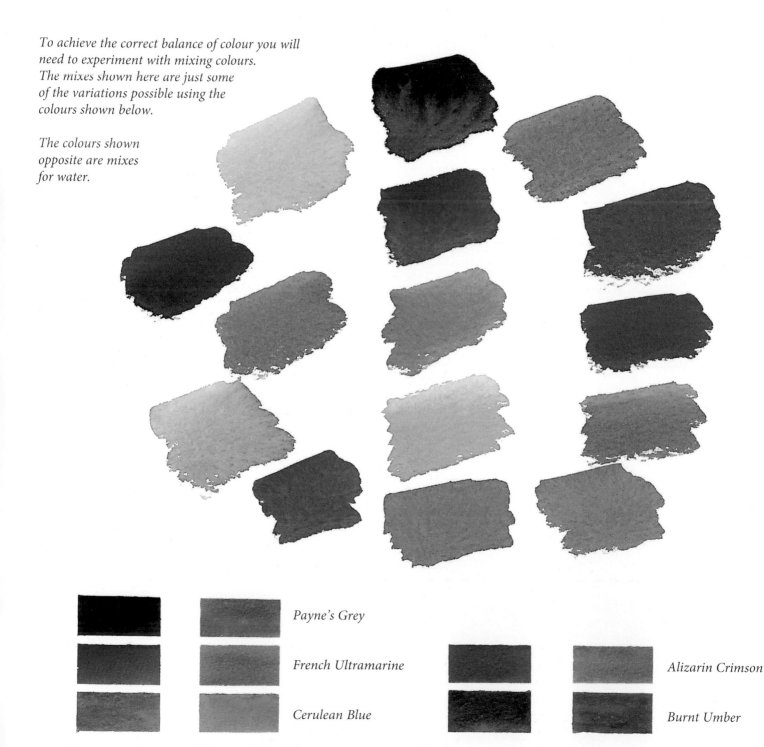

Strong colour **Water added** *Payne's Grey*

French Ultramarine

Cerulean Blue

Strong colour **Water added** *Alizarin Crimson*

Burnt Umber

These are the colour mixes I use most for painting water; which mix you use will, of course, depend on where you are painting. Practise mixing them yourself.

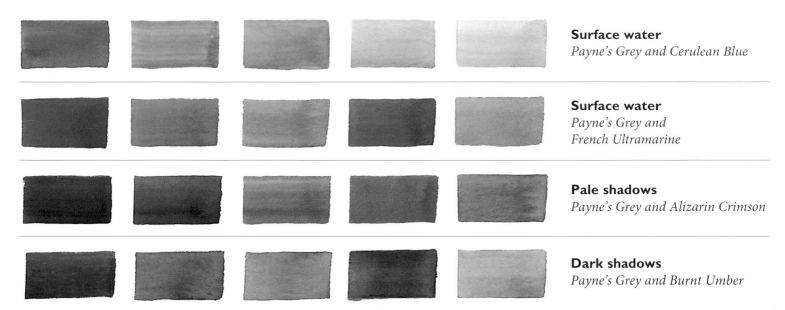

Surface water
Payne's Grey and Cerulean Blue

Surface water
Payne's Grey and
French Ultramarine

Pale shadows
Payne's Grey and Alizarin Crimson

Dark shadows
Payne's Grey and Burnt Umber

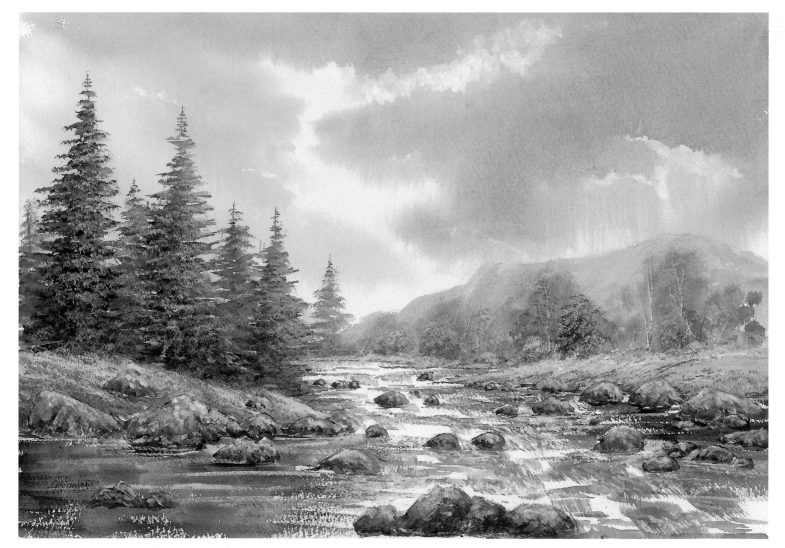

In **Scottish Landscape** *I used quick, light strokes with the hake brush to achieve the effect of fast-flowing water.*

Hartsop Beck in the Lake District is one of my favourite places to paint. I made a TV programme there and to me it represents the countryside at its best. The main feature of this acrylic painting is the fast-flowing beck, which is fed by water flowing from the mountains, running through the old hamlet of Hartsop.

The trees

Let's begin with the tall birch tree just off-centre. Using the rigger brush, I painted its structure in pale Burnt Umber. When the paint was dry, I painted the foliage with the side of a size 14 brush using light downward strokes. The colours I chose were mixes of pale green to Burnt Sienna. When this was dry, darker tones were painted on the tree structure to achieve a more realistic effect.

The tree on the left was darker in tone. I used the same process as described above but in this instance darker tones of Payne's Grey/Permanent Sap Green were added to create depth in the foliage. To achieve a realistic impression of foliage, I stippled with a round-ended hog-hair brush loaded with a pale green.

The rocks

Various glazes of Raw Sienna, Burnt Sienna and Payne's Grey were applied to create the three-dimensional look of the rocks, which are an important feature in this painting. Acrylics enable several glazes to be applied without the worry of lifting the underpainting.

I used the rigger brush to scumble a little white paint mixed with Raw Sienna to create texture and highlights on the rocks. Think of scumbling as pressing the brush to the paper and wiggling it about to deposit paint in various patterns. Finally I used the rigger to paint in a few fissures in the rocks and added some darker shadows.

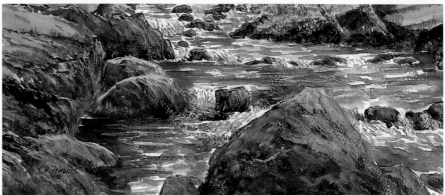

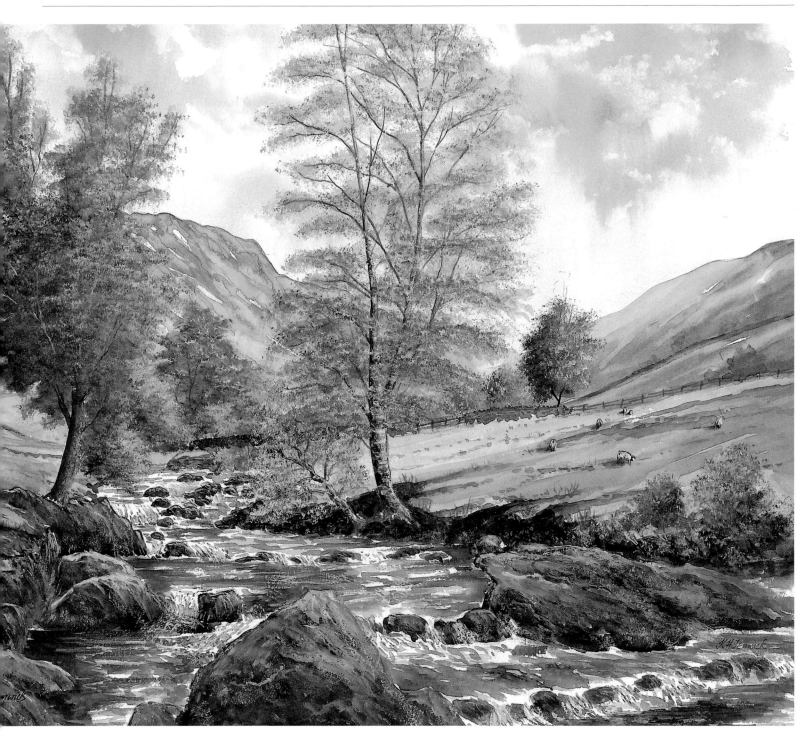

Hartsop Beck – *a fine example of fast-flowing water in an area of outstanding natural beauty.*

The water

Initially, I used the side of the rigger brush to paint the flow lines between each of the rocks, representing flowing white water. The next stage was to paint some medium tones as horizontal lines to fill in the expanses of water between each level of rock. For this I used the hake brush. Finally, I added some darker tones to each side of the river bank to represent reflections and give depth to the water.

The colours used to paint the water were Cerulean Blue and Payne's Grey in various mixes and tones. The water area was painted in less than three minutes. In order to achieve recession in this painting, more white of the paper was left uncovered in the distant water.

Autumn Flow is the type of scene that makes being an artist so exciting. At the time, I was painting a lake scene and had noticed water running into the lake from an unknown source. Having completed my sketch, I decided to explore.

My curiosity was rewarded when I discovered this lovely woodland stream flowing between clusters of rock. I just had to sketch and photograph the scene to give me the basis for this stage-by-stage for you to paint.

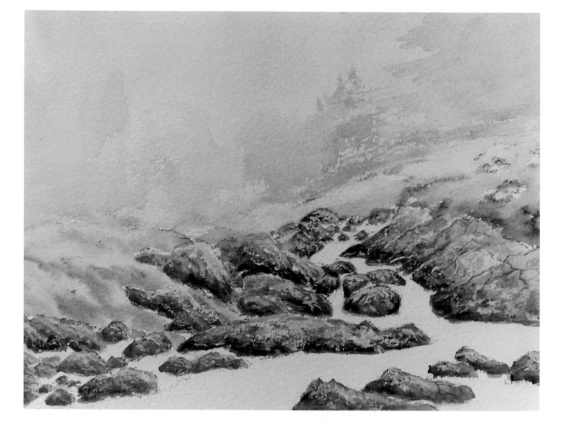

1 The rocks

The most difficult and time-consuming task was the positioning and painting of the rocks. I started by drawing the outlines using a brown water-soluble crayon and painting in a loose wet-into-wet background.

The rocks were painted with a 2cm/¾in flat brush. I used Raw Sienna washes to outline the rocks and while this was still wet added Burnt Sienna and finally darker tones of Payne's Grey/Alizarin Crimson.

When the paint was dry, I added some highlights to the rocks with a softened white water-soluble crayon. The fissures in the rocks were painted using a rigger brush.

2 The trees

The background trees were painted wet-into-wet and when the shine had gone from the paper I scratched in a few light tree structures with my thumbnail. I could have used a palette knife but my thumb is always handy!

When the paint was dry, I put in the tree structures, using a rigger brush loaded with various mixes of Payne's Grey/Burnt Sienna. Then I stippled in the foliage using a sponge dipped in Burnt Sienna and Permanent Sap Green. The ivy was added to the trunks and more detail painted on the river banks.

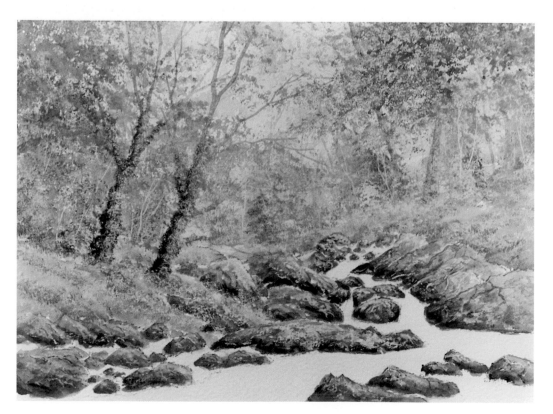

If your drawing skills are poor, no matter how good you are at applying
paint your landscape won't look right – so practise your drawing.

61

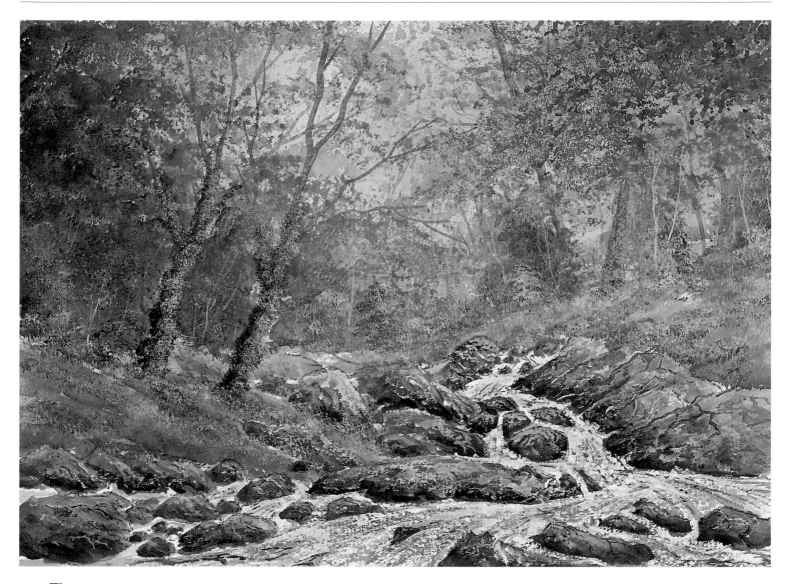

3 The water

Painting the water is the simplest and quickest part of this painting. I used light, quick, short strokes with the 4cm/1½in hake brush loaded with mixes of Payne's Grey/Cerulean Blue. I employed the corner of the hake brush for the narrow flows and its full width for the wider flows. Initially I applied lighter tones and when these were dry they were followed with darker tones. The final stage was to add a little Raw Sienna to colour the water.

A word about drawing

When preparing an initial drawing it's important that you draw the scene correctly. In **Autumn Flow**, for example, the positioning of the rocks would be quite tricky for the less skilled.

Excessive erasing of pencil marks on the watercolour paper you are using for your painting can damage the surface. It is a good idea, therefore, to make your drawing on a separate piece of paper, correct it, and then – using the approach described on page 91 – transfer it to your watercolour paper. There's no need to take a photocopy in this instance.

Colours you will need

Payne's Grey	Cerulean Blue	Alizarin Crimson
Raw Sienna	Burnt Sienna	Permanent Sap Green

The landscape shown in **Tumbling Water** is typical of those found in the Yorkshire Dales National Park. It isn't my intention to show you how to paint the scene as a whole but rather to concentrate on how to create the effect of fast-flowing water as it tumbles over rocks. The land in this part of the country is quite peaty, which colours the water a warm Sienna as it runs over the rocky shelves.

1 Establishing flow patterns

As always, my first step was to complete a tonal study to determine the most appropriate vantage point. This study helped me to clarify my approach to the painting, to identify the most important flow patterns and to establish the light and dark values. The water was complex, so simplification was needed.

Using the hake brush, I initially made a few marks to identify the principal flow patterns. I turned to a rigger brush to paint in a few small rocks, using a weak Payne's Grey wash.

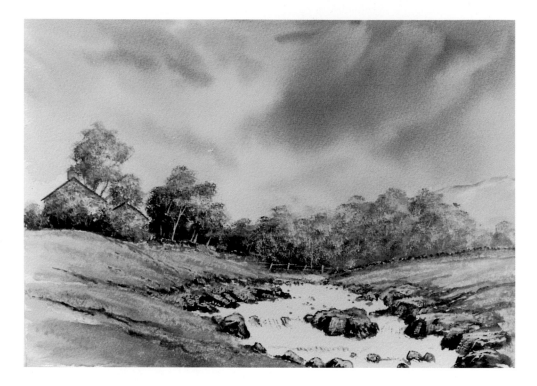

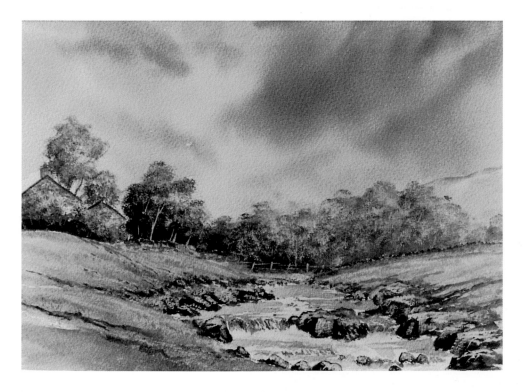

2 Building up the water

Using horizontal strokes with the side of the size 14 round brush and a weak Cerulean Blue mix, I painted in the water, being careful to leave some of the white paper uncovered.

The next step was to give more definition to the water flowing between the rocks, using the corner of the hake brush loaded with a Payne's Grey/ Cerulean Blue mix. To create this effect you need to just 'twitch' the brush; in other words, deposit the paint by using fast, short strokes. It's a good idea to practise on a similar type of watercolour paper first until you are happy that the paint is being deposited as you wish. Following this, a weak Burnt Sienna was brushed in to represent the colour of peaty water.

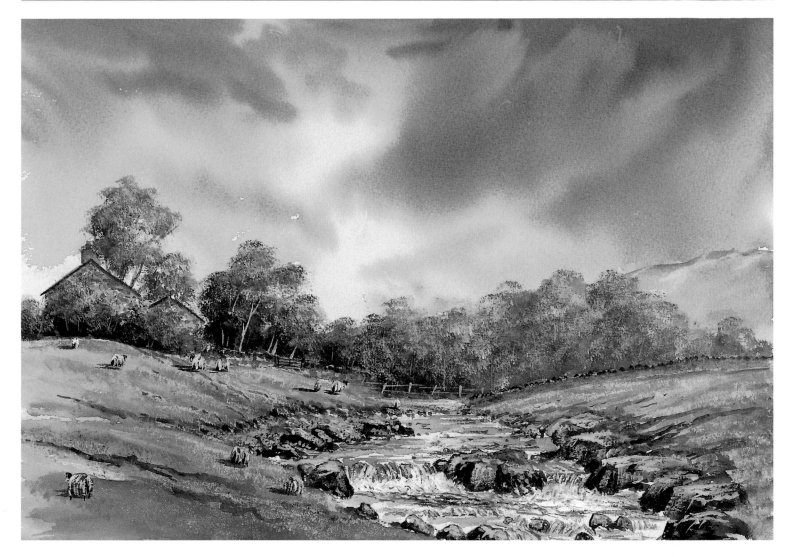

3 Adding depth and detail

All that was left to do was to paint in some darker tones of Payne's Grey to add depth and detail to the water flowing away from the base of the rocks.

When painting water, it's inevitable that you will get carried away and overdo it in places. In my case, I hadn't left sufficient white paper showing through between the rock on the right and the bank. This can easily be corrected by dipping a hog-hair brush into clean water and washing off the paint, then dabbing the area with a tissue to restore the white paper. Simpler still is to try the technique I have used here: take a white water-soluble crayon and add a few white streaks.

Adding interest

You will notice that I have positioned a few sheep in this painting. They make such a difference to the foreground and add life to the picture.

These are the colours you will need

Payne's Grey	*Cerulean Blue*	*Alizarin Crimson*	*Raw Sienna*
Burnt Sienna	*Permanent Sap Green*	*White water-soluble crayon*	

In this painting I want you to take note of how I have ensured linear perspective. First the brush strokes are directed towards the vanishing point; secondly, the river bank is shaped so that it is wider in the foreground and narrow in the distance; and finally the trees gradually diminish in height as they recede into the distance. By these principles of linear perspective the eye is led into the painting, through to its furthest point where the river vanishes out of sight round the bend.

Shaping the river bank

If you make your river banks a feature of your painting it will look more interesting. Don't paint them as straight lines. The bank will have land jutting out into the water and inlets where the water, with time, has washed away the soil. In this example you'll see that I've painted in some dark shadows or reflections to give the water depth and interest. Adding a few rocks also helps to create a pleasing effect.

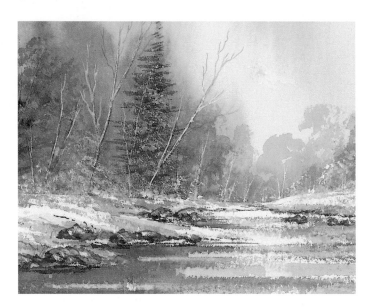

The rocks

The shadows on and under the rocks were achieved by applying darker tones of a Payne's Grey/Alizarin Crimson mix with a 2cm/¾in one-stroke brush. When the paint was one-third dry, I moved it around with a palette knife to give the rocks a realistic look. When the painting was completely dry, I used a softened white water-soluble crayon to add the effect of a little snow.

The water

The reflections from the trees were painted wet-into-wet, using downward strokes with a flat brush loaded with the tree colours (Raw Sienna, Burnt Sienna, Payne's Grey, Alizarin Crimson, Permanent Sap Green and Burnt Umber). The wind lines were made by removing some of the paint by means of a tissue shaped to a wedge. Burnt Umber applied with a rigger brush was used to paint the reflections of some of the trees.

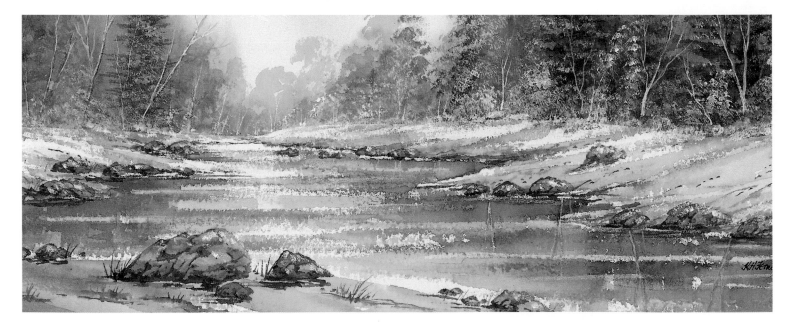

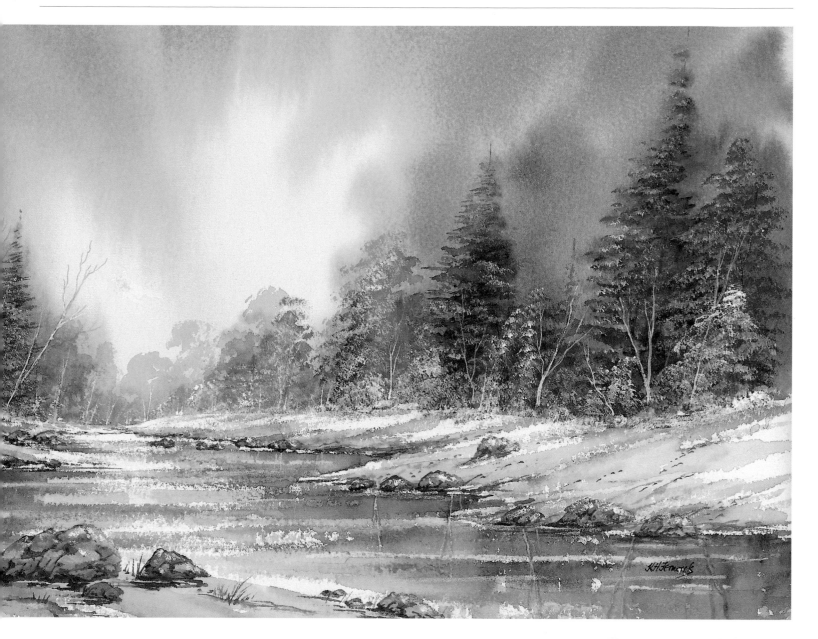

The trees and bank

The trees lining the bank vary in shape, height and variety. Two firs stand out, however, and these were painted with a rocking, stippling technique. The remaining trees and bushes were painted using a size 16 hog-hair brush with a stippling action, while the snow on the trees was added by stippling with white acrylic paint. The distant trees have been loosely painted in very pale, cool colours to achieve recession in the painting.

* Some of the sky colours (Payne's Grey, Alizarin Crimson, Cerulean Blue) were introduced into the bank by wetting the white of the paper with clean water and letting the subtle touches of colour blend in.*

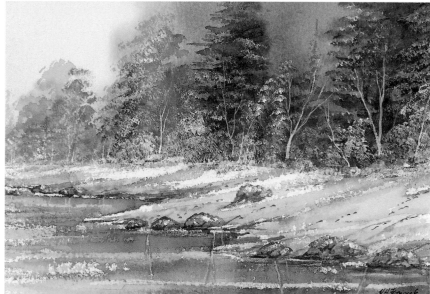

Artists down the centuries have endeavoured to capture the magical effects of light on the landscape. Watercolour painting is ideal for this by providing contrasting tonal values and colour, wet-into-wet and the ability to incorporate both hard and soft edges.

Coloured glazes consisting of a small amount of paint and lots of water can easily be applied, either to warm up sections of a painting to represent sunlight or to provide contrast by applying cool colours.

It's important to remember that the white of the paper and the transparency of watercolour provide the greatest source of light in a watercolour painting. However, a source of light can be brightened further by surrounding it with darker contrasting tones of colour. You can prove this for yourself: take a piece of waste watercolour paper, paint your light source, then paint dark tones of colour around it. You will immediately see that your light source appears lighter.

To begin with, it's a good idea to select your subject and produce simple tonal studies to establish the effects of light on your landscape. If you paint your subject at different times of the day, you will experience the effect changing light has on the landscape. The knowledge you get from these exercises will be invaluable for your paintings.

The colours I find most useful are shown below.

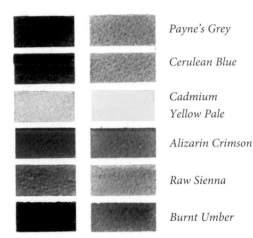

Payne's Grey

Cerulean Blue

Cadmium
Yellow Pale

Alizarin Crimson

Raw Sienna

Burnt Umber

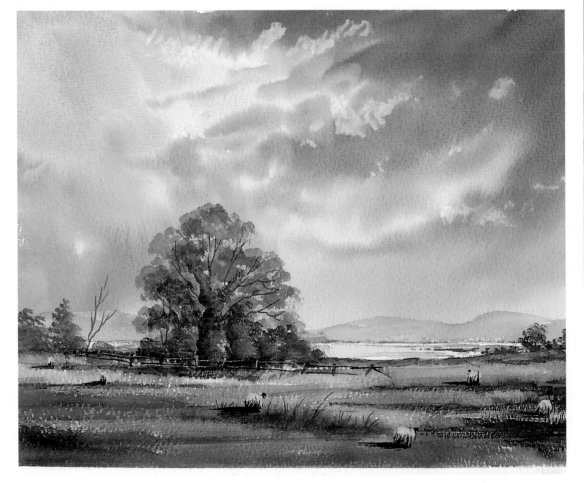

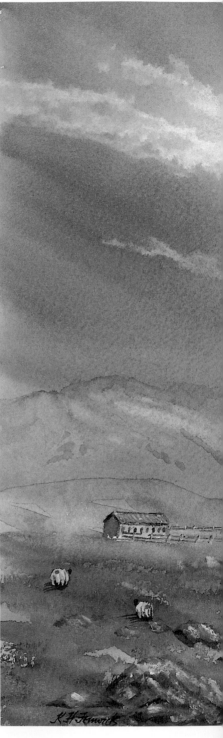

In **Evening Light** *I used various tonal values in the clouds on the right and left lighter areas surrounding the large tree, to emphasize its structure. I painted cloud shadows in the foreground to provide contrast with the soft light in the sky.*

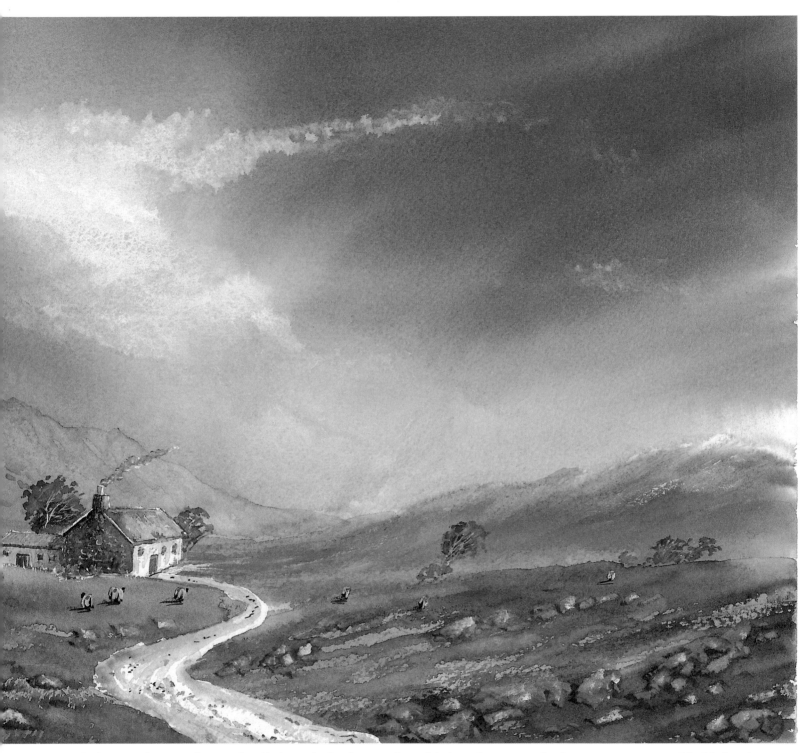

Moonlight *provides a good example of light in the landscape. The soft light radiates over the distant mountains and highlights the farmstead and the track, leading the viewer's eye into the painting. Masking fluid was initially applied to preserve the white of the paper representing the track. Washes and detail were applied after the masking fluid was removed.*

Practice

- Study the examples in this book and practise painting wet-into-wet skies to represent the various light situations.
- Practise colour mixing, using the colours specified in the text.
- Practise using an eraser to remove colour, creating shafts of light as in a woodland glade or an atmospheric sky.

Colour has fascinated artists for generations. Many books have been written about this subject but there's no substitute for experience. I'm often asked by my students to divulge the percentages of each hue I have mixed together to achieve a particular colour, but I can't tell them. I just mix quantities of each colour together until I am satisfied with the outcome.

Certain rules obviously have to be followed. If fresh, clean colours are required, it's best to mix only two colours together. For more subtle shades, mix three colours together. If you mix more than three colours you are likely to end up with a dull colour. Artists call this 'mud', but there may be occasions when this is precisely what is needed.

The basics of colour mixing

The primary colours are red, yellow and blue. If similar quantities of each primary colour are mixed together the result is almost a black colour, as shown in the colour circle right. If blue and yellow are mixed together, they will produce green. Mixing red and yellow gives orange, while mixing red and blue results in a violet or purple colour. These mixtures are known as secondary colours. Tertiary colours are created by mixing a primary colour with a secondary colour; any red, yellow and blue will suffice.

Follow the arrows in the colour circle. By using three primary colours in the above combinations with various amounts of water, a wide variety of tints can be produced. Of course, a vast range of colours can also be bought, but there's nothing like experimenting with the basics to discover the range of colours and tones you can produce.

Some colour combinations I find useful are shown below.

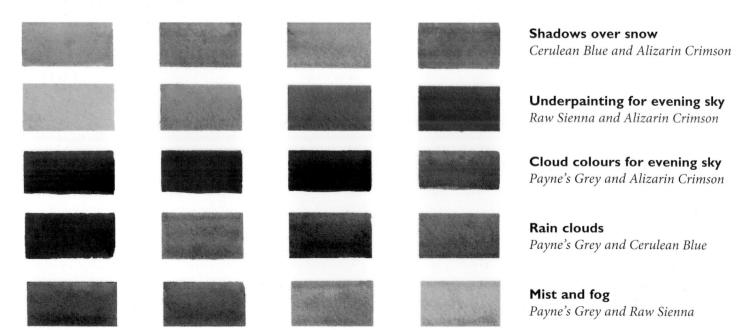

Shadows over snow
Cerulean Blue and Alizarin Crimson

Underpainting for evening sky
Raw Sienna and Alizarin Crimson

Cloud colours for evening sky
Payne's Grey and Alizarin Crimson

Rain clouds
Payne's Grey and Cerulean Blue

Mist and fog
Payne's Grey and Raw Sienna

My basic palette of colours is shown below. You won't go far wrong if you begin with this selection. Additional colours I use to support my basic palette are also shown below. I call these extra colours my 'supportive' palette. Occasionally, I may select further colours from the wide range available.

Basic palette

Payne's Grey	*Cerulean Blue*	*Alizarin Crimson*	*Raw Sienna*	*Burnt Sienna*	*Burnt Umber*	*Cadmium Yellow Pale*	*Permanent Sap Green*

Supportive palette

French Ultramarine	*Indanthrene Blue*	*Quinacridone Red*	*Winsor Yellow*	*Brown Madder*	*Gold Ochre*

Payne's Grey and Alizarin Crimson – Storm clouds

Alizarin Crimson and Cerulean Blue – cloud colours

Payne's Grey and Burnt Umber – Storm clouds

French Ultramarine and Cadmium Yellow Pale – light in the sky

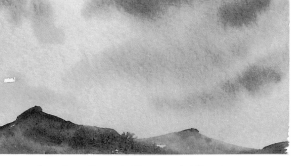

Storm clouds – *Payne's Grey and Alizarin Crimson, painted over a pale Raw Sienna wash.*

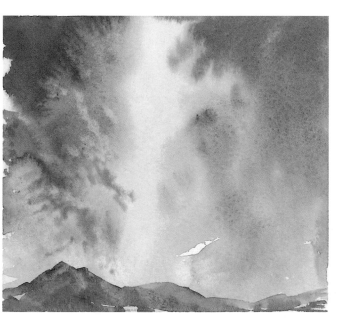

Light on the landscape – *French Ultramarine on the right and French Ultramarine/Alizarin Crimson on the left, painted over a Cadmium Yellow Pale underpainting.*

I've included this woodland scene, **Coat of Many Colours**, to provide you with an opportunity to practise your colour mixing. I would like you to note the variations in tone throughout this painting – this variation is important.

The tree grouping on the left side of the painting has been painted in darker tones, leading the eye beyond it and into the distance.

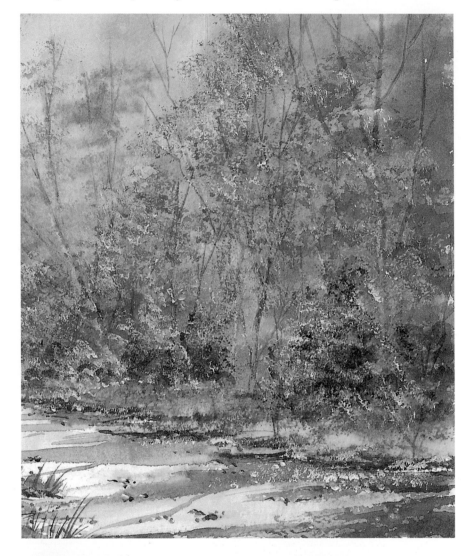

Autumn trees

In this grouping you will observe a wide range of green and autumn tints. The greens have been created by using Cerulean Blue mixed with Cadmium Yellow Pale and Raw Sienna. The autumn hues have been mixed using combinations of Raw Sienna, Burnt Sienna and Alizarin Crimson.

Trees and bushes appear dark on the inside and become lighter towards the extremities. To capture this depth in the foliage, I overpainted with dark tones of Payne's Grey mixed with a little Alizarin Crimson when the underpainting was completely dry, producing a dark mauve colour. Never use black for this purpose – it really kills a painting.

The tree structures were painted using a weak Burnt Umber, followed by stippling in the foliage with a small artist's sponge, incorporating suitable autumn colours. Before you try this, practise first on a similarly textured piece of watercolour paper.

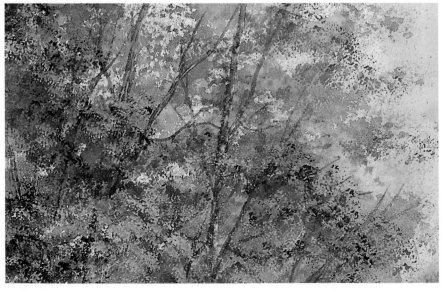

Adding darker tones

To create the foliage on the left-hand trees, I applied a wide range of greens in varying tones, mixed from Cerulean Blue, Cadmium Yellow and Raw Sienna. To paint the foliage, I stippled with the sponge dipped in paint, pre-mixed on my palette. When this was completely dry, I over-stippled with dark tones of a Payne's Grey/Alizarin Crimson mix to create depth in the foliage. Depth is so necessary to the success of a painting such as this, because it leads the eye beyond the darker tree grouping into the distance.

When the paint was dry I added some white gouache paint to the green mixtures to lighten them. Using the stippling technique, I added a few highlights in the foliage to retain the overall impression of depth.

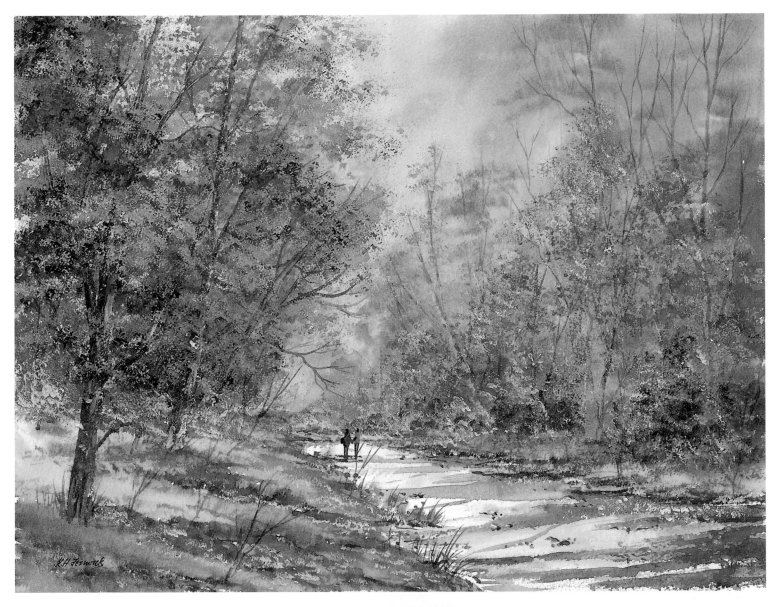

Texture

*Your painting can be made more realistic by adding
texture to the grassy areas. This is achieved by applying
initial washes of a soft pale yellow in the distance,
followed by green to selected areas. When the paint
is approximately half dry, the hake brush with the tip
brought almost to a chisel edge is used to paint in some
darker tones to represent texture; loading the brush with
a Payne's Grey/Alizarin Crimson mix is ideal for this. You
must touch the paper lightly to deposit paint, then, using
the corner of the brush, flick upwards to create tufts of
grass. It's a very simple technique.*

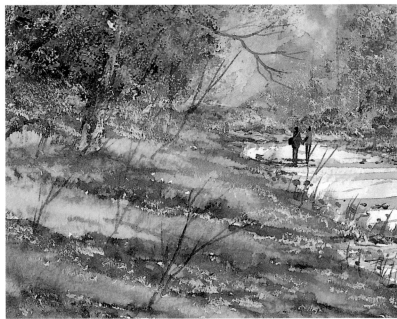

*The walkers are important in this painting – they're
the focal point, leading your eye down the path. Don't
forget to paint some shadows across the footpath.*

Here are three different examples of early morning light: first light as dawn breaks; a back-lit subject where the light has broken through the clouds, creating a glow over distant mountains; and a front-lit woodland scene.

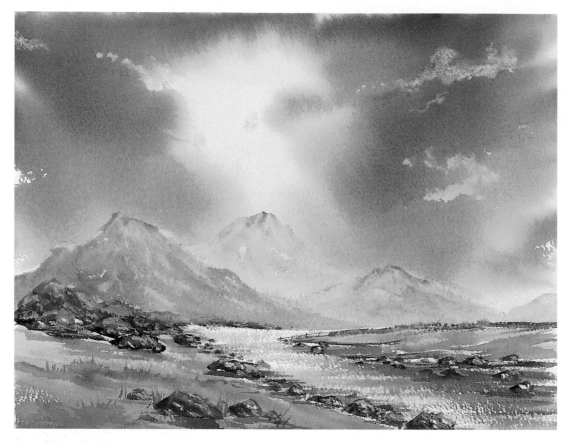

Skylight *is a fine example of early morning sun breaking through the clouds, lighting up the landscape. The distant mountain seems to sparkle, as does the surface of the water. The sky is the main feature in this painting, although it was painted in less than three minutes. Initially, I painted a circle of Cadmium Yellow Pale. While the paper was flat, I painted French Ultramarine on the right-hand side and a Payne's Grey/Alizarin Crimson mix on the left.*

Using a spray bottle, I sprayed water in the centre of the Cadmium Yellow Pale and, lifting up the board, tilted the paper to allow the colours to run in different directions and blend together. An occasional spray here and there encouraged the paint to flow freely. When I was satisfied with the cloud formation, I laid the board perfectly flat to allow the paint to dry. When it was approximately one-third dry, I used an absorbent tissue to add a few white clouds.

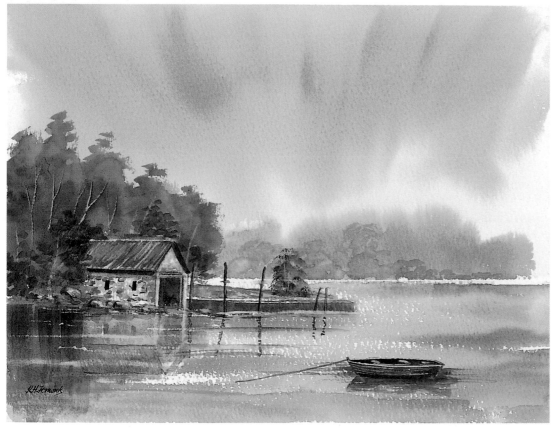

Boathouse *was painted at the first light of dawn. The background is a simple wash of varying light tones of Payne's Grey over a weak Raw Sienna underpainting. The distant trees were painted wet-into-wet to achieve a soft, diffused look. The foreground trees are in silhouette. The red roof of the boathouse is quite dull, as is the pale-coloured stonework. The lake surface reflects the colours of the sky and the water on the left-hand side is in shadow from the dark tree grouping. The boat was added to give a brighter note in this otherwise neutral-coloured scene.*

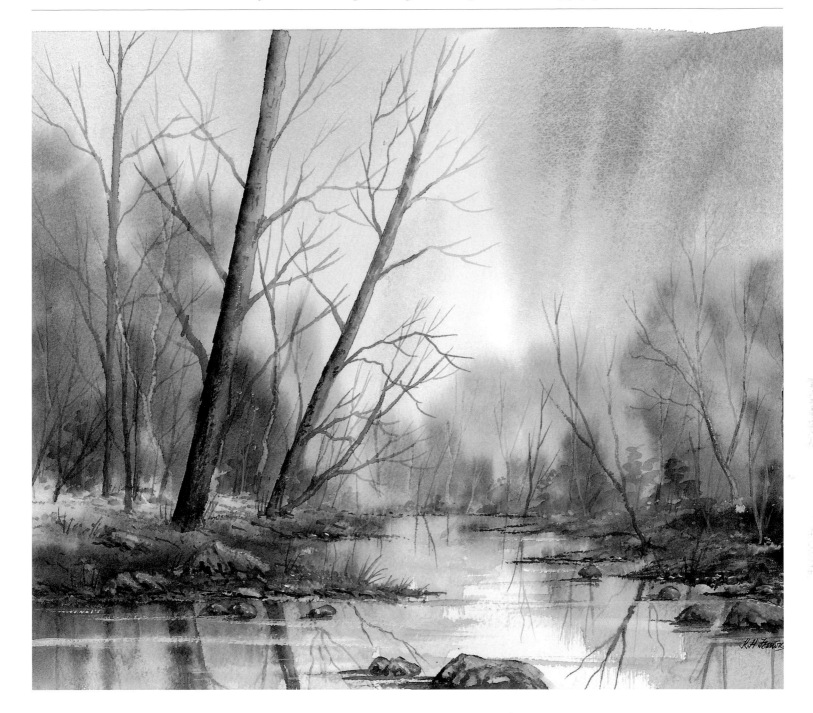

River Rhapsody *is the type of scene I love to paint. The subdued early morning light was behind me, attempting to break through the early morning mist. The far distant trees can barely be seen and blurred images of the trees in the middle distance provide a background to the large trees on the left.*

It's autumn and the leaves have fallen, allowing the structure of the trees to be visible. Distant tree structures were scratched out with the palette knife. If the paint is too wet when scratched out it will run back, resulting in a dark tree structure. The trick is to leave the paint until it is about one-third dry, when a pleasing light tree structure will result.

In this painting some structures are light and others dark.

The trunks of the large trees in the foreground were painted in dark tones of brown and a tissue shaped to a point was wiped down to remove paint, lightening the right-hand side of the trunks. A rigger brush was used to paint some dark tones on the trunks, making them look round. The branches were added, again with a rigger brush, and a few reflections were painted in the water.

Very important in this painting are the contrasts of pale tones and colours representing the soft, diffused early morning atmosphere.

Evening is probably my favourite time to paint. The landscape is going to sleep. It's so peaceful, a time for contemplation. The clouds have darkened, contrasting with the light in the sky, making the light appear even brighter. The sky colours are reflected on the surface of the water, creating a sense of peace and tranquillity.

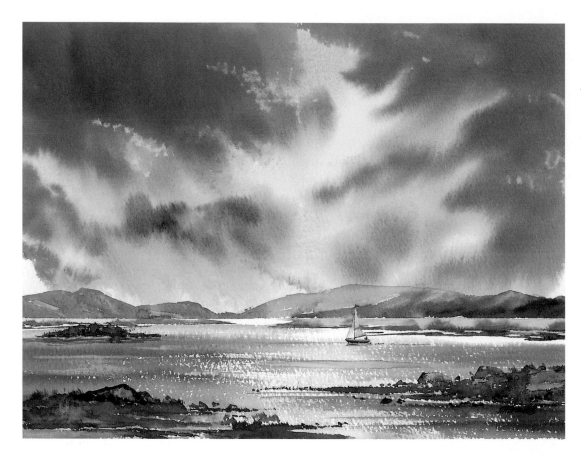

*In **Lone Sailor** the silhouettes of the foreground rocks and the sailor contrast with the fading light.*

I want you to use your imagination to try to capture this scene in paint. Don't aim to copy the colours I have used exactly – refer to them only as guides. Make the painting your own and have some fun with it.

Soft Light *contrasts with the painting above, the light soft and diffused, providing a glowing background to this autumn scene. I painted the sky by initially applying a pale Raw Sienna wash to wet the whole of the painting. In the sky, I brushed in soft purple mixes made from Payne's Grey and Alizarin Crimson, adding lots of water to produce the pastel colours. While the paint was still wet, I brushed in some pale grey to represent distant trees.*

The ivy covering the base of the trees was painted by stippling various green tones with a round-ended hog-hair brush. This brush was also used to stipple in the foreground texture after the initial wash had dried. (For detailed instructions on painting tree structures, see pages 42–43.)

The sea is calm, the day's fishing is over and the light is quickly fading. The scene depicted in **Resting** *was completed in 40 minutes on the coastal road near Mallaig in Scotland.*

An initial Raw Sienna wash was applied to the sky area with a hake brush. I added a little Alizarin Crimson as I worked towards the horizon. When the underpainting was approximately one-third dry, the clouds were painted using mixes of Payne's Grey and Alizarin Crimson. The same colours were used to paint the water.

The boat was added to balance the darker cloud formations in the left-hand side of the painting, but it's the sky that establishes the atmosphere and mood.

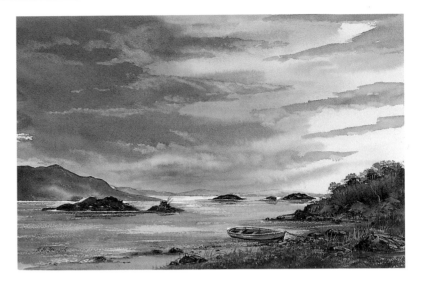

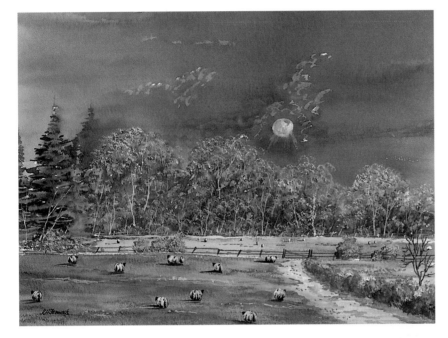

The treetops and a distant field are illuminated in **Moonlight***. I began by painting the full moon with masking fluid. When this was completely dry, I painted the sky by wetting the paper with clean water, using the hake brush, and followed this with washes of French Ultramarine with a little Alizarin Crimson added. A tissue was used to create a few white cloud shapes. When the rest of the painting was completed, the masking was removed and the shadows on the moon were painted. Note that the path was painted by retaining the white of the paper and adding a little colour here and there. It's an important feature, leading the eye into the painting and up to the moon.*

Walk on the Beach *shows a glorious sky lighting up the landscape. I used a range of colours to capture it. In addition to soft Cerulean Blue and Raw Sienna, with a touch of Gold Ochre for the underpainting, I used a combination of Payne's Grey/Cerulean Blue and Burnt Sienna for the clouds. A tissue was used to soften the edges and create a few white clouds. The sea was painted with a hake brush. I put in the rocks initially by applying washes and then created the shapes by moving paint with a palette knife. Note the shadows over the sand – such little touches improve a painting.*

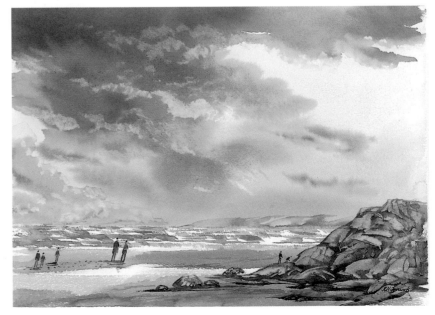

The scene depicted in **The Garden in Bloom** is one that I felt I just had to paint, as a reminder of my visit to Bodnant Gardens in Wales. The soft blue sky contrasted beautifully with the colourful azaleas and rhododendrons. I remember sitting on a seat, thinking how peaceful it was. The painting provided the opportunity to use some imaginative techniques to achieve the end result.

1 Drawing and masking

I drew a rough outline with a dark brown water-soluble crayon and, using masking fluid, masked the tree structures using a twig for the trunks and a cocktail stick for the finer lines. These tools were disposable, which saved me the effort of having to remove the masking from brushes. I used a stippling action with a crumpled piece of greaseproof paper dipped in the fluid to mask the foliage. To paint the sky, I poured a Cerulean Blue wash over the area, followed by a Permanent Sap Green wash over the areas of foliage. Both of these washes were pre-mixed in ceramic saucers.

2 Building up tone

In order to represent shadows in the foliage, I waited until the washes in the first stage had completely dried and then poured a dark tone of pre-mixed Permanent Sap Green/Burnt Umber over the lower half of the painting.

3 Removing masking and painting the bushes

After removing the masking from the trees and bushes above the bridge by means of a putty eraser, I painted in representations of azaleas and rhododendrons. The colours I used were mixes of Raw Sienna, Cadmium Yellow Pale, Alizarin Crimson and Burnt Sienna, applied with a size 6 round brush.

4 Removing masking, painting flowers and water

The masking was removed from the lower half of the painting and the flowers were painted with mixes of French Ultramarine, Alizarin Crimson, Raw Sienna, Cadmium Yellow Pale, Payne's Grey and Burnt Sienna. Payne's Grey and Alizarin Crimson provided a darker tone as shadows in the foreground bushes. The stream was painted using various tones of a Cerulean Blue/Payne's Grey mix.

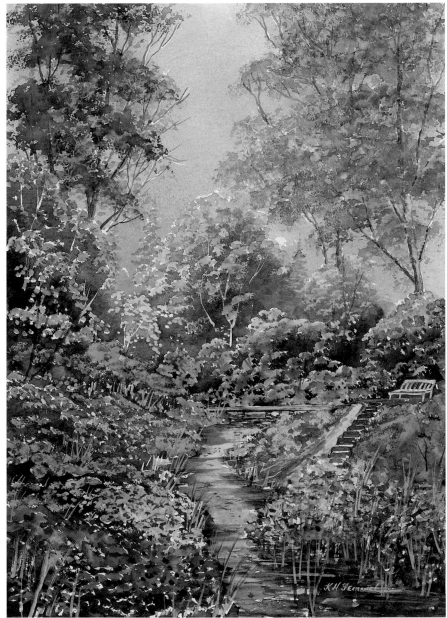

5 Final stage

To complete this painting the background trees were added, using darker tones of green for the left-hand tree and lighter tones for the right-hand tree. A range of soft yellow greens and darker greens were mixed using Cadmium Yellow Pale and Permanent Sap Green. A natural sponge dipped in the mixes was used to stipple in the foliage, while the tree structures were painted with a rigger brush loaded with Burnt Umber.

The colours used

 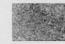

| Payne's Grey | Cerulean Blue | Alizarin Crimson | Raw Sienna | Burnt Umber | Cadmium Yellow Pale | Permanent Sap Green | Burnt Sienna |

There's an old saying that goes 'Labourers work with their hands, craftsmen work with their hands and their head, and artists work with their hands, head and heart.' This is particularly relevant when creating atmosphere and mood.

Emotions can be stirred by a fast-flowing river, the beauty of falling snow, the effect of light, children playing on a beach or the excitement of colour in a landscape.

Creating atmosphere and mood isn't just attempting to capture a sense of drama such as wind-blown clouds over a dominant mountain structure. It may be a sense of peace and tranquillity, a pastoral scene or the shape of trees in a particular setting. It's whatever stirs our emotions and provides us with a sense of excitement, contentment, fascination or awe – and it's the artist's role to attempt to capture that special moment in time, using the tools at his or her disposal.

Diagonal lines provide a sense of movement, as in a wind-blown sky. Vertical lines suggest a sense of awe and power, such as in tall buildings or high mountains. Horizontal lines suggest a pastoral scene. An atmospheric effect can be subtle or bold but the overall effect should be representative of the place you are painting and sympathetic to nature.

In the following pages, I'm going to show you how to paint a wide range of atmospheric effects and encourage you to use your imagination to create paintings that will give you many years of pleasure and satisfaction.

Painting is rather like making a cake – gather all the ingredients together in the best mix and create your masterpiece.

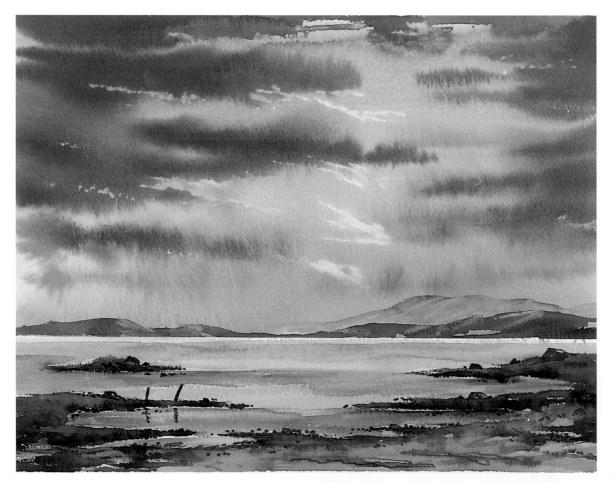

I painted the evening sky in **From the Road to Mallaig** *by initially applying a Cerulean Blue wash at the top and adding a Raw Sienna/Alizarin Crimson mix as I approached the horizon. When the underpainting was approximately one-third dry I painted the clouds, using the hake brush loaded with a dark-toned Payne's Grey/Alizarin Crimson mix.*

Points to remember

- Try to create a wide range of atmospheric effects.

- Use your imagination.

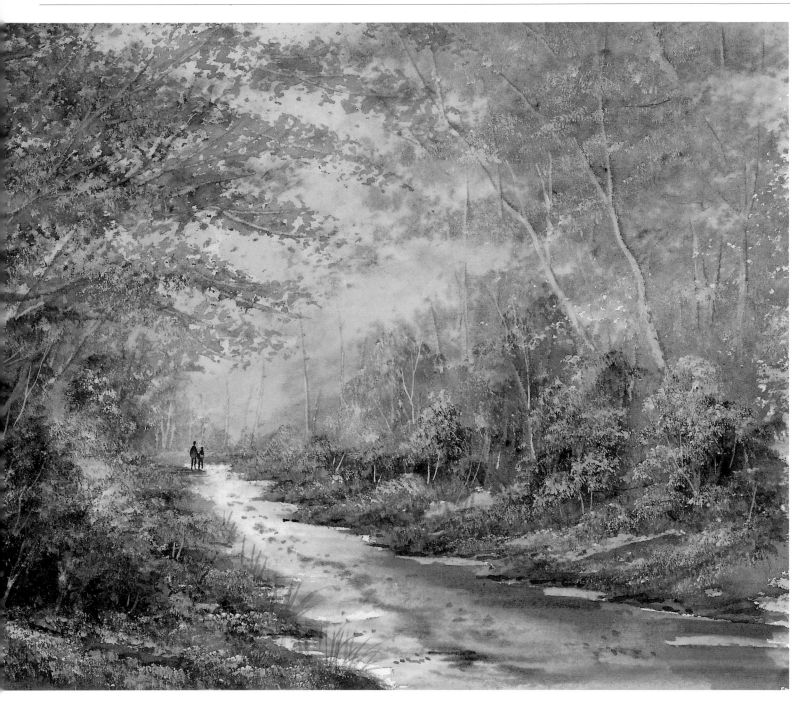

The tonal values on the left side of this typical woodland path in **Green Harmony** *are darker than those on the right. In the distance the colours are paler and cooler, taking the viewer's eye down the path into the painting. The walkers are the focal point and have been placed to direct the eye.*

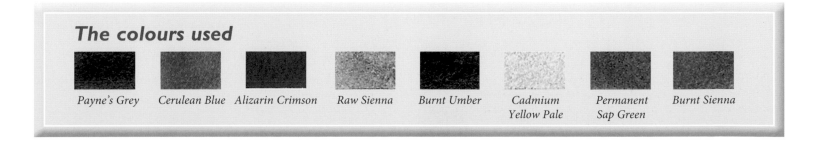

The colours used

| Payne's Grey | Cerulean Blue | Alizarin Crimson | Raw Sienna | Burnt Umber | Cadmium Yellow Pale | Permanent Sap Green | Burnt Sienna |

It can be an informative and enjoyable experience to paint the same scene at different times of the day. The changing light has significant effects on the landscape, creating contrasts in atmosphere and mood. Compare these paintings of the same scene in early morning, at midday and in early evening.

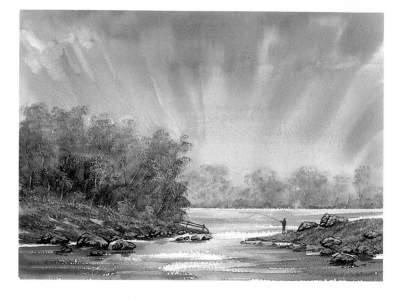

Early Morning *Blue-green mixes and simple washes were used here to clearly define the time of day.*

The shadows are ill-defined, and the subtle distinctions between the elements lack sharpness. The colours tend to a bluish green and there's a suggestion of mist that will quickly disappear as the sun rises.

I painted a wet-into-wet sky, using Cerulean Blue, and added a weak Permanent Sap Green to the blue to paint the distant trees. Various tones of these two colours were used to paint the foreground trees and bushes, the land and also the water.

Midday *The clarity of this landscape suggests that it's noon. Any early morning mist has been burnt off by the warmth of the sun. A division between the lights and darks can easily be seen. There's a greater contrast in colours and tones because the light is stronger.*

I used combinations of French Ultramarine, Cadmium Yellow Pale, Raw Sienna and Payne's Grey for the trees and painted warmer colours in the land areas. The sunlight is reflected in the water.

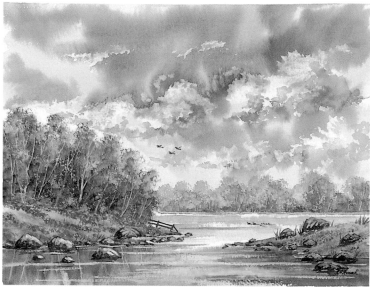

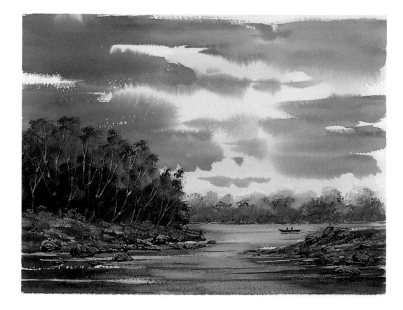

Late Evening *The sun is beginning to set. The elements are silhouetted against the warmth of the sky and there's less detail to be seen. The water reflects the colours of the sky. Night is rapidly approaching. In a short time the landscape will fade into darkness. Everything is at rest; the birds have gone to roost and the fishermen are enjoying peace and quiet, away from the stresses of life.*

The colours I used to paint this scene were Cadmium Yellow Pale, Raw Sienna, Alizarin Crimson and Burnt Umber.

Exercises

- *Select a local scene, within your present competence level, and paint it at different times of the day. Make notes of the principal differences in terms of light, cloud structures, colour contrasts, tonal values and sharpness.*

- *Take lots of photographs of interesting cloud formations to build up a resource from which you can draw as and when required.*

- *Study the effect rain clouds have on the colours in the landscape.*

- *Choose a landscape painting in this book and paint it as if it were a depiction of another season.*

- *Practise painting sheep, figures and boats.*

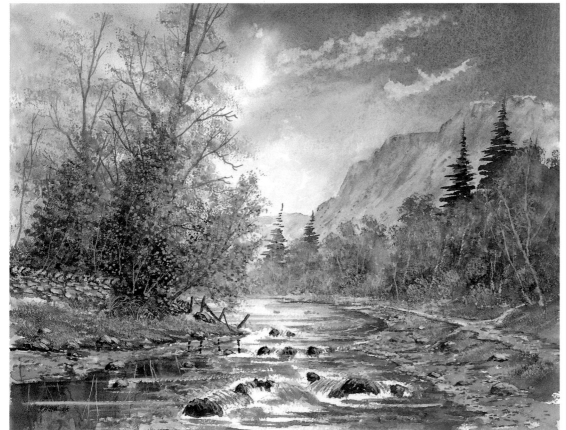

Autumn Light *depicts the changing colours of autumn. Note the variety of colours in the foliage and the effect of light in the atmospheric sky radiating over the mountain range.*

Because this is a back-lit subject, shadows are cast in the water.

Points to remember

- An atmospheric effect can be subtle or bold, but the overall impression should be representative of the region and sympathetic to nature.
- When painting early morning, shadows are ill-defined and the subtle distinctions between the elements lack sharpness.
- In the evening shapes become silhouettes against a soft, warm sky.
- The sky sets the scene in a painting, creating atmosphere and mood.

- Fog and mist cast a veil over distant objects; colours are softened and the elements appear diffused. Distant fog or mist can be emphasized by adding a little more detail and colour to the foreground than can actually be seen.
- When painting snow, always establish the value relationships between the sky and its reflections in the snow.
- To paint rain, apply a wet initial wash, paint in the cloud colours, lift the board and tilt it to encourage the paint to run in the direction required. When you are satisfied with the result, lay the board flat and allow the paint to dry naturally.

The sky establishes the atmosphere and mood in a painting. The effects of light in the landscape are vital to bring your watercolours to life. Don't forget that practice makes perfect – you're not expected to get it right first time.

When I want to emphasize the effects of light in the landscape in order to create atmosphere and mood, I take photographs that depart from the usual conventions. Rather than having the sun behind me, I will shoot looking directly into it. While the landscape in the photographs will print much darker, the contrasting lights and darks will be very distinctive. I experiment with different camera settings and then assess the results.

Try this approach for yourself. When you come to apply paint to your subject, it will be up to you to create the atmosphere and mood you want.

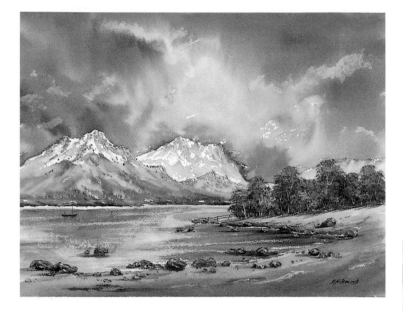

The sky in **Scottish Loch** *was painted with the same technique as that used in* **Snow Capped**. *The colours used were Raw Sienna, French Ultramarine and Alizarin Crimson.*

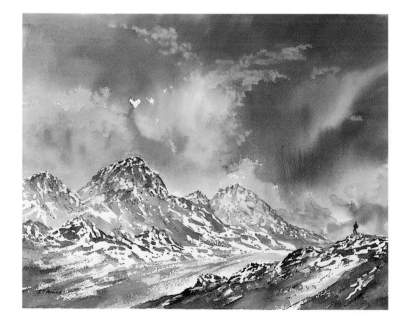

Snow Capped *is a dramatic sky painted with a hake brush. A circle of Cadmium Yellow Pale was painted to represent light radiating from the sun. Mixes of Cerulean Blue/Payne's Grey and Alizarin Crimson were used to paint various tones of colour in the sky. While the paint was still very wet the paper was tilted to allow the colours to flow and blend together.*

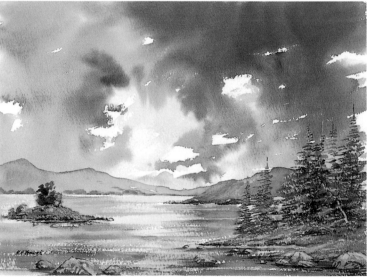

The dramatic sky in **Not Quite There** *was painted in less than four minutes. A greater variety of colours and tones was used for this sky study than for the other two shown on this page: Raw Sienna for the underpainting, followed by Cerulean/ French Ultramarine mixes and Payne's Grey/Alizarin Crimson to create the darker tones. A few white clouds were created by removing paint with an absorbent tissue.*

A sky full of rain is possibly the easiest type to paint with watercolours. Attach your paper to a board and lay it flat, apply a very wet wash of a pale tone of Cerulean Blue or Raw Sienna and, while the paper is still very wet, brush in dark tones of Payne's Grey mixed with Raw Sienna, Burnt Umber or Alizarin Crimson at the top of your paper. Immediately lift up the board and paper and, holding them almost vertical, tilt them in the direction required to encourage the paint to flow. Watch the result as you do this, and once the paint has run sufficiently to create the effect you're looking for, lay the paper perfectly flat and let the paint dry naturally. Use a tissue to soak up any unwanted pools of colour at the bottom of the sky. It's as easy as that. This technique was used for both of the paintings shown below.

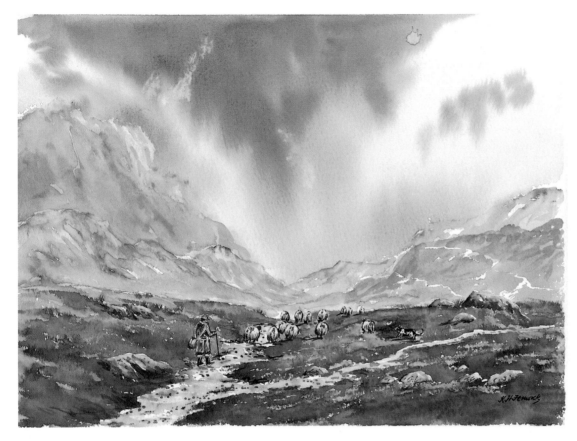

Homeward Bound *was started in the English Lake District while my wife held an umbrella over me. Such weather conditions encourage speedy work.*

For the sky, I quickly brushed in a weak Cerulean Blue and added a little Raw Sienna in selected areas, followed by a Payne's Grey/Raw Sienna mix. The shepherd and sheep were painted in my studio later.

The House on the Moor *offers you an opportunity to practise the technique I use for depicting a rainy landscape. Although the technique is very easy, timing is important. Only experience through practice will teach you how to get this right.*

To paint the sky, wet the area initially with a weak Raw Sienna or Cerulean Blue, and use a mix of Payne's Grey/ Raw Sienna for the clouds.

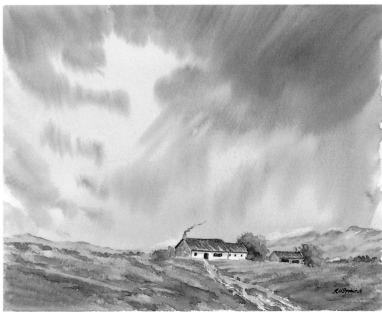

Wet and Windy is full of atmosphere and mood. The rain is streaking down. The distant mountains are barely discernible through the torrential rain and this gives them a ghostly appearance. It's not the day to be out and about. The smoke from the chimney indicates that those living in the croft are of the same opinion. I think you will enjoy painting this scene.

The sky

I fastened the paper to the board and laid it flat before painting the rain clouds. I used a hake brush to apply a very wet Cerulean Blue wash to the whole of the sky area. While the underpainting was still wet, a strong mix of Payne's Grey with a little Burnt Umber added was brushed into the top of the sky. The board was immediately lifted and angled vertically to allow the paint to run down the paper. Once the desired effect was achieved the board was laid perfectly flat and the paint left to dry naturally.

Mountains and buildings

The mountains were painted using the hake brush loaded with a pale grey mix of Payne's Grey/ Alizarin Crimson, also used to paint the foreground. While still wet, some Raw Sienna and a little Burnt Sienna were brushed in using the round brush. The colours were allowed to blend together. The roofs of the buildings were painted with Raw Sienna and Raw Sienna/Burnt Sienna washes. The doors were painted using Alizarin Crimson. The windows and shadows were mixes of Payne's Grey/Alizarin Crimson.

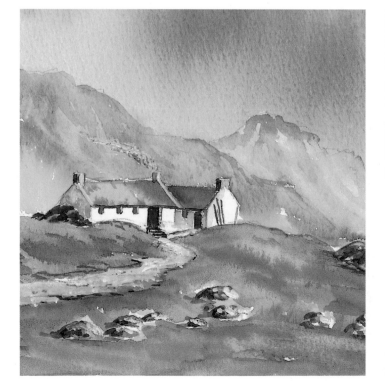

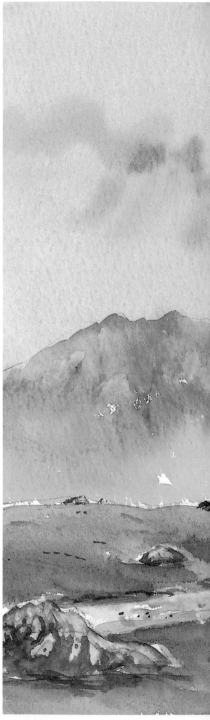

Atmosphere

In this painting the atmosphere is created almost entirely by the rain clouds and their effect on the landscape.

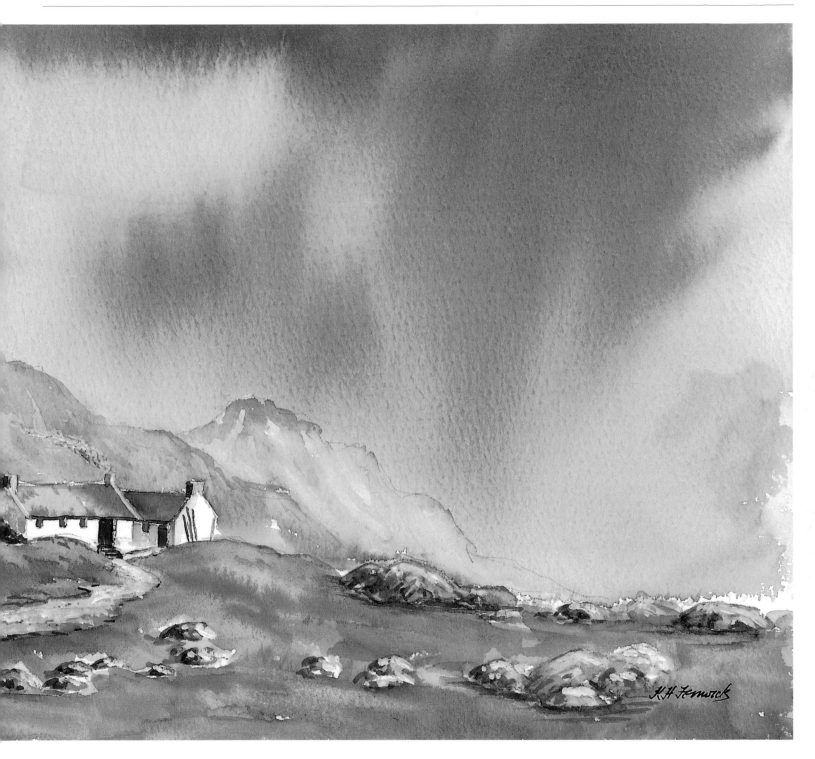

Rocks

After removing the masking the rocks were painted using Raw Sienna as an underpainting and Payne's Grey/Burnt Umber for the shadows. Highlights were made by removing paint from the tops of the rocks with a tissue rolled to a point. Dark shadows were painted under the rocks to make them look more realistic.

Fog and mist cast a veil over objects in the distance and colours appear soft and diffused. It's important to keep distant values light in tone and add a little more colour and definition in the foreground. The foreground must be more sharply focused than it appears in reality in order to give emphasis to the mist or fog in the background.

The sky for **Lakeside** *was painted wet-into-wet, by applying a weak Cerulean Blue wash and brushing in some Alizarin Crimson. I continued working downwards and painted the water using the same colours. While the paint was still wet, I painted the distant mountains and the trees in the middle distance, wet-into-wet, to achieve a soft diffused look. The fir trees were painted with a stiffer Permanent Sap Green, then I used a tissue to remove some colour and soften the tree grouping. Reflections using very pale colours were added to the water while the paint was still wet. When the paint was dry the land and rocks in the foreground were painted in more detail to lead the viewer's eye into the painting.*

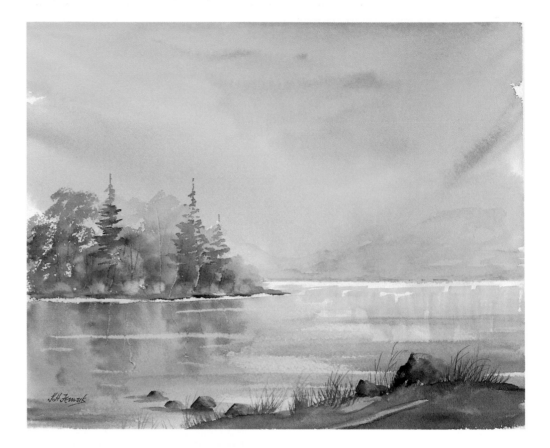

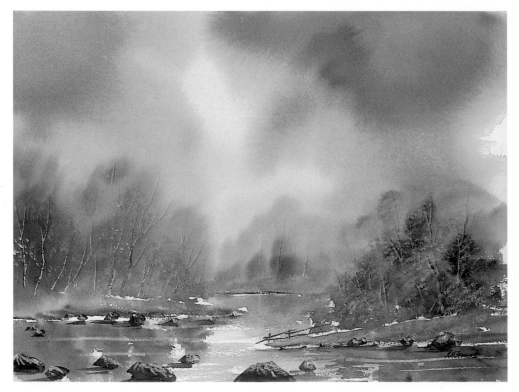

Mist on the River *depicts an early morning scene, with the sun struggling to shine through the mist. The sketch has been painted wet-into-wet to achieve the soft, filtered-light effect that is so necessary when painting mist or fog. My aim was to create a hazy atmospheric effect. The colours used were Cadmium Yellow Pale, Raw Sienna, Payne's Grey, Alizarin Crimson, Cerulean Blue and Burnt Sienna.*

When painting snow it's important to establish the value relationships between the snow and the sky. Snow isn't always white, just as the sky is not always a pretty blue. Leave the paper untouched for the whitest snow. The washes used for the sky can be transferred to the snow area to create the shadows reflected from passing clouds.

Snow scenes don't have to look cold. You can use soft washes of Cerulean Blue for a cold scene, a purple hue made from Payne's Grey or French Ultramarine and Alizarin Crimson for a slightly warmer effect, and for warmer sunlit snow you can apply a Raw Sienna glaze over a blue or purple underpainting. Show some stubble, tufts of grass or even the odd rock protruding through the snow to add interest.

In the following two examples, you'll notice how important the skies are to the success of the paintings.

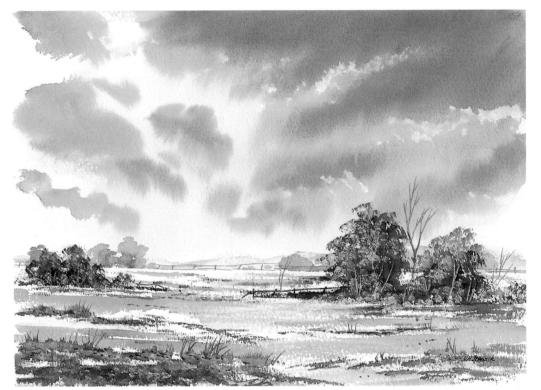

Early Snow *depicts the first coating of snow on the landscape. The subject is back-lit; I have painted a little Raw Sienna into the sky to reflect this, and have also transferred some of this colour into the snow lying on the fields. Note how I have achieved recession by painting the trees and bushes in the far distance in cooler pale tones.*

To paint the stubble and vegetation showing through the light covering of snow, I used the edge of a hake brush, touching the paper lightly with an upward flicking motion.

In **On Thurstaston Hill**, *a favourite beauty spot in the Wirral, where I live, I have used the sky colours of Payne's Grey and Alizarin Crimson to paint the path and the pool of water on the right. This was important to achieve colour harmony in the scene. The white of the paper has been left uncovered to represent snow at ground level. I used a little white acrylic paint to stipple the effects of snow on the trees and foreground gorse bushes.*

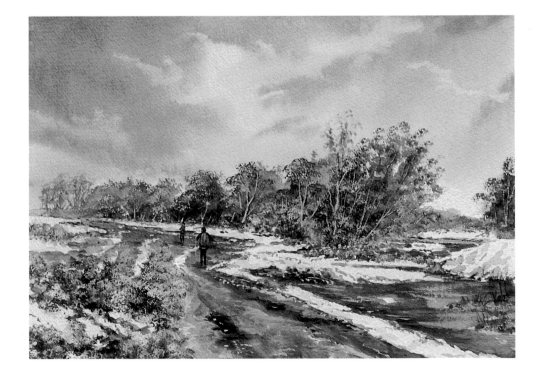

There's nothing quite like a walk in the woods on a crisp winter's day – nature in all its glory is a joy to behold. **Woodland Walk** is one such scene, providing the opportunity to incorporate a soft atmospheric sky, a wide variation in the colours of winter and the effects of a light dusting of snow on the landscape. This is the type of scene I love to portray. In this case I used acrylics to paint it.

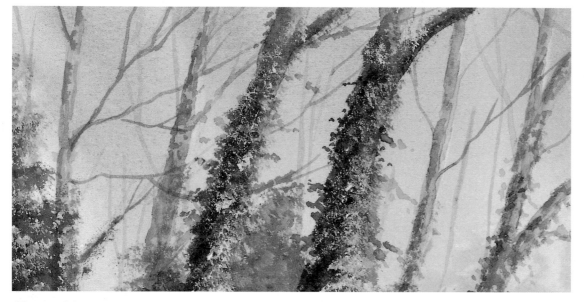

Sky and ivy

I painted the sky by initially applying a pale Raw Sienna wash over the sky area with a hake brush. Using downward strokes, I then brushed in Cerulean Blue, starting on the left and gradually changing to a soft purple as I worked my way across to the right of the painting. I left some of the Raw Sienna uncovered to represent the sun breaking through a diffused background. When the paint was approximately one-third dry, I painted the distant trees, using a stiffer mix of Payne's Grey/Permanent Sap Green to achieve a blurred effect to lead the viewer's eye into the distance.

The ivy on the trees was painted with a hog-hair brush using a stippling technique; dark tones of Burnt Umber/Permanent Sap Green were applied, followed by a paler, brighter green and finally white paint stippled on to give the effect of snow.

Trees and shadows

Using a rigger brush, the trunks and branches were initially painted with pale Raw Sienna. When the paint was approximately one-third dry, some dark tones of Burnt Umber were added to make the branches look realistic. The soft purple mix for the sky was also used to paint the shadows on the path, applied with the side of the round brush.

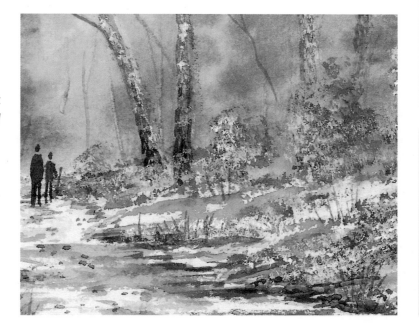

Snow

Using white acrylic paint is only one way of representing snow. There are other techniques to try: see page 87.

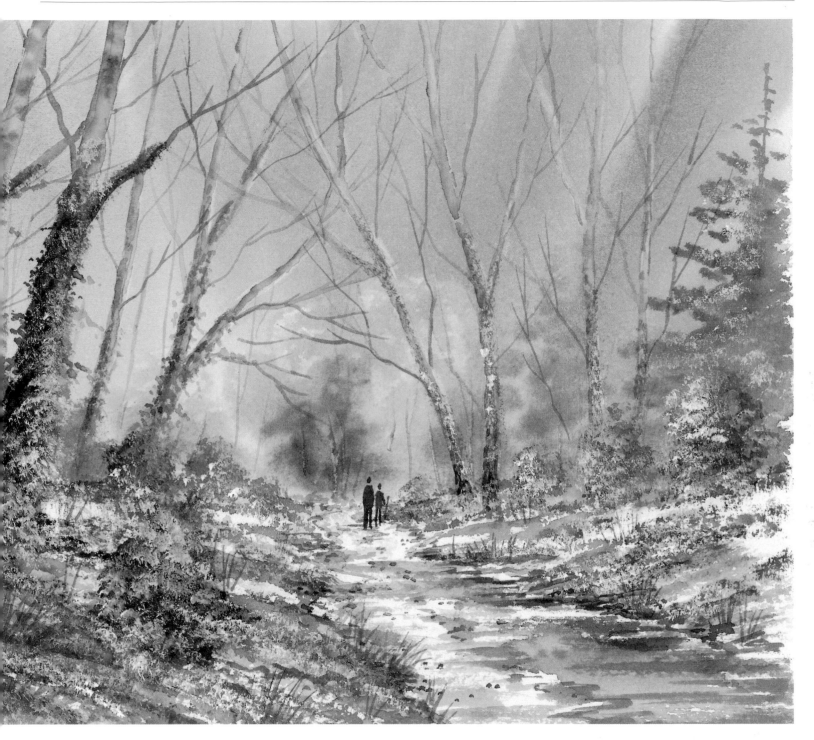

Foreground texture

I lightly stippled a variety of colours using the edge of a hake brush, and left some white of the paper uncovered. I applied soft greens and Raw Sienna in the main and added a small amount of Payne's Grey for the darker tones. Finally, a little white has been stippled with a hog-hair brush to soften areas where the snow has drifted into the stubble.

We've already seen how useful it can be to include a feature in your painting other than what nature provides in the shape of the elements and the landscape. Many of the more common details are easy enough to paint. Here are some simple methods to try.

Sheep

When you come to paint sheep, think horseshoes. If the sheep is looking to the right, add a second horseshoe to extend the body to the right and then a triangle for the head. Naturally it is the same process reversed if the animal is looking to the left – extending the body to the left and adding a triangle for its head. I use Payne's Grey/ Burnt Umber to block in and then overpaint with either white acrylic paint or gouache. It's essential to add shadows beneath your sheep to make them look realistic.

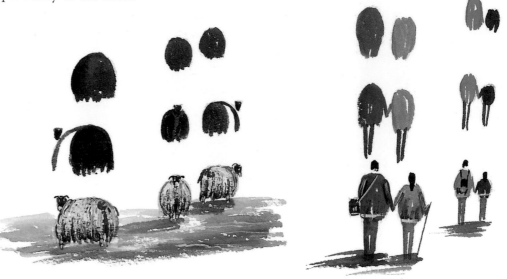

Figures

So you think you can't paint figures? If you follow the steps shown, you'll find it easy. Before adding figures to your painting, it's a good idea to draw them first on clear film or tracing paper using a felt tip pen and then place this over your painting to determine the best position for them.

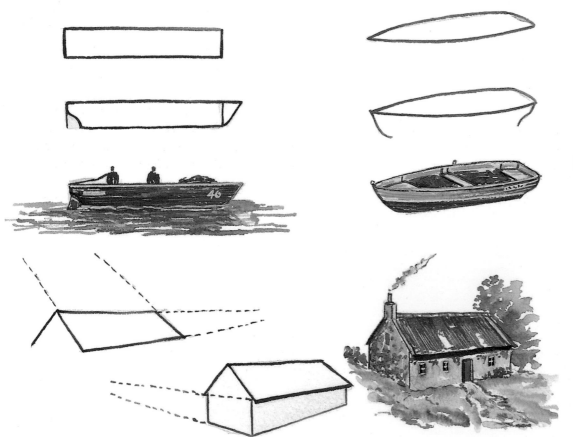

Boats

Follow the simple stages shown and soon you will be competent to add boats to your paintings.

Buildings

Here I have simplified the painting of a building. The dotted lines are included to help you simplify your drawing and show you how vanishing points go off into the distance. Linear perspective is the key to making your buildings look realistic.

To become a successful artist it's essential to understand tonal values, which I believe to be the most important contributing factor to painting a successful landscape.

All paintings need contrasts of tone and the balance between lights and darks arranged in relationships that enhance the quality of the painting. Many beginners tend to splash paint on without any preliminary thought about the design of their painting, and as a result what they produce looks flat and uninteresting.

Utilizing tonal values

The following are two distinct ways in which tonal values can be successfully utilized in a painting, to ensure that your work never looks flat:

Counterchange is an effective way to highlight the principal subject matter in a painting, such as the focal point. By emphasizing lights against darks and vice versa, interesting features can be made more distinctive. Examples could be surrounding the light in a sky with darker contrasting tones of colour to make the light source appear brighter; painting a light-toned figure against the dark background of a building; or painting dark trees behind the light-toned roof of a building.

Gradation occurs when a colour gradually changes, either from a light tone to a darker tone or the reverse. Examples could be the transition in colour from foreground grass to that in the distance or the transition in colour from wet to dry sand on a beach.

It has always been my practice to clarify my thinking by producing small tonal sketches, using a dark brown water-soluble crayon. These sketches are only 7.5 × 10cm/3 × 4½in in size and display little detail. Their purpose is to help me choose the best view of the landscape I am about to paint and to establish the best combination of light and darks. These tonal studies are simple scribbles but are vital to the success of my painting. If you produce tonal sketches to clarify your thinking before you apply paint, I guarantee that your paintings will improve significantly.

Autumn Fields *was painted on a warm early autumn day. The focal point was the lone tree on the left. Darker tones were painted into this to make it more distinctive. Note the variation in tonal values in the grass areas, necessary to create realism in the scene. The distant trees were painted in lighter tones to achieve recession. The variety of colours and tones in the right-hand tree grouping gives structure and depth to the painting, while the dark posts and bush on the left-hand bank balance the larger tree grouping on the right.*

How to transfer an outline drawing of a completed painting onto watercolour paper

The next technique is not a substitute for learning to draw and should only be used until you are competent at drawing.

1. Take a black and white photocopy of the painting to the size required.

2. Using a soft pencil (6B), scribble across the back of the photocopy.

3. Position the photocopy over your watercolour paper, then trace around the outline and key features using a biro or 2H pencil.

4. Remove the photocopy. The image will have transferred to your paper ready for you to apply paint.

Peace and Tranquillity depicts Scotland's salmon country. I was inspired by the atmospheric sky and the variety of tree species. The mountains provided the backcloth to the painting.

The only problem I encountered when painting this scene was presented by the many rocks in the river, which were time-consuming to paint.

I hope you enjoy painting this scene.

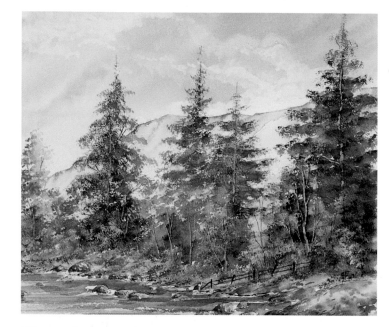

Fir trees

Fir trees are quite easy to paint; simply use a flat brush and stipple, working upwards from ground level. As you stipple, rock the brush from side to side to define the shape, using more of the corner of the brush as you progress up each tree. Varying tones of Permanent Sap Green and Payne's Grey were used.

A number of bushes were painted in front of the fir trees to add variety of height, tone and colour. Some highlights were added to the foliage on the fir trees where the light reflected, using a mix of Cadmium Yellow and Permanent Sap Green with a little acrylic white added.

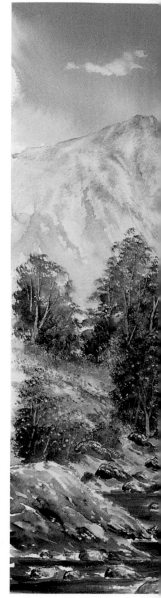

Sky and mountains

The sky is an important feature in this painting. The light from the sky softened the mountain structure and created sparkle on the surface of the water.

Skies such as this are easily painted. Apply the usual Raw Sienna wash and brush in the cloud shapes with, in this case, varying tones of blue. To create the light effects, dab out some of the colour with a tissue to produce the feathery white clouds.

The mountains were painted with a hake brush, using sweeping directional strokes from peak to ground level. Shape your mountains by means of a tissue formed into a tight wedge, creating light areas by applying downward strokes at an approximate angle of 45 degrees following the structure of the mountain. The colours used were Raw Sienna, Payne's Grey and Permanent Sap Green.

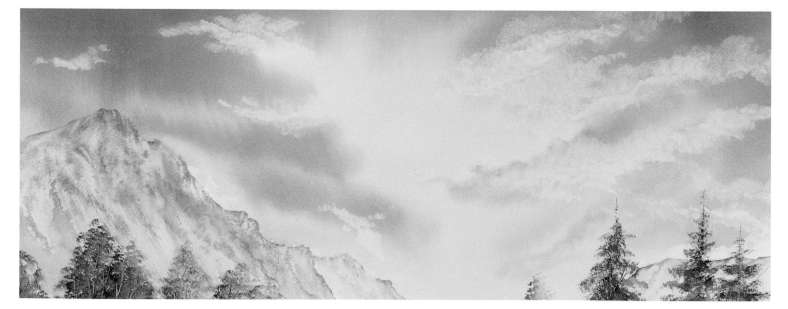

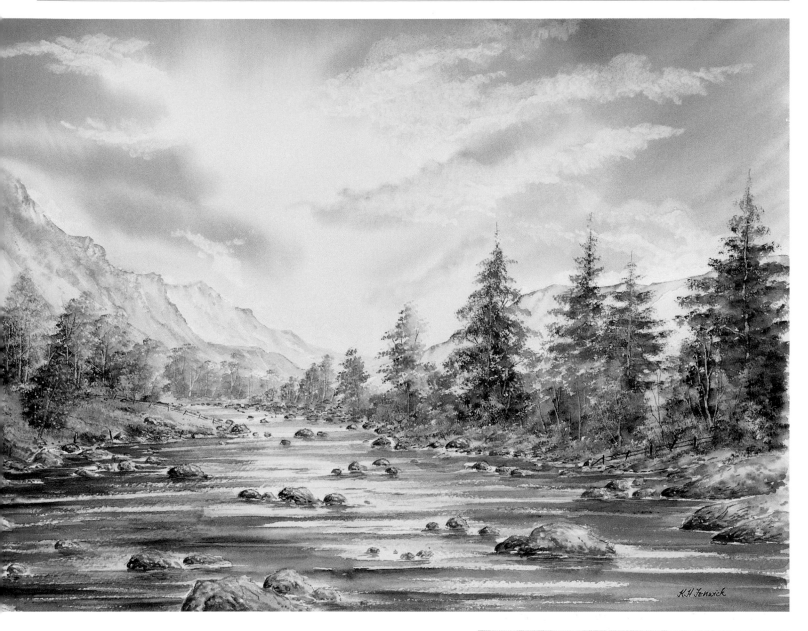

Trees, rocks and running water

On the left bank were various young trees, their leaves changing colour
as autumn approached. I stippled with a round hog-hair brush to create
realistic-looking foliage, using mixes made from Raw Sienna, Burnt Sienna,
Permanent Sap Green and Payne's Grey.

When painting water it's a useful technique to partially close your
eyes to allow observation of the various tones more clearly. A hake brush
was used to paint the water with Cerulean Blue/Payne's Grey mixes,
taking care to leave lots of white paper uncovered to represent the light
shimmering on the water.

A flat brush is ideal for shaping rocks. Paint a few of them at a time,
applying a wash of Raw Sienna, followed by darker tones of Burnt Umber
to give them shape. Don't forget to paint shadows under the rocks or
they will look as if they are floating on the surface. This attention to detail
distinguishes the more experienced painter from the beginner.

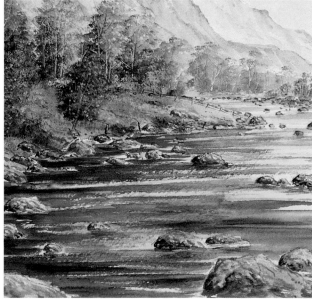

When writing my books, it is never my intention to attempt to impose a style of painting on anyone, but rather to show different techniques which will allow you to stamp your own style on your paintings with both confidence and pleasure. I like to think of an artist's style as being akin to handwriting in paint. You may wish to paint in a loose, free style or perhaps represent the landscape in detail. Over time you will develop your own style of painting – it can't be imposed on you.

Woodland Beck incorporates all the techniques described in this book. I used acrylics, but I could have used traditional watercolour paints just as easily.

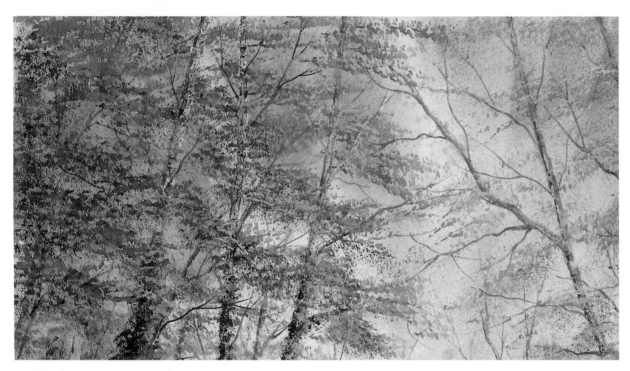

Foliage

After the tree structures were drawn in, the foliage was painted by initially stippling dark tones of a Payne's Grey/Permanent Sap Green mix. When this dark underpainting was dry, lighter greens were stippled over it. I turned to a round hog-hair brush of the type used for oil painting for this technique. The beauty of acrylics is that you can easily work light to dark or dark to light.

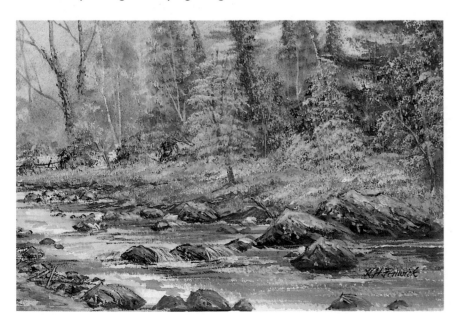

Water

Initially I painted the fast-flowing water between the rocks. This was done by dipping the hairs of a round brush in Payne's Grey and then fanning them between thumb and finger to create irregular sections. The fine hairs were then quickly brushed between the rocks, which had the effect of leaving paper uncovered to represent the running water.

I used a round, pointed brush with mixes of Payne's Grey and Cerulean Blue to add a variety of tones to complete the beck. The strokes were horizontal in direction. A little Raw Sienna was brushed in to represent reflections from the background light.

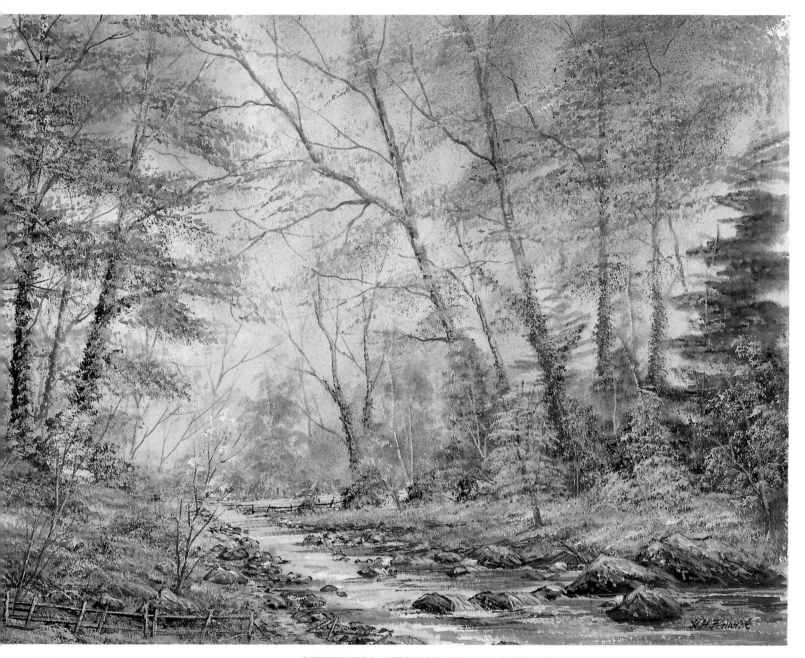

Texture

There's considerable detailed texture in this painting to reflect the plant life you find when walking through woodland – tufts of grass, young bushes and saplings and, in this case, a carpet of bluebells.

Over the years, I have experimented with various brushes to achieve a natural look for depictions of a woodland floor. I find that stippling with an old hog-hair brush gives my preferred result, and I've used this method here.

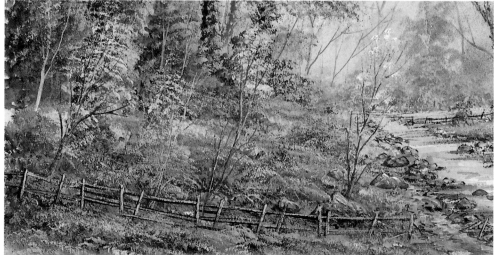

All artists who are truly dedicated to their work continually experiment with new techniques to create paintings that stir their emotions. You may be fired to capture a sense of realism or the beauty of nature's creation, or simply to complete a painting with which you are happy.

Experimentation is important if you want to be able to call on a wide range of techniques in your paintings. I have been able to produce several interesting landscapes by using different techniques, such as controlling the flow of paint with masking fluid or masking tape, pouring paint from saucers, scumbling, glazing, knifing out or spattering.

Autumn Flow is one such painting. I'm delighted to have the opportunity to show you some of the techniques I used to paint it.

1 Masking and pouring

An initial tonal study was completed and the outline of the painting drawn. Masking fluid was applied by brush to the mountains and the water and to the foliage with a crumpled piece of greaseproof paper. A cocktail stick dipped in masking fluid was used to draw the tree structures.

The sky was painted with a hake brush loaded with mixes of Cerulean Blue and Alizarin Crimson and then allowed to dry.

The mountain was painted using a weak mixture of Payne's Grey and Alizarin Crimson and allowed to dry.

Washes of Raw Sienna, Burnt Sienna and Payne's Grey were pre-mixed in ceramic saucers and poured over the tree areas after the tops of the rocks had been masked out with a piece of masking tape to prevent the washes from running below this line. The board was tilted to allow the washes to run slowly and merge together. The paper was then laid flat to dry, with a hair dryer eventually used to ensure the paint was completely dry.

2 Establishing tonal values

Further pourings of the paint added depth to the trees. When this was dry the rough shapes of the fir trees were painted with a flat brush loaded with a Permanent Sap Green/Payne's Grey mix. The distant fir trees on the left were painted using a weaker mix.

3 Removing the masking

The distant mountains were given more definition by applying a Payne's Grey/Alizarin Crimson wash. When this was dry a putty eraser was used to remove the masking from the mountains and the areas of foliage.

Painting the rocks was a very easy process and came next. Washes of Raw Sienna followed by Burnt Sienna, Burnt Umber and Payne's Grey were applied to selected areas. A palette knife was then used to shape the rocks. The paint wasn't applied with the knife but simply moved around to create the shape of the rocks. At the end of each stroke of the knife the build-up of paint left a dark edge, representing shadows. The paper wasn't damaged by this.

Finally the masking was removed from the waterfall and the waterfall was painted in a Payne's Grey/Cerulean Blue mix, using light strokes with a hake brush following the direction of flow. The rocks projecting through the water were painted using a flat brush loaded with the colours used previously.

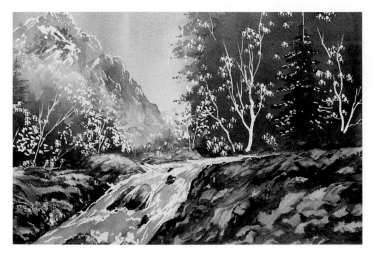

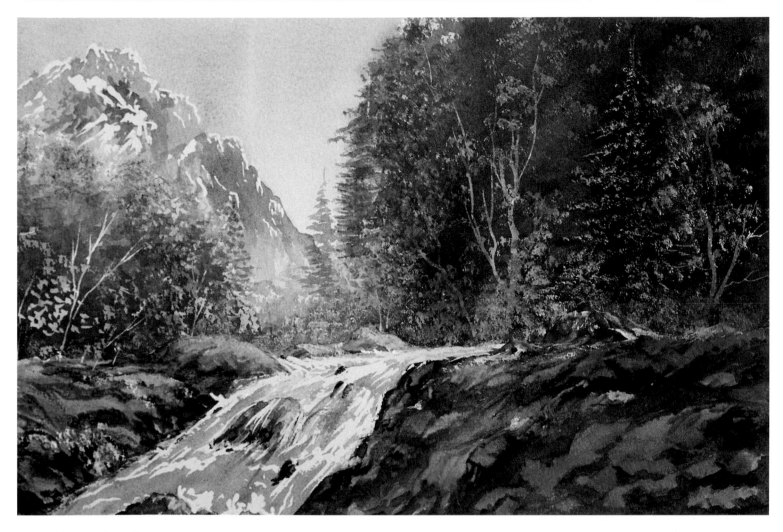

4 Adding detail

It was time to bring the painting together and add the finishing touches. Raw Sienna, Cadmium Yellow Pale and Burnt Sienna glazes were applied to the foliage and tree structures. These same glazes were also used to colour the rocks and create depth of tone.

Highlights to the foliage were then applied. Paper masks had to be first cut to shape to protect other areas, such as the sky; I used a piece of mounting card cut to various profiles to fit around the trees. To apply the paint, I took an old toothbrush, dipped it in Cadmium Yellow Pale, then ran my thumb over the bristles to spatter the colour onto the foliage.

Taking time to get it right

I rarely complete a painting in one sitting. I prefer to work on it over several days, looking at it critically and making any changes I feel are necessary. I might remove paint to lighten areas or apply glazes (a little paint mixed with lots of water) to improve the variation of colour and tone.

Using the above process, I have been able to produce several interesting landscapes and enjoy this different approach to painting. I recommend you try these methods. Above all, have fun and enjoy your painting.

The colours used

| Payne's Grey | Cerulean Blue | Alizarin Crimson | Raw Sienna | Burnt Umber | Cadmium Yellow Pale | Permanent Sap Green | Burnt Sienna |

The subject of buildings covers a very wide field. Because they come in a variety of shapes and forms, buildings offer the watercolourist an exciting range of opportunities. In this book, I have attempted to reflect this range by showing you my approach to painting many different types of building, from old farmsteads to medieval castles.

I am fascinated by the structure of buildings and the textures you find in them. An interesting window, an old door with rusty hinges, a stairway or an element in a street scene with people, all are worthwhile subjects. You don't have to paint a complete landscape to get a rewarding watercolour.

To paint buildings well, it's important to be able to sketch and draw reasonably accurately to represent the scene effectively. I felt it was necessary, therefore, to include in the text some basic instruction on how to draw. Drawing isn't difficult, just common sense, but there's an approach to drawing that I follow, which I will explain in the following pages.

Perspective plays an important part in the drawing of buildings. Some people find perspective easy to understand, others don't. If you are one of the latter, don't worry – you will find perspective simplified for you on pages 104–5.

Paintings don't just happen, they need to be designed, and if you learn how to do this your end result won't be just a matter of luck. You will discover that you must establish a plan using your imagination, asking yourself what the main features in your chosen picture are and how you can emphasize them. Tonal values, colour, texture and contrast all play a part in this.

In the exercises and demonstrations in this section, I will be describing and showing how all this is done.

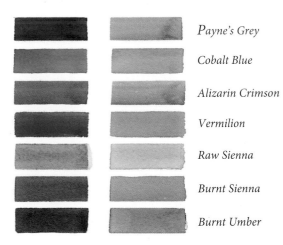

Payne's Grey

Cobalt Blue

Alizarin Crimson

Vermilion

Raw Sienna

Burnt Sienna

Burnt Umber

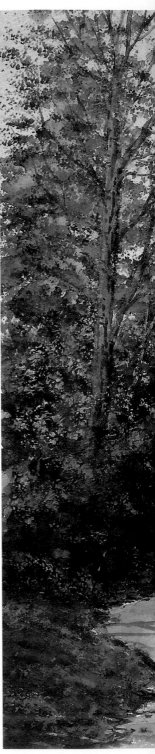

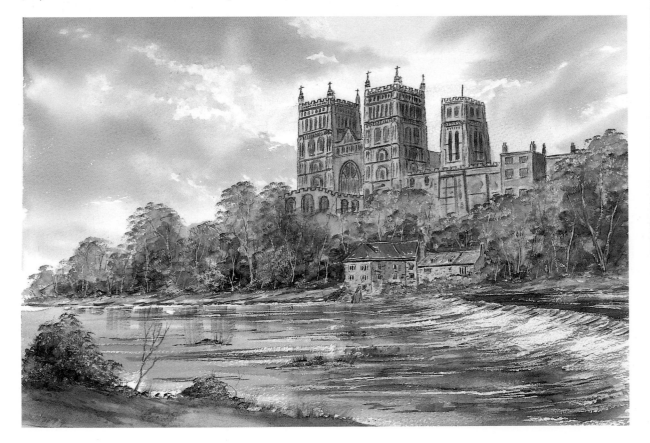

Majestic **Durham Cathedral**, *overlooking the River Wear in the north of England, makes a lovely scene to paint.*

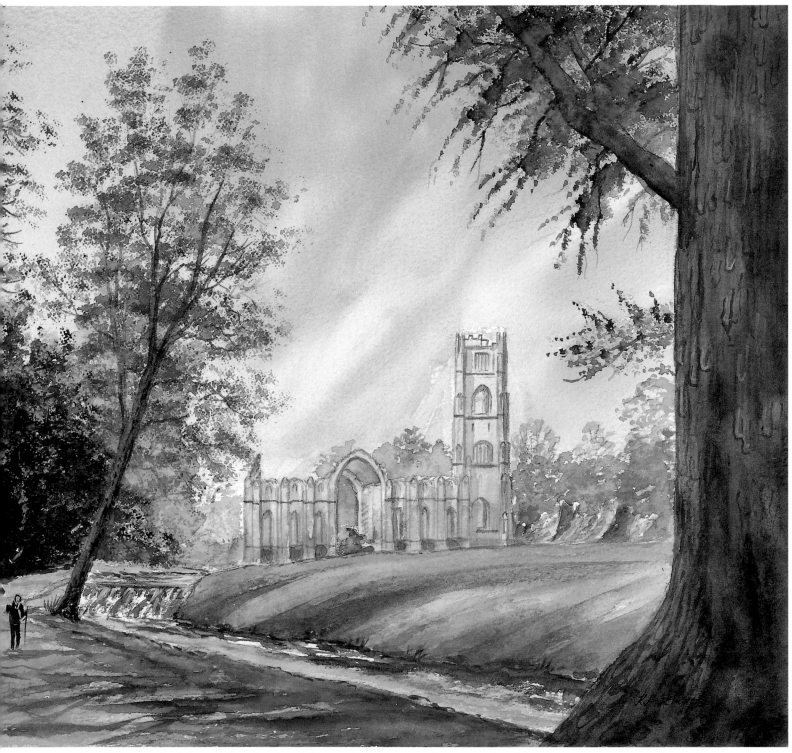

Fountains Abbey *in Yorkshire. When I painted this scene the sun was shining on the abbey, throwing it into stark relief against the heavy shadows in the trees and across the path.*

Practice

- Study the examples in this book and practise painting wet-into-wet skies to represent the various light situations.
- Practise colour mixing, using the colours specified in the text.
- Practise using an eraser to remove colour, creating shafts of light as in a woodland glade or an atmospheric sky.

There's no substitute for sketching and drawing. No matter how good you are at applying paint, if your initial drawing is out of scale and your perspective is wrong the end result will be a failure. Draw, draw, and draw again is the answer.

The sketches I produce when on location are not intended to be masterclass drawings but quick doodles to act as a record of my visit to an area or as a simple outline direct on to watercolour paper ready for applying paint at a later date. The amount of detail you include in your sketches or outline drawings and the techniques you use to create texture will depend on the particular subject, the time available for drawing or the intended use of the finished work. Knowing when to stop will come with experience.

Sketching and drawing is a pleasant and relaxing experience which forces you to think about your subject and observe it very closely. When you have been sketching and drawing for some time you will no longer think about your style but concentrate on the statement you are trying to make.

Windmills near Amsterdam.

Drawing materials

How you interpret your subject is personal, whether you use pencil, crayon, charcoal, conté crayon, felt tip pen or drawing pen and ink. My personal choice includes 4B and 6B pencils, water-soluble crayons and drawing pens (sizes 0.5 and 0.7mm). For both pencil and pen work, I like to use 2 ply Bristol board, which has a bright white surface. When using water-soluble crayons, I find the fine texture of an oil or acrylic painting pad is perfect for creating shading and textures speedily.

Approaches to sketching

I find that many of my students just want to paint without first spending time observing their subject, simplifying the scene and studying the relationships of darks and lights, the direction of light and shadows and the scale of the various elements in the scene. Consequently, they go on to waste a perfectly good piece of watercolour paper.

Beginning with a drawing instead provides you with thinking time and the opportunity to produce several sketches that will help you to discover the viewing point you should choose for the best composition. Try to spend three minutes observing and thinking to every minute drawing or painting.

Using a viewfinder

We all have our likes and dislikes; we sketch subjects that appeal to us and and try to express what we feel about them at the time. A viewfinder can help us to select what is most important to us and is useful for identifying potential scenes from different viewpoints. It's very easy to make your own viewfinder, which you can cut from a piece of mounting card. The one I use has an aperture of 7.5 × 11.5cm/3 × 4½in.

When you view a scene, get into the habit of looking at it in terms of the lines, colours, textures, tonal values, shapes and contrasts. Don't think of what you see as buildings, trees, mountains, and so on – that will limit your imagination.

Quick sketching

When I visit an area I make quick sketches, supplemented by photographs, from which I can produce a completed painting on my return to my studio. Sketching and drawing on location with limited time sharpens your observation of the scene. It encourages you to simplify, discarding unnecessary detail that doesn't contribute significantly to the overall representation.

Squinting your eyes to view the subject will help to establish the lights and darks, eliminating unnecessary detail. As an artist, you must create your own composition using your imagination and skills to simplify and organize your subject in accordance with the principles of good design.

The poet Wordsworth's home at Grasmere in the English Lake District.

A view of the medieval city of Bruges in Belgium.

The initial black and white sketch or drawing is an important aspect of planning before you begin applying watercolour. Through your tonal studies you can determine the most attractive composition and work out your values and shapes. Use artistic licence, if necessary, to improve your composition. Simplify and prepare your drawing loosely or in detail. I prefer to draw on to my watercolour paper with a dark brown water-soluble crayon because I do not like to see pencil marks in a finished painting. When I draw faintly with the crayon and apply my watercolour washes, the lines will wash out.

Both of the sketches here were drawn with a drawing pen and shaded with a water-soluble crayon.

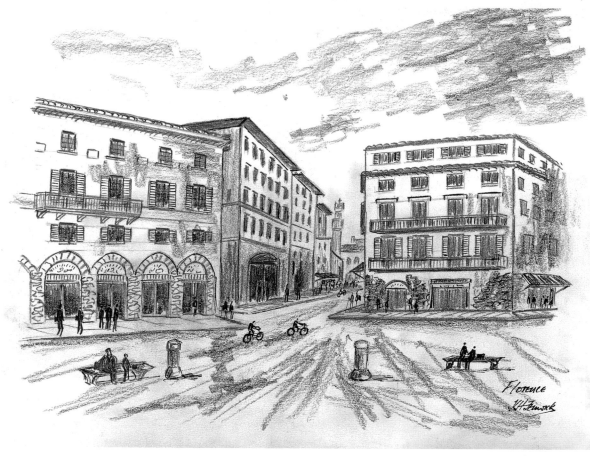

Drawing a street scene

For this street scene, follow the same procedure as that given for drawing the Grand Canal opposite.

Take particular care getting the perspective of the roofs, footpaths and windows right. Each block of buildings has a different vanishing point.

Getting the size right

Drawing isn't difficult provided you follow a logical procedure. When drawing a complex scene, where a significant number of buildings are involved, for example, always use a piece of watercolour paper that is larger than is actually required.

Draw in your buildings and then trim your painting to size. There's nothing more frustrating than running out of paper before you've drawn all of the buildings. Using a larger sheet and trimming to size until you've mastered the art of drawing to scale will avoid the frustration of having to erase what you've done and virtually begin again.

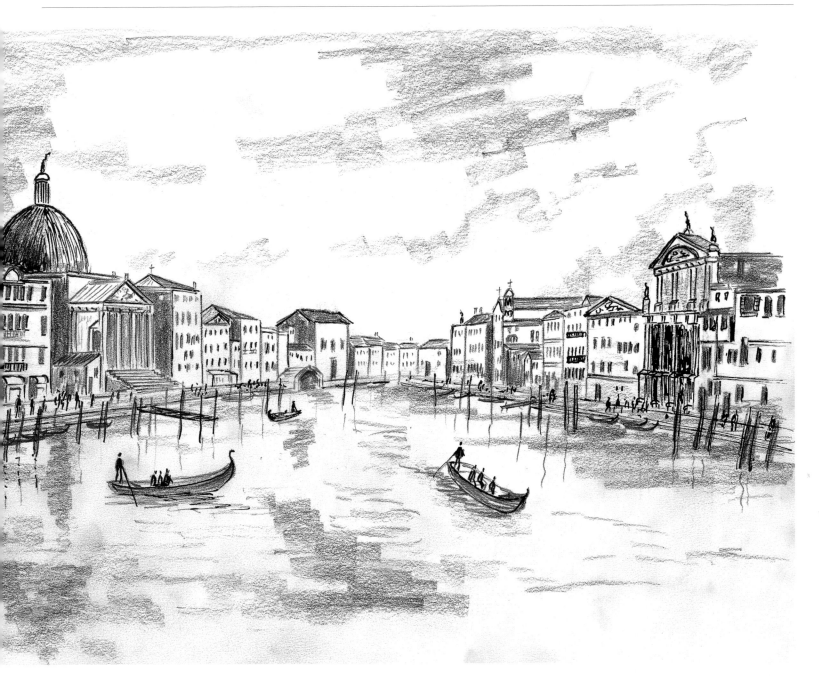

Drawing the Grand Canal, Venice

When drawing any group of buildings, there's a logical procedure I follow. If you adopt this approach you will be able to draw most scenes realistically. The procedure:

- *Commence by establishing the angles of the water level and the vanishing point.*

- *Draw one building in the scene first, making sure the height of the building is in proportion to its frontage.*

- *Draw in the vertical lines of all other buildings, taking care that the length of frontage of each building is in proportion to that of the adjoining buildings.*

- *Draw in the height of each building in proportion to its frontage and the height of its neighbours.*

- *Hold your pen or pencil at arm's length and line it up with the angle of the roof, then move your arm down towards your paper to determine the correct linear perspective.*

- *Finally, draw in the windows, steps, balconies, and so on.*

It's as easy as that. Following this logical procedure will ensure that your buildings are drawn to scale in the correct proportions. If your buildings are out of proportion and your perspective is incorrect, no matter how good you are at applying paint the result won't be pleasing.

Perspective is an important consideration if you want to make your drawings of buildings look believable. Most of my students find perspective difficult. Let's see if we can simplify the subject.

When you look at a scene, the area where your eye meets the horizon will always be your eye level, known as the horizon line. This will naturally change as you lower or raise your viewpoint.

In the first diagram we are looking straight at our subject from a viewpoint slightly to the left, enabling us to see the gable end of the building. The lines of the roof, windows and ground level converge to one point on the right; this is known as the 'vanishing point'. From the gable end of the building, lines will converge to a vanishing point on the horizon line to the left; this is known as two-point perspective.

In the second diagram we are looking down at our subject. Our eye level is higher than the building. The same principles apply, though.

When painting outdoors, all you have to do is hold a pen or pencil directly in front of you and line it up with the top of the roof. Move your arm down to your paper and draw in the angle. Repeat this process with other parts of the building to establish the correct perspective.

An even simpler technique is to cut an aperture from a piece of mounting card and position some elastic bands around the perimeter. View your subject through the aperture. Line up the elastic bands with various elements of the building such as the roof, windows and base and, transferring this card to your paper, draw along the elastic bands to ensure the correct linear perspective.

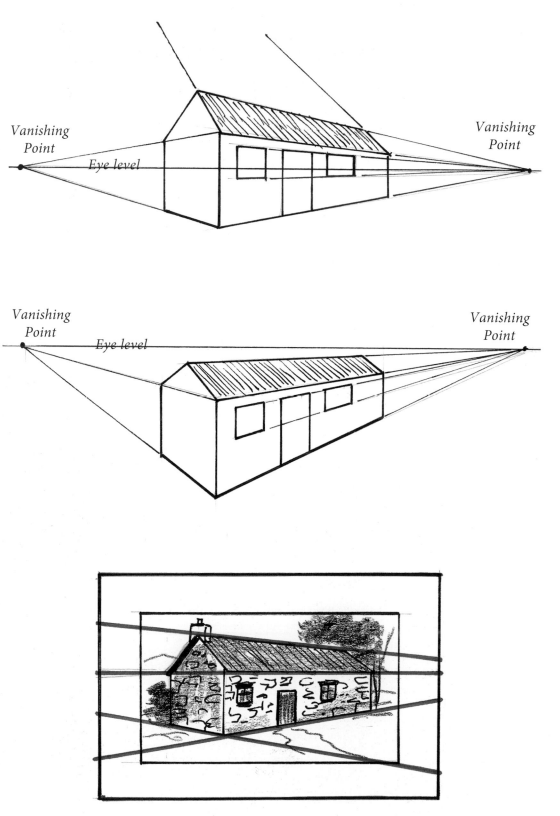

Vanishing Point Eye level Vanishing Point

Vanishing Point Eye level Vanishing Point

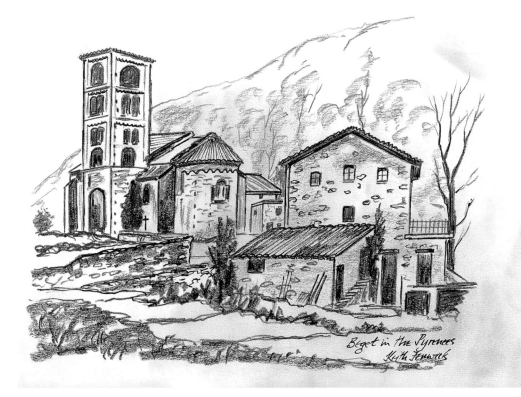

Note the perspective in this quick sketch of the old village of **Beget in the Pyrenees**. The angles at the top of the tower in particular are good examples of linear perspective.

Beget in the Pyrenees
Keith Fenwick

This sketch of **The Creek** near Salcombe in Devon, England, was a lovely scene to draw and paint. My students found the perspective quite challenging. The roofs of the thatched cottages highlight the need for the perspective to be correct if the sketch is going to work.

The Creek - NR Salcombe, Devon 2002

One of the beauties of watercolour is its transparency, making it an ideal medium to create textures on buildings. Buildings come in many shapes and sizes and offer the artist numerous exciting features to paint. The rough texture of stonework, the watermarks, cracks, crumbling plaster and weathered exteriors can all make fascinating subjects to capture in watercolour, using a limited range of pigments.

The texture on the stonework surrounding this window in Brittany was painted by initially applying white and dark brown oil pastels to areas of white paper. A Raw Sienna wash was applied to the whole of the stonework and while it was still wet, Burnt Sienna and a Payne's Grey/Alizarin Crimson mixture was selectively applied. The deposits of oil pastel repelled the watercolour washes, creating the textured effect. Finally, the shadows around the individual stones were emphasized using various tones of Payne's Grey.

Window in Morbihan - Brittany

Image of Provence

I have attempted to capture the weathered exterior of this old apartment in Provence by initially wetting the paper with a pale Raw Sienna wash and while this was still wet dropping in some Burnt Sienna and a Payne's Grey/Cobalt Blue mixture. The colours have been allowed to blend together wet-into-wet. Using a size 6 brush, I moved colour to create the effect of weathering.

Round chimney - the sign of an old building - note the dovecote

I was fascinated with this old building in the English Lake District. The round chimney signifies its age. Note too the dovecote at the base of the chimney, leading in to the roof area. The brickwork was painted white and weathering had created some surface stains. I applied a weak Cobalt Blue wash to selected areas and when this was dry I indicated the brickwork using a rigger brush loaded with a Payne's Grey/Cobalt Blue mix. I drew the bricks on the chimney at a slight curve to indicate the round form. Note how the dormer window fits into the roof – you will need to get the angles right to make a window like this look convincing.

Victorian Postbox at Wasdale Head

I couldn't resist painting this old Victorian postbox housed in a rough stone wall in the hamlet of Wasdale in the English Lake District. The postbox was painted using various tones of an Alizarin Crimson/Vermilion mix to look realistic.

The texture on the stonework was achieved by initially drawing the outlines of the stones and making deposits with both white and cream oil pastels. A Raw Sienna wash was applied overall and splashes of Burnt Sienna and a mix of Payne's Grey/Alizarin Crimson were applied wet-into-wet. An absorbent tissue was used to lighten the stonework by dabbing to remove paint. The shadows around the stones were painted in last. The oil pastel repelled the watercolour paint, resulting in a weathered, textured appearance.

Cape Town's famous waterfront, with its restaurants, shopping mall, bustling harbour and magnificent Table Mountain as a backdrop, was irresistible as a subject for painting while I was on a recent trip to South Africa. I painted the scene shown here in my studio from sketches and photographs taken from a boat.

Sky and mountain

The simple sky was painted with a mix of Cobalt and Cerulean Blue. Darker washes were applied top left to provide some gradation of colour. A tissue was used to remove paint, indicating a few wispy white clouds. Table Mountain was painted by applying various tones of a Payne's Grey/ Cerulean Blue mix over a Raw Sienna underpainting and creating highlights with a tissue shaped to a chisel edge.

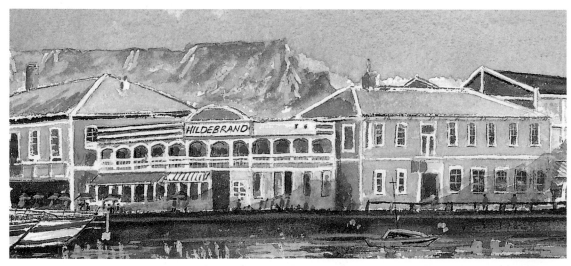

Buildings

The buildings were drawn in lightly with a 4B pencil and masking fluid was applied to windows, doors, balconies, parasols and boats. When it was dry, various washes of Raw Sienna and Payne's Grey were applied. Once these were dry, the masking was removed and the parasols and boats were painted.

Perspective

Spend some time drawing to scale to enable you to get the proportions of each building right. Ensure your perspective is reasonably accurate, otherwise your finished painting will be a failure.

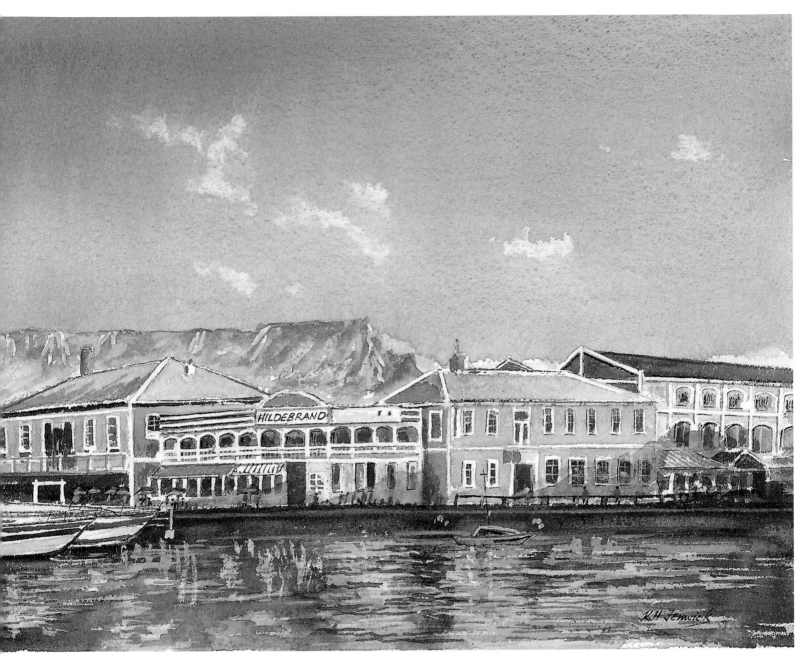

Water and details

Masking fluid was initially applied to the water to represent light reflections. When it was dry, washes of Raw Sienna, Payne's Grey and Cerulean Blue were applied. The masking was removed when the paint was dry, then a pale wash of Raw Sienna was applied.

Finally, the figures were painted and the canopies were coloured blue and green.

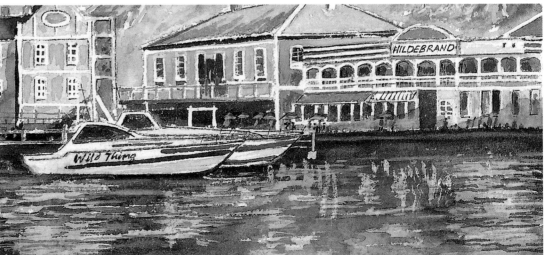

The Grand Canal in Venice has been a favourite of artists over many generations. The most time-consuming aspect of this painting was the initial drawing of the buildings, which I had to ensure were in proportion to one another. The many windows were also a challenge. I used the procedure outlined on page 103 to draw the scene.

1 Preparatory drawing and sky

The water line was drawn in, followed by the verticals of the building, ensuring that the length of frontage of each building was in proportion to that of its neighbour. The height of each building was established in proportion to its frontage. The windows, balconies, canopies and parasols were drawn and masking fluid was applied to maintain the white of the paper. Masking was also selectively applied to areas of the water.

The sky was painted using Payne's Grey, Raw Sienna, Alizarin Crimson and French Ultramarine. The same colours were used to paint the water as a mirror image.

2 Buildings

Artistic licence allowed me to create warmer colours in the buildings than were the reality. Mixtures of Raw Sienna, Burnt Sienna and Alizarin Crimson were washed over the buildings, using a hake brush. Cobalt Blue was then dropped in here and there to indicate weathering. A Payne's Grey/Alizarin Crimson mix was used to paint in the shadows.

3 Windows and details

The roofs were painted using an Alizarin Crimson/Burnt Sienna mix. The windows were painted by applying various tones of a Payne's Grey/Alizarin Crimson mix. While the paint was still wet, a tissue shaped to a point was used to dab the windows, removing paint to suggest reflections of light. The same mixture was painted over the balconies. When this was dry the masking was removed, leaving white areas around the balconies and the windows. Next the masking was removed from the parasols and canopies prior to applying paint. The masking in the water was not removed at this stage.

The colours used

Payne's Grey	*Cobalt Blue*	*Alizarin Crimson*	*Raw Sienna*	*Burnt Umber*	*French Ultramarine*	*Permanent Sap Green*	*Burnt Sienna*

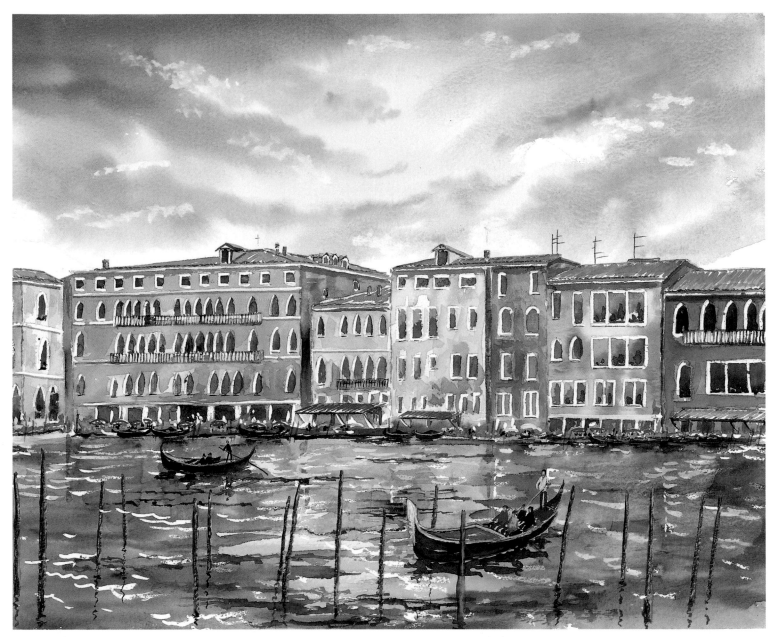

4 Gondolas

Before painting the gondolas I established their best positions by initially drawing their shapes with a felt-tip pen (water-based non-permanent) on a clear acetate sheet and then moving this over the water. Next, the mooring posts were painted in, using Burnt Umber.

5 Water

The water was overpainted using a hake brush loaded with mixtures of Payne's Grey, Cobalt Blue and Permanent Sap Green. When the paint was dry the masking was removed using a putty eraser.

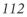

I have painted this boathouse many times. Located on the shores of Lake Ullswater, in the English Lake District, it's a special place where I have spent many enjoyable hours. It's a very peaceful place to sit and paint. My favourite time is in the evening when the tourists have retired for their dinner and I am left with a few swans or ducks for company. Acrylic paints were used for this piece, which was done for a TV programme.

After painting the sky and mountains, I painted the trees, boathouse and shore, leaving the water until last.

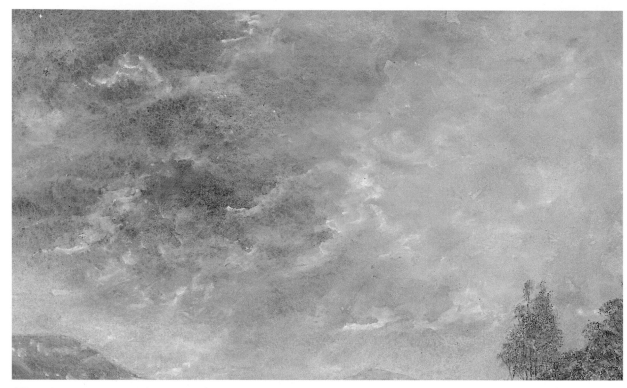

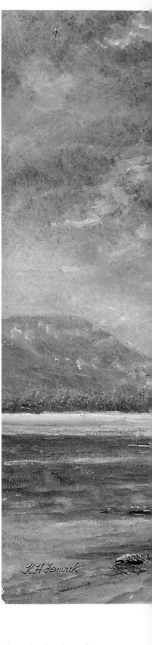

Sky

The sky was a feature in this painting. I used a Raw Sienna wash and then, with a hake, brushed in Payne's Grey and Burnt Umber. When this was dry, I created the white edges to the clouds by wiggling the side of a size 14 round brush dipped in Titanium White.

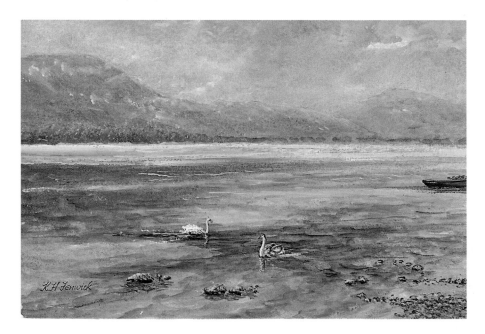

Mountains and water

The mountains were put in with a hake brush after a piece of masking tape had been positioned across the painting to represent the waterline. Raw Sienna and Burnt Umber mixes were used and the row of distant trees was painted by adding a little Permanent Sap Green to the mixture. The masking tape was removed when the paint was dry.

Horizontal strokes with the side of the size 14 round brush were used to paint the reflections in the water over an initial Raw Sienna underpainting while this was still wet. A Payne's Grey/Cerulean Blue mix was brushed in to create variety in the water. The swans were painted last.

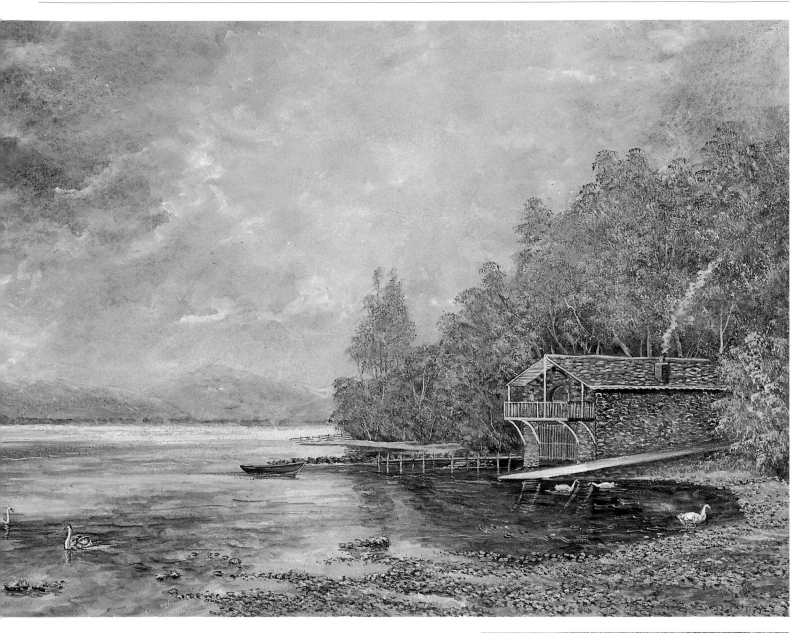

Trees

The trees were painted by initially applying a Burnt Umber underpainting around the drawing of the boathouse. Then I stippled a range of greens, using an old hog-hair brush, to create the impression of foliage.

Boathouse

The stonework on the boathouse and access ramp was completed by applying a Raw Sienna wash and dropping in Burnt Sienna and Burnt Umber wet-into-wet. When this was dry, a rigger loaded with Titanium White was used to create the effect of mortar around individual stones. The balcony entrance and landing stage were then painted. Don't forget the fence in the middle distance; I painted this using a fine rigger brush. I used the same brush for the smoke from the chimney, painted in white over a Payne's Grey underpainting.

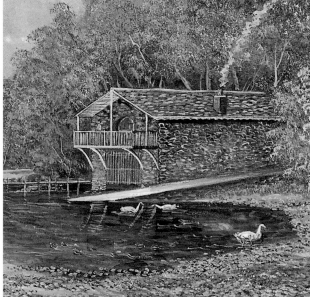

The 14th-century manor house at Lower Brockhampton in Herefordshire, England, is a lovely old timbered building, with a detailed 15th-century gatehouse straddling the moat. I have included this scene as an exercise in drawing because it makes a pleasing composition and is useful practice for drawing in general and perspective in particular. It's important to ensure that the buildings are drawn in proportion and the perspective is correct. Study the angles of the roofs and try to represent them accurately.

Sky

Remember the golden rule: a detailed foreground demands a simple sky. With this in mind, I used my 4cm/1½in hake brush to paint a wet-into-wet sky with Payne's Grey/Cerulean Blue dropped into a Raw Sienna underpainting. A tissue was used to shape the cloud structures.

Water and foliage

The water was painted using mixes of Payne's Grey, Cerulean Blue and Permanent Sap Green. Note the reflections from the trees and buildings. It's not necessary to paint a complete mirror image of the buildings — just include a few of the main factors to indicate reflections. Impressions of a few water-lilies were included. Note the variation in the foliage of the bushes and trees. An old bristle brush was used to create light areas of foliage and flowers on the bushes near the building, using a stippling action. To paint this lighter foliage, add a little white acrylic or gouache to your watercolour paints. If you do this the detail will stay on top of the underpainting, whereas traditional watercolour on its own will sink into the underpainting.

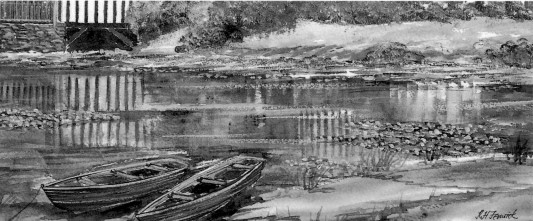

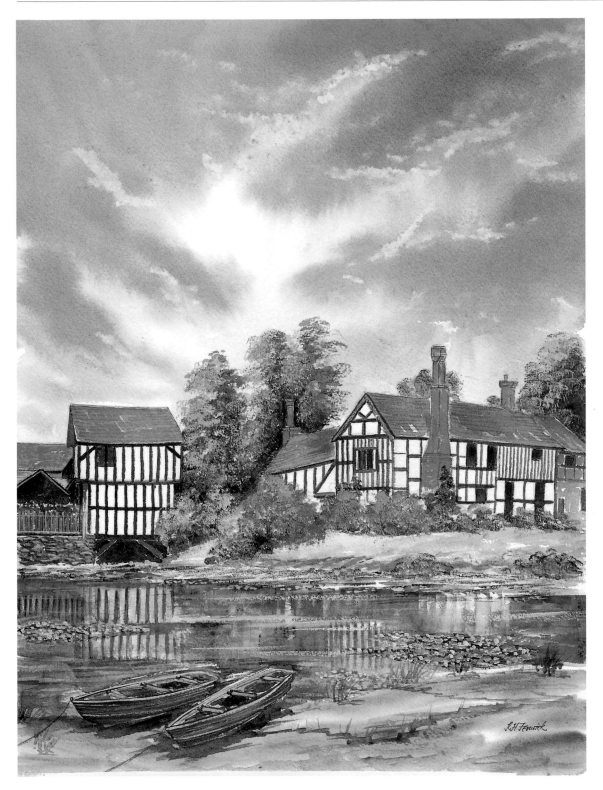

Checklist

- When painting buildings you will need to sit well back in order to fit in the number of buildings necessary to obtain a good composition.

- Never paint a building front-on. You will need to sit slightly to one side to see some of the gable end. It makes a much more pleasing composition.

- Make sure you draw the perspective correctly or your painting won't look realistic.

- Squint your eyes when viewing – it helps to establish the light and dark tones and eliminate unnecessary detail.

Buildings and banks

A Burnt Sienna/Alizarin Crimson mix was used to paint the roofs, chimneys and brickwork. For the extensive woodwork I used a Payne's Grey/Burnt Umber mix, taking care to ensure the perspective was correct. The windows were painted by applying a Payne's Grey/Alizarin Crimson mix and dabbing with a tissue to soften areas. To achieve gradation in the grass banks, I applied a weak Raw Sienna wash and brushed in a mid-green to selected areas, followed by darker green, brushing upwards from the water's edge. The colours will blend together, achieving a subtle gradation in the greens. If you overdo it, use a tissue shaped to a wedge to lift colour and thus create lighter areas.

The old mill at Langstone in Hampshire, England was once a famous spot for landing contraband. It is now a peaceful haven for bird watchers and sailing enthusiasts. I think you will enjoy painting this scene.

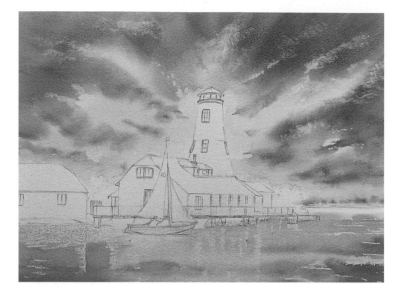

1 Sky

I commenced by drawing the right-hand group of buildings, making sure the mill tower was correct in diameter and height in relation to the building. I took care to ensure that the drawing was in correct linear perspective and each building was in proportion to its neighbour in terms of height, width and length.

Masking fluid was applied to the windows and the railing and to highlight reflections and other areas in the water. The sailor and boat were also masked.

The sky was painted using a 4cm/1½in hake brush and various mixes of Payne's Grey, Cerulean Blue and Alizarin Crimson over a Raw Sienna underpainting. Brush strokes were directed towards the mill tower. The same colours were used to paint the water.

2 Buildings

A Payne's Grey/Burnt Sienna mix was applied to the mill tower and the dark areas at water level. A Payne's Grey/Cerulean Blue mix was used to overpaint the masking on the railings, the front of the pavilion and the windows.

Approximately 20 per cent Alizarin Crimson and 80 per cent Burnt Sienna were used to mix a rich reddish-brown colour for the roofs. The stonework was painted by initially applying a weak Raw Sienna and while this was still wet dabbing in some Burnt Sienna and Cerulean Blue, allowing the paint variations to blend together.

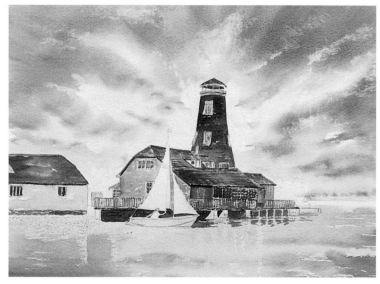

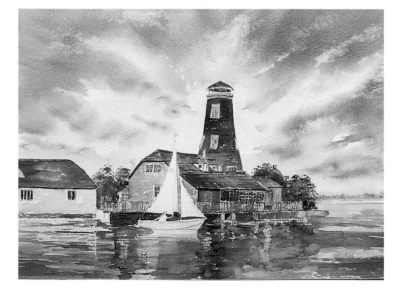

3 Trees and water

The trees in the distance and middle distance were painted using a variety of light and dark greens made from mixes of Raw Sienna and Permanent Sap Green.

More depth was created in the water by applying various darker tones of a Payne's Grey/Cerulean Blue mixture, painting over the masking, which repelled the various washes. The brickwork supports were painted with mixes of Raw Sienna, Burnt Sienna and Alizarin Crimson and some reflections were painted in the water, using the same mix.

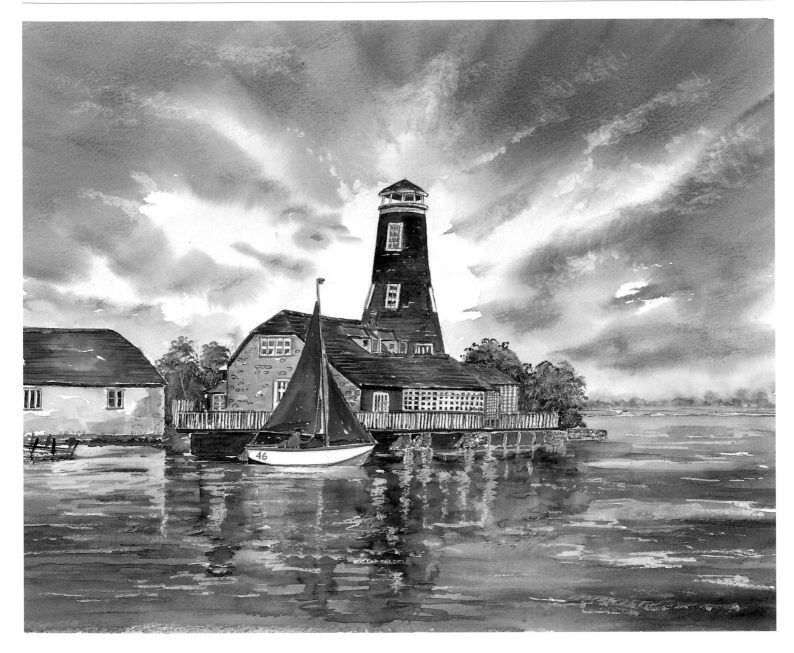

4 Adding detail

The boat was painted after removing the masking with a putty eraser and the sailor added using the rigger brush loaded with dark green. A few posts and the landing stage were painted on the far left using a Payne's Grey/Burnt Umber mix. Finally, highlights were added to the water using a white water-soluble crayon.

The colours used

Payne's Grey	Burnt Umber	Raw Sienna	Cerulean Blue
Alizarin Crimson	Permanent Sap Green	Burnt Sienna	

Bridges and walls are primarily functional creations, though many, both ancient and modern, are built not just for purpose but with an eye to aesthetics too. Bridges come in all shapes and sizes and in a variety of materials from stone and brick to wood, concrete or iron, while walls tend to be in local stone or brick and thus in a range of colours from sandstone to granite.

Generally speaking, walls and bridges made out of modern materials offer far fewer challenges to the artist, and it is for this reason I have concentrated on showing you examples made out of traditional materials such as stone. Many of these are works of art in their design, especially the stone bridges and walls found in country districts, where the traditions that go into their building are often closely associated.

Bridges and walls such as this offer artists wonderful opportunities to exercise their skills. Quite apart from their sheer beauty, they are master works of design and craftsmanship. Over the years I have derived immense pleasure from painting them and I hope you too will be rewarded by seeing the workmanship and ingenuity that has gone into their construction.

In the following pages, I'm going to show you some helpful techniques and give you opportunities to practise them. The colours I find most useful when painting bridges and walls are shown below.

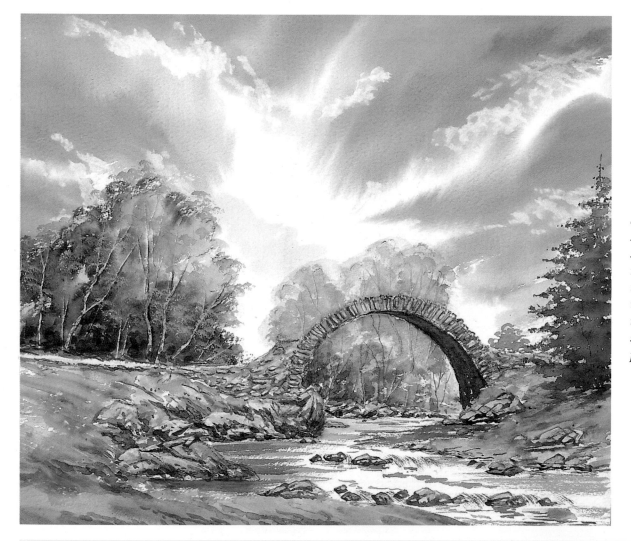

Wades Bridge in Scotland is an unusual shape. Almost a perfect semi-circle, it is a mystery why it needed to be built so high. This uncharacteristic shape in what is a picturesque setting inspired me to paint this scene.

The colours used

| Payne's Grey | Burnt Umber | Raw Sienna | Cobalt Blue | Alizarin Crimson | Burnt Sienna |

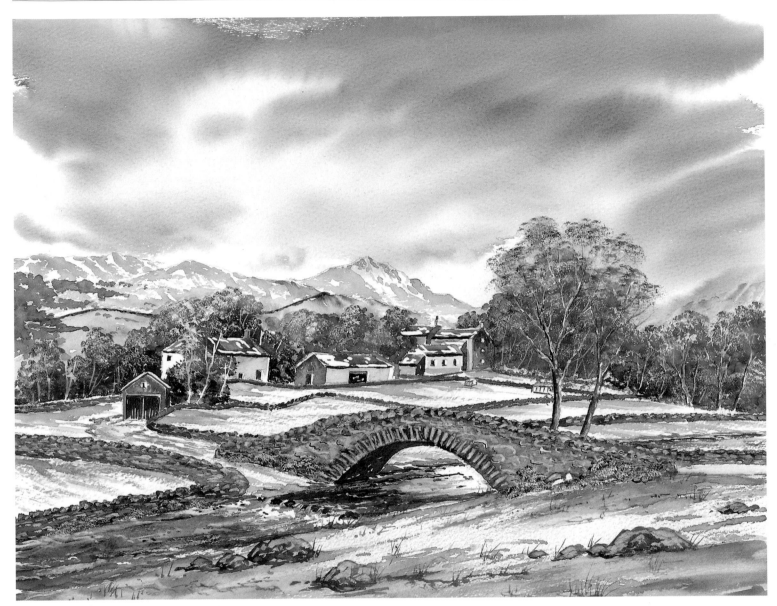

Fine examples of a bridge and walls can be found at Longsleddale in the English Lake District.

Points to remember

- The structure is the starting point for any successful painting of a bridge or wall.
- Look for the small details that make each wall different. 'Hogg' holes, for example, are holes which allow yearling sheep, called 'hoggs', to pass through the wall to reach further grazing areas. Postboxes are often incorporated into a stone wall, and stone gateposts have holes which allow poles to be positioned across an opening instead of a gate. 'Rabbit snoops' for catching rabbits are built into some walls. Many ingenious practical devices are incorporated in stone walls. Look out for them.

- Each waller will use the type of stones available to him in the vicinity. As artists, we need to take this into account when painting stonework. If the walls are near a river the stones may be round, if near a quarry long and thin, so paint your wall accordingly.
- When painting bridges, try to select a viewpoint which enables some of the underside of the arches to be seen. This makes a more pleasing composition.
- When incorporating stone walls in your composition, never paint them stretching from one side of your painting to the other without leaving an opening or incorporating a gate. Otherwise you are putting up barriers to the viewer and saying, 'Don't come into my painting.'

I have chosen four attractive and interesting bridge styles for you to consider here, with a step-by-step diagram showing how to draw a simple bridge.

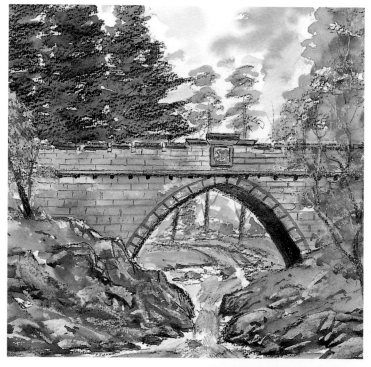

I completed this quick demonstration sketch in water-soluble crayons when I was tutoring a painting holiday at Braemar in Scotland. The bridge is the famous Linn of Dee, a popular tourist attraction. Constructed from blocks of stone, it creates a pleasing, functional design over a gorge with fast-flowing water.

I used water-soluble crayons washed in with brushstrokes to create this simple representation. Water-soluble crayons are ideal for sketching and painting outdoors. I always carry a small tin of ten. This can be tucked into a pocket and all you need in addition is a brush to produce quick 'doodles'. The rocks were created by moving wet paint with a palette knife.

This bridge is typical of those found in many states in the USA. They are simple, functional, wooden structures that are partially covered. Note the variety of colours used to paint the woodwork.

'Clapper' bridges are simple in form, crudely constructed and rough in appearance. They were one of the first types of bridge, made by placing large slabs of rock across a river or beck, and were used prior to the use of arches in bridge building. Examples can be found in most counties of England; this one is at Postbridge in Devon.

How to draw a bridge

Drawing a bridge can be very simple if you know the correct
procedure – just follow the steps shown below.

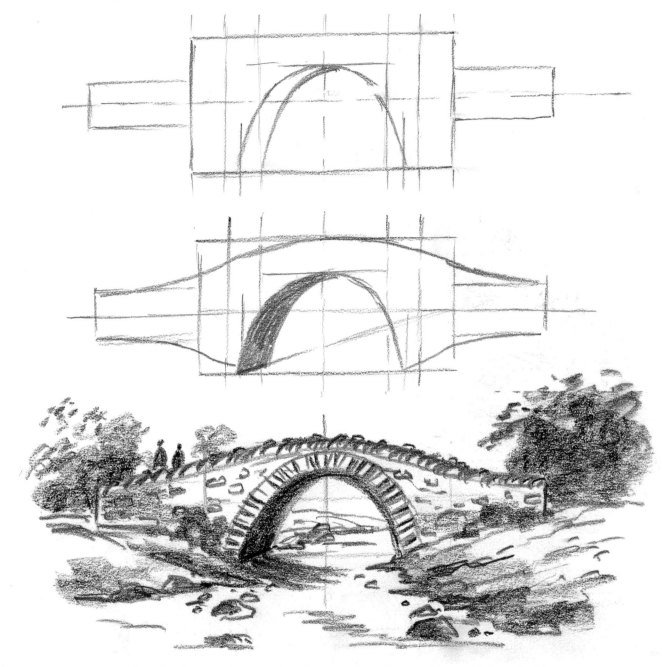

This simple river scene spanned by a bridge was drawn using the procedure shown above and described below.

1. Draw a rectangle. Divide the rectangle into four equal parts by drawing one vertical and one horizontal line
 through its centre.
2. Draw two further rectangles, one each side of the large one.
3. Divide the large rectangle into eight equal parts by drawing a vertical line in each half.
4. Divide each of the two outer areas of the large rectangle in two by drawing two further vertical lines.
5. Draw a horizontal line to represent the top of the arch by dividing the top area in half horizontally.
6. Draw two equally placed vertical lines to represent the width of the bottom of the arch.
7. Draw in the arch itself.

A newly built stone wall in a rural setting is a pleasure to behold. Stone walls come in many imaginative designs, depending on the requirements and skills of the farmer, who will use the natural materials available to him. If the wall is near a river, rounded stones are used; if it is near a quarry, natural slivers of slate/stone may be chosen. The waller may incorporate flat stones and project them from the wall at various points to make steps which allow it to be scaled.

The techniques that are discussed here can also be used for painting bridges.

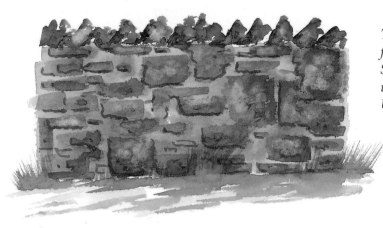

This wall has been built using large stones unearthed from land clearance. To capture it, I applied Raw Sienna wet-into-wet over a weak Payne's Grey underpainting. When this was dry, I used Burnt Umber to paint in the darker stones and shadows.

There are two interesting features in this wall: a hole, known as a 'hogg' hole (incorporated to allow young sheep known as 'hoggs' to pass through), and a large stone gatepost.

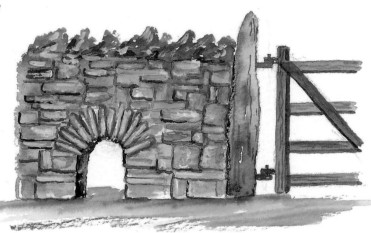

A 'flag wall' is created by positioning large stone or slate slabs in the ground. This type of wall is often seen around churches and gardens, or is used to denote boundaries. I used various tones of Payne's Grey to create texture.

For this brick wall I applied first a Raw Sienna/Alizarin Crimson underpainting and while it was still wet dropped in Burnt Sienna, Payne's Grey and Vermilion, allowing the colours to merge together. When the paint was approximately one-third dry, I used a tissue to create light areas on the bricks. When it was completely dry, I painted shadows along the left-hand and lower edges of each brick to create a three-dimensional appearance.

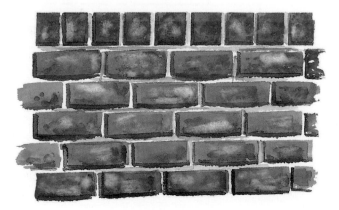

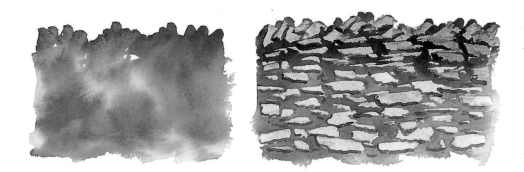

A palette knife helped me to create this painting of a stone wall. After applying a Raw Sienna wash I brushed in Burnt Sienna with dark tones of a Payne's Grey/Alizarin Crimson mix wet-into-wet. I waited until this was about one-third dry before moving the paint with the palette knife to create the stone structure and the coping stones.

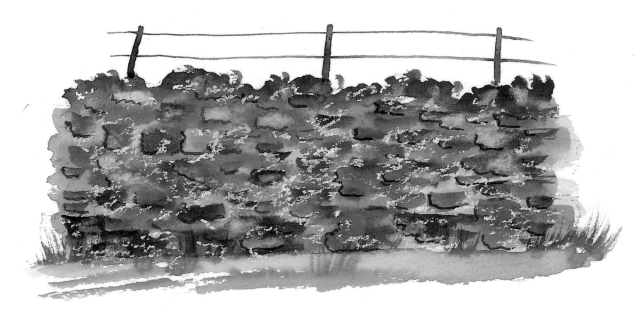

Watercolour and oil pastel can combine well to create texture. In this example the wall was painted initially with a cream-coloured oil pastel and then overpainted with watercolours. After applying the usual Raw Sienna wash, I used Burnt Sienna, Burnt Umber and a Payne's Grey/Alizarin Crimson mix, and when this was dry painted shadows on two edges of selected stones.

Useful colours for painting bridges and walls

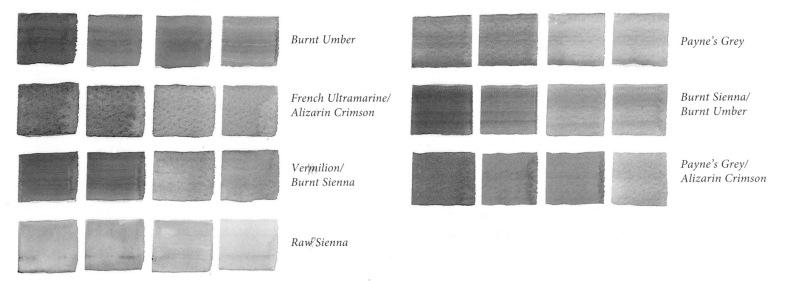

Burnt Umber

French Ultramarine/
Alizarin Crimson

Vermilion/
Burnt Sienna

Raw Sienna

Payne's Grey

Burnt Sienna/
Burnt Umber

Payne's Grey/
Alizarin Crimson

This atmospheric scene of **Wasdale Head** in the west of the English Lake District was painted in acrylics. The farmstead and lovely stone packhorse bridge make it a pleasing composition. In the background is Kirk Fell, its peak shrouded in low cloud, and next to it the impressive bulk of Great Gable, which is partly obscured behind the trees in their full summer canopy.

The public house in Wasdale is the 'gathering hole' for those setting out to climb either of these local landmarks. The well-worn track they take can be seen in the painting.

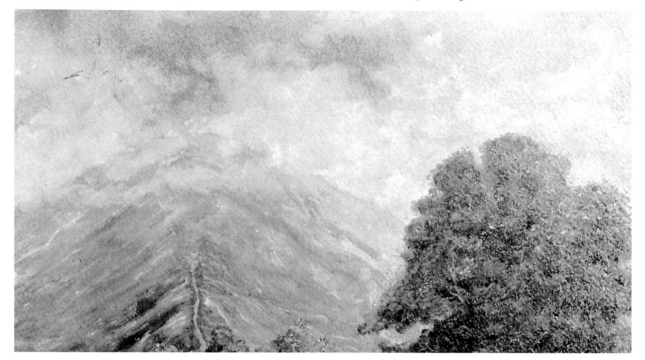

Fell and sky

In this painting I particularly wanted to capture the effect of the cloud around the top of Kirk Fell. The cloud was so low that the fell was barely visible. I painted the fell first, using directional strokes with a hake brush. After applying a Raw Sienna wash, and while it was still wet, I brushed in various greens, following the structure of the mountain. While the paint was still wet, I painted in the sky, allowing the paint to run over the top of the fell. With a tissue I removed paint to create the effect of cloud over the peak of the fell.

Foliage and foreground

The detailed bushes and specimen trees were painted by stippling in the dark underpainting, using a Payne's Grey/Permanent Sap Green mix. When this was dry, lighter groups of foliage were stippled in using an old bristle brush loaded with various tones of green.

The rough foreground was painted using the same techniques as that for the trees. When the paint was dry, a Raw Sienna/Burnt Sienna glaze (a small amount of paint and lots of water) was washed over the near foreground to add colour and sparkle. The grazing sheep were then painted.

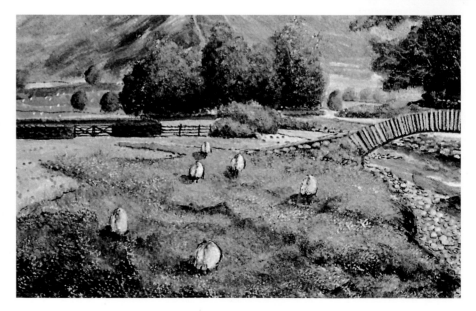

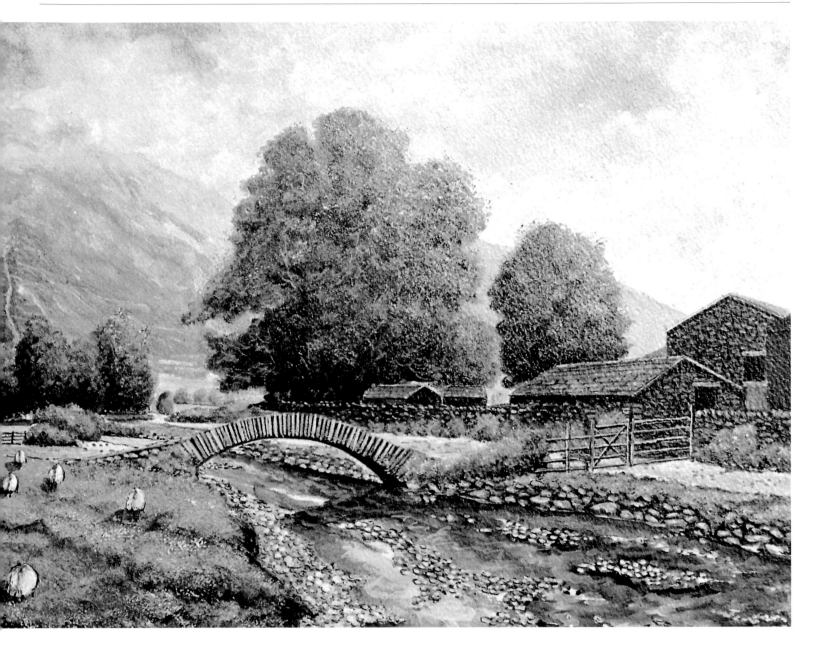

Bridge and water

The bridge was very simple to paint, using angular strokes with a rigger brush. The colours were Raw Sienna and Burnt Sienna, with Payne's Grey added for the shadows. Take care to ensure your bridge is a pleasing shape and paint in a little of the underside. The stones in the river were painted with a size 6 round brush and for the water I used a hake brush loaded with a Payne's Grey/Cerulean Blue mix, leaving areas of white paper

uncovered. When the painting was completed, a Raw Sienna glaze was selectively applied to areas on the fell, the distant fields, the trees and the water – just small amounts here and there to add sparkle to the painting.

Eilean Donan is Scotland's most recognizable castle and a source of inspiration for generations of artists. The castle has been a fortified site for at least eight hundred years, although the present castle was restored in the early 20th century.

Eilean Donan and its magnificent setting attracts visitors world wide. The castle has been the venue for many films, notably *Highlander*, starring Sean Connery, and *The Master of Ballintrae* with Errol Flynn.

Sky and mountains

A piece of 2cm/¾ in masking tape was positioned across the paper to represent the water line. The sky was painted using a 4cm/1½in hake brush by initially applying a pale Raw Sienna wash and creating the cloud formations by brushing in mixes of Payne's Grey, Cerulean Blue and Alizarin Crimson. A tissue was used to soften the cloud edges and create an interesting cloud study.

When the sky was dry, the distant mountains were painted using various tones of the same mixes used for the sky. When these were dry, the masking tape was carefully removed.

Buildings and water

When preparing the initial outline drawing, I took care to ensure the buildings were put in correctly. For painting buildings from a distance, I find a small pair of binoculars invaluable. In this example, there are so many variations in the design of the building that I needed the binoculars to determine some of the features – particularly as the shadows, so important in this scene, tended to make observation with the naked eye difficult.

The buildings were painted by applying a Raw Sienna wash overall and brushing in a little Burnt Umber and a Payne's Grey/Alizarin Crimson mix.

The shadows were painted once the underpainting was dry, as were the windows and darker features. The tonal values of the shadows were important in this landscape.

Horizontal strokes with the side of a size 14 round brush were used to paint the water, with sparkle added by means of lighter touches. I painted the rocks after completing the bridge and water.

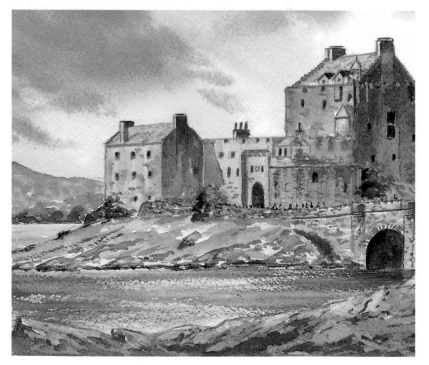

Tonal Studies

Use tonal value studies to determine your best viewpoint. These studies help to establish your values – lights and darks – prior to applying paint.

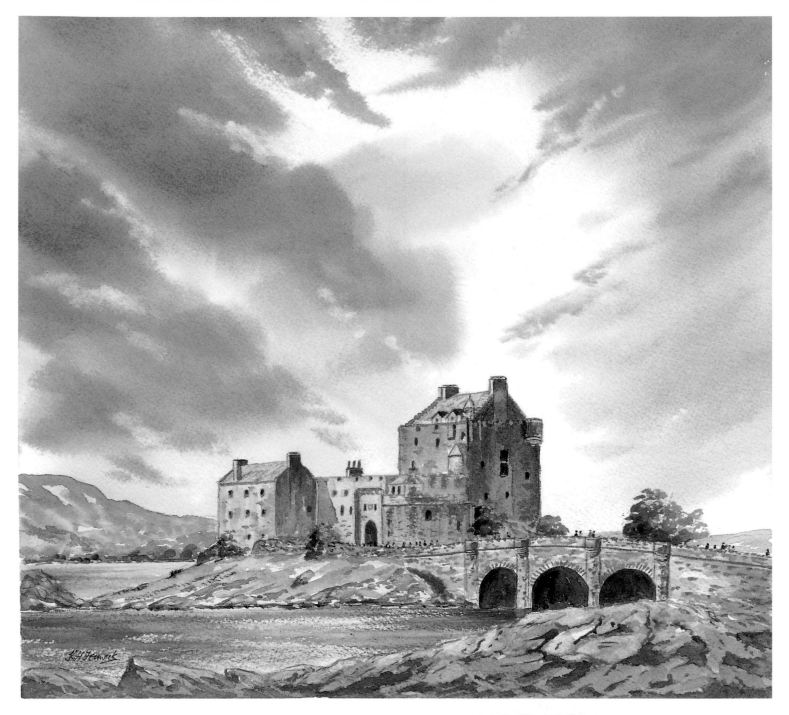

The bridge

From my chosen viewpoint the arches of the bridge linking the castle to the mainland had to be carefully drawn, as did the towers and buttresses. Care was taken to observe and capture the shadows on the arches. The bridge is quite simple in structure, but from my viewpoint it was a tricky exercise to draw, in particular its relationship with the stone wall surrounding the path and leading to the castle entrance. The colours and techniques used were similar to those for the main buildings.

I added a few figures walking to the castle; at the time I painted the scene there were far too many people to include.

KEITH FENWICK is one of the UK's leading teachers of painting techniques. He enjoys a tremendous following among leisure painters, who flock to his demonstrations and workshops at major fine art and craft shows.

A chartered engineer, a Fellow of the Royal Society of Arts and an advisory panel member of the Society for All Artists, Keith holds several professional qualifications including an honours degree. He served an engineering apprenticeship, becoming chief draughtsman, before progressing to senior management in both industry and further education. He took early retirement from his position as Associate Principal/Director of Sites and Publicity at one of the UK's largest colleges of further education in order to devote more time to his great love, landscape painting. His paintings are now to be found in collections in the UK and other European countries, as well as in the USA, Canada, New Zealand, Australia, Japan and the Middle East.

As well as the painting holidays he runs in the UK and Europe, seminars and workshops nationwide and demonstrations to up to 50 art societies each year, Keith can be seen demonstrating painting techniques at most major fine art and craft shows in the UK. He has had a long and fruitful association with Winsor & Newton, for whom he is a principal demonstrator. His understanding of student needs is evidenced by the popularity of his books and his 20 best-selling art teaching videos, which have benefited students worldwide. He is also a regular contributor to art and craft magazines.

Keith finds great satisfaction in encouraging those who have always wanted to paint but lack the confidence to have a go, as well as helping more experienced painters to develop their skills further. He hopes this book will be a constant companion to those wishing to improve their skills and experiment with new ways to paint the landscape.